FEARLESS
PHOTOGRAPHER
SPORTS

Michael Skelps

Cengage Learning PTR

CENGAGE
Learning

Professional • Technical • Reference

Australia, Brazil, Japan, Korea, Mexico, Singapore, Spain, United Kingdom, United States

CENGAGE
Learning®

Professional • Technical • Reference

Fearless Photographer:
Sports
Michael Skelps

Publisher and General Manager,
Cengage Learning PTR:
Stacy L. Hiquet

Associate Director of Marketing:
Sarah Panella

Manager of Editorial Services:
Heather Talbot

Senior Marketing Manager:
Mark Hughes

Acquisitions Editor:
Dan Gasparino

Copy Editor/Development Editor:
Cathleen D. Small

Project Editor:
Cathleen D. Small

Technical Reviewer:
Donna Poehner

Interior Layout:
Jill Flores

Cover Designer:
Mike Tanamachi

Indexer:
Sharon Shock

Proofreader:
Sue Boshers

For product information and technology assistance, contact us at
Cengage Learning Customer & Sales Support, 1-800-354-9706

For permission to use material from this text or product, submit all requests online at **cengage.com/permissions**
Further permissions questions can be emailed to
permissionrequest@cengage.com.

All trademarks are the property of their respective owners.

All images © Michael Skelps unless otherwise noted.

Library of Congress Control Number: 2012934302
ISBN-13: 978-1-4354-5905-2
ISBN-10: 1-4354-5905-9

Cengage Learning PTR
20 Channel Center Street
Boston, MA 02210
USA

Cengage Learning is a leading provider of customized learning solutions with office locations around the globe, including Singapore, the United Kingdom, Australia, Mexico, Brazil, and Japan. Locate your local office at: **international.cengage.com/region**.
Cengage Learning products are represented in Canada by Nelson Education, Ltd.

For your lifelong learning solutions, visit **cengageptr.com**.
Visit our corporate Web site at **cengage.com**.

Printed in the United States of America
1 2 3 4 5 6 7 15 14 13

For my wife, Janine, who has always believed in my dreams and tirelessly worked to help me achieve them. Without your love and support, none of this would have been possible.

Preface

Sports photography has been my passion since 2005, and I've made it my profession as well. Taking sports photos myself as well as working with and managing other photographers has been an experience that I'm very grateful for, and I've learned a lot in the process. I'm happy to share with you some fundamentals, techniques, and tips I've learned through the years. One of the overarching themes I've come to understand in sports photography is that it's not so much about creativity as it is about having a set of tools that you can employ when shooting action. Working with scores of photographers at events around the country, I've developed a systematic approach that anyone with the right equipment can employ to reliably produce high-quality sports images, and I'll lay out that approach for you.

I've learned that to be most successful in life, you need to specialize, so I've built my company and my career around a specific photography niche. (When I tell someone that I'm a photographer, they almost always say something like, "You must be very busy when wedding season comes!" I chuckle to myself and say that I don't do weddings.) Instead of becoming a jack-of-all-trades photographer, who might do weddings, portraits, and other types of photography, I've chosen to specialize in sports photography. Throughout the years, I've had a lot of fun photographing various sports in action: baseball, hockey, football, gymnastics, swimming, and everything in between. But my specialization really goes beyond the still broad category of sports. My micro-niche is shooting races, such as 5Ks, marathons, adventure races, and triathlons, which is where I spend most of my time. While reading this book, you may notice a predominance of race photos, peppered with photos of other sports. That mix is just a reflection of the portfolio of my current professional photographic activities; it doesn't imply that the content presented in the book is more particularly suited to photographing one type of sport than any other. Whether you choose to focus your photography on a particular sport or you shoot a wide variety of sports, you'll find that the principles outlined in this book are applicable to any type of action photography. Where there is a moving subject—particularly a rapidly moving subject—you'll be well served to use the techniques and approach outlined in this book.

Acknowledgments

A life and career never exist in solitude. We are blessed, and sometimes challenged, by the interactions with those we encounter in our personal and professional lives. In the vast majority of these cases, I believe we emerge better through working with and helping others. It is my hope that those I've had the privilege of knowing throughout my life feel the same way about the encounters we've shared.

It's undeniably true that without the help, support, subtle influence, or other input of some sort from so many, this book would not have been possible. There are too many to name, but a few particular acknowledgments are in order.

I am fortunate to have had the opportunity to work with, compare notes with, and learn from more than a handful of the highest-caliber professional photographers in the industry. People like Mike Tureski, Ryan Miner, Bob DeChiara, Scott Slingsby, Gary Hamilton, Tammy Belanger—fine sports shooters one and all. Working with them on assignment as well as seeing the quality and quantity they consistently produce helped me validate and refine my approach to efficient and effective sports photography. Rusty Adams, in addition to being one of the top shooters I know, was such an enthusiastic advocate that it helped inspire me to dream of what could be possible in an expanding realm of sports photography at events across the country, while keeping it as much fun as it is work. I've met so many photographers who are amazing professionals and great people, and it would be impossible to name them all. Thanks to all of you. You know who you are.

In particular, I'd like to thank the photographers who have contributed their images to this book. It is through your eyes and technique that budding photographers will be introduced to our trade.

I'd like to thank my office staff, including my right-hand man, Antonio Arreguin, for your tireless work ethic and enthusiasm in taking professional photography farther and wider than I might have imagined.

A special thanks is due to my editors, Cathleen Small and Dan Gasparino, for their patience and support in publishing this book during a time when many conflicting demands for my attention sometimes slowed the writing and editing processes.

Finally, I must thank my wife, Janine, who should be singled out for her contributions to this book above all others. She believed in my crazy vision and gave moral and financial support to my career and my growing business from the start. Too many times, she has gotten up at 3 a.m. and sweated alongside me at grueling assignments, and she has become an impressive sports photographer in the process. Janine, you have my love and my greatest thanks for a debt that could never be fully repaid.

About the Author

Following an unconventional route to professional photography, **Michael Skelps** started with a technical background, earning his BS in aerospace engineering from the University of Virginia in 1990. He served in the U.S. Navy as a nuclear engineer aboard the submarine USS *Bergall*. After joining corporate America as an IT and communications manager at United Technologies, he founded Capstone Photography.

Michael focused his activities on developing prowess as a photographer personally, while he grew the base of photographers within the company. Shooting different types of events, week after week, month after month, he developed experience in shooting many different types of sports. What transpired was the development of a standard, repeatable, teachable approach to taking great sports photos, no matter what the conditions. As his network of photographers grew, Michael came to work with many excellent shooters around the country. Learning from their mistakes while leveraging what they did best, Michael has refined this standard approach and documented it here in simple, clear principles and practical applications.

Contents

Introduction . xiv

Chapter 1 **What It Takes to Be a Great Sports Photographer 1**

The Right Equipment . 3

The Basic Approach and Theory of Sports Photography. 4

Proficiency in Shooting under Various Lighting Conditions 4

Commitment and Practice. 6

Are You Ready? . 8

Chapter 2 **The Challenges of Sports Photography:
Why Isn't Everyone a Good Sports Photographer? . . . 10**

Available Lighting and Conditions . 12

There's No Saying "Oops" . 18

 Be Alert and Interactive . 18

 Shoot a Lot of Frames. 18

Fast Shutter Speeds . 21

Equipment Challenges . 22

Conclusion. 24

Chapter 3

Photography Concepts . 26

Exposure . 28

Shutter Speed . 31

ISO . 32

Aperture . 35

Conclusion . 39

Chapter 4

Camera Equipment . 40

What's So Special about a Sports-Photography Camera? 42

Shutter Lag . 42

Low Noise Sensor . 43

Low F-Stop . 45

Fast and Clear Focus . 45

High Frame Rate and Long Battery Life 46

Gear I Suggest You Don't Consider 46

Recommended Gear . 47

Canon 20D–60D Series . 48

Canon 1D Series . 49

Canon 5D . 49

Canon 7D . 50

Nikon Bodies . 50

D2H and Other Older Nikon Bodies 50

D300 . 51

D700 . 51

D3 . 51

Lenses . 51

Nikon Lens Recommendations . 53

More Expensive Lenses . 53

New versus Used Gear . 54

Find a Reputable Retailer . 54

Is Used Gear a Viable Option? . 55

Other Equipment Considerations . 56

Lens Filter . 56

Hood . 56

Camera Grip . 57

Tripod Collar/Monopod . 58

Extra Batteries . 58

Memory Cards . 60

Gear You'll Have *Less* Success With . 60

Consumer-Grade SLRs . 61

Lenses . 61

Chapter 5 **Understanding and Managing Exposure** **62**

What Is Exposure? . 64

Analyzing the Histogram to Determine Exposure 66

Chimpin' Ain't Cheatin' . 67

Underexposed versus Overexposed . 70

Conclusion . 71

Chapter 6 **Understanding and Managing White Balance** **72**

Light and Color . 74

White Balance in Digital Photography 74

Avoid Auto White Balance . 75

Custom White Balance . 76

Conclusion . 79

Chapter 7 **Focus** . **80**

Camera Auto-Focus: Shotgun or Sniper? 83

Lens Auto-Focus . 84

Panning . 86

Conclusion . 89

Chapter 8 **Framing and Composition** **90**

Go Vertical . 92

Framing . 94

Don't Shoot the Head . 99

Landscape Framing . 102

Conclusion . 103

Chapter 9 **Shooting in Ideal Conditions** **104**

Your Subject Matter . 106

Front-Lit Conditions . 107

Cloudy/Overcast Conditions . 110

Conclusion . 112

Chapter 10 **Low-Light Photography** . **114**

Stage 1: From Very Bright to Just Bright 118

Stage 2: From Bright to Moderate . 118

Stage 3: It's Starting to Get a Little Dark 119

Stage 4: Okay, It's Really Dark Now! . 120

Conclusion . 121

Chapter 11 **Backlit Subjects** . **122**

An Important Secret . 126

Why Shoot Backlit? . 126

How to Shoot Backlit Subjects . 128

 Method 1: Change Your Metering Mode to Spot Metering . . . 129

 Method 2: Shoot in Manual Mode . 130

 Method 3: Use Manual Exposure Compensation 130

Assessing Exposure . 133

Other Thoughts on Backlit Subjects . 133

Conclusion . 136

Chapter 12 **Shooting in Inclement Weather** **138**

Wet-Weather Shooting . 140

Cold-Weather Shooting . 143

Other Inclement-Weather Considerations 145

Conclusion . 146

Chapter 13 | **File Considerations** **148**

JPG versus RAW. ... 150

 RAW Images. ... 150

 JPG Images ... 150

 The Case for RAW .. 152

 The Case for JPG ... 152

Large, Medium, or Small 153

File Compression .. 154

Conclusion. ... 155

Chapter 14 | **Workflow and Image Enhancement** **156**

A Recommended Digital Workflow 158

Download Your Images and Name Your Folders. 159

Rename Your Files ... 164

Select Your Best Shots. 165

Adjust Brightness ... 165

Adjust Color Balance. .. 169

Adjust Color Saturation 170

Crop. ... 171

Reduce Noise. ... 172

Unsharp Mask ... 175

Save the Image .. 176

Conclusion. ... 177

Chapter 15 Safety. **178**

Chapter 16 Conclusion . **184**

Index . **188**

Introduction

The crowd has gathered, and the event is about to begin. The national anthem is just about to finish. The crowd and spectators are geared up and ready for the action. The athletes have trained and prepared for this moment. This is what they've come for. They've suited up with the right gear, stretched, and hydrated, and they're ready to go. You can feel the tension, excitement, and anticipation in the air.

The sport doesn't matter: football, baseball, hockey, gymnastics, or a 5K road race. For every event, the feeling is the same. You've prepared mentally, starting the night before, when you cleaned your lenses, checked your memory cards, and charged your batteries. You even brought a spare or two. You've figured out the position from which you want to shoot as the action begins. You've checked your camera settings: Camera Mode, Shutter Speed, Aperture, ISO, White Balance, and more. You even have your rain gear in case the weather worsens from the forecast of a few hours ago. The athletes are fired up as the time for the event draws closer. And so are you, the photographer.

No matter how many events I've photographed, it's always the same feeling, even after hundreds of shoots. I always get that amazing sensation and energy, that level of excitement, the butterflies that accompany the surge of adrenaline. Even with the confidence that comes over time, that feeling never goes away. I love the action, the competition, and the electricity of sporting events.

Why We Love Sports Photography

Sports photography is like no other segment of the field. It's extraordinarily challenging, and it produces, in my opinion, some of the most dramatic photos of any type of photography.

I have peers and colleagues who do an unbelievable job in wedding photography, portrait photography, and other segments. With all due respect to them, you'd be hard-pressed to convince me that any other segment of photography is nearly as exciting, as rewarding, or as impressive as sports photography.

We've all seen dramatic sports pictures in national sports magazines, and I think most of us can relate to viewing a still photo at the peak of human competition. In a way, I think sports represent our species in its greatest moment—with each athlete trying his hardest to be his best. This involves a tremendous amount of emotion, desire, and determination. Sports show a culmination of weeks, months, or even years of preparation. Whether it's a child's baseball game or the Olympic Games, the reason we love sports remains constant. It's us as a human species, reaching out—striving to excel, striving to surpass our current state, and trying to reach and even exceed our potential. And that's why sports photography is so appreciated, whether at the amateur, collegiate, or professional level. It's about capturing humanity in this endeavor and all of its facets—the struggle, the emotion, and the desire to be the very best that we can be as individuals.

But there is another reason why non-photographers have such an appreciation for great action photography. Photographing sports gives a perspective that no human eye can capture. As humans, we witness sports (and everything else) in real time, but in sports there is action and a quickness of motion. With the

movement of the bodies, the ball in midair, sweat and mud flying, and perhaps water splashing, it becomes impossible to take in the nuances of the entire scene in real time with the naked eye. Sure, we can appreciate sports and find them exciting, but there is a limit to how much we can appreciate the scene unfolding so rapidly before us. There are aspects that we just can't appreciate in detail until they are slowed down or, in the case of a photo, stopped for us to view. Only through a photo, a moment frozen in time, can those details become apparent to and appreciated by us. So as a sports photographer, I believe that you truly open up a new perspective, a new connection between the fan or the family member who is watching and the athlete in the photo. You are providing that person with a perspective that he could never achieve with the human eye or even by viewing a slow-motion video. The detail you can capture as a successful sports photographer allows the viewer of the photo to connect with the athlete at that moment in time. And I think it's really an amazing connection when you look at a sports photo and see the emotion, determination, and effort in that real context, frozen in time, with whatever surrounds that—the mud, the sweat, and anything else.

But sports photography doesn't come easily. It is very challenging and demanding. It's a skill you must learn and hone over time through repeated instances of going out and shooting. This book will help get you started quickly and efficiently, but don't expect that the first time you shoot sports will be your best or most successful time. Developing this skill requires an investment, time, commitment, and a willingness to practice and look for areas where you can improve. But the rewards are well worth the investments that you will make to get started and continue developing your skill. If you're willing to learn, practice, and make some level of investment in the right gear, then you're already on your way to becoming a capable sports photographer.

Shooting sports is also demanding with regard to the type of equipment you'll need. Even if you're an amateur who is looking to get your first "sports-ready" digital SLR, you must understand that there is a certain minimum standard for the type of equipment you'll need. I talk to budding photographers who are so excited that they purchased a $500 digital SLR, only to find out that their gear isn't really going to produce the results they're hoping for when shooting sports. When I tell them they don't have the right caliber of gear, people are often in disbelief. They can't imagine that their new camera (the nicest one they have ever owned, mind you) isn't really up to the task of *reliably* capturing sports photos. But the first hurdle is education and awareness, so in this book I'll lay out some specific recommendations to take away much of the guesswork in filling your camera bag with the right caliber of gear. And while the minimum gear requirement is very real, the good news is that prices have come down, particularly if you're willing to look at the aftermarket segment and consider quality used gear.

To be clear, let me say that you're not going to have any significant luck producing quality sports shots with a point-and-shoot camera. Likewise, don't expect to have much success shooting sports using a consumer-grade SLR. This is another reason why sports photography becomes sort of an exclusive club. You have to have the right type of gear and the right skills. From time to time, I also see people holding very expensive, high-quality cameras—ones capable of shooting sports—only to see them shooting with their camera set to fully automatic. Part of me wonders what the point is. As I'll discuss in detail, you won't shoot sports in a fully automatic camera mode. I'll lay out a specific approach and guidelines for shooting sports, resulting in a repeatable regimen you can follow at sporting events. This approach will ensure that you're shooting in the best possible manner for successful sports photography.

This book is not about how to occasionally take a good action photo. The process I'll lay out is one where you can *predictably* and *reliably* get high-quality action photos. With a consumer-grade camera, it's true that you could possibly catch a great shot now and then. I've seen excellent photos produced on occasion through a chance alignment of the right conditions. Even with the wrong settings, you might still once in a while get an action shot that comes out well. But rather than relying on chance and hoping to get a good shot, the approach in this book will leave you confident that you can come home from the ballpark, soccer field, or road race with great-looking photos.

Be Intrepid and Press On

After reading this introduction, I hope you remain undaunted. I hope you're excited about continuing your journey into sports photography. I say *continuing*, not *beginning*, because by reading this book, your journey is already underway! And I hope you're already looking forward to the first time you'll step out with your camera, whether you'll be at your child's football game or at a local race event. I hope you're already thinking about what it will feel like when the athletes are ready to start their game at the close of the national anthem. And I hope you feel the same way I do when I say to myself prior to every event, "It's show time!"

Commitment

I want to be clear that being a good sports photographer requires a commitment. If you're strictly a casual photographer with a point-and-shoot camera or a camera phone, I hate to break the news to you, but you may not be in the best position to pursue a specialization in sports photography. But if you're interested in moving forward with sports photography, I recommend that you look at your current inventory of photography equipment and determine whether your camera body or lens is in need of an upgrade. If you're just entering photography and you're not able to make an investment to get a higher grade of equipment, there are many other types of photography, such as landscape or portrait fields, where the entry-level hardware requirements aren't as stringent.

If you have some of the right equipment or if you're willing to make an investment in the $1,000 to $2,000 range, you can put yourself in a great position to learn and practice sports-photography techniques. You can turn out results that will amaze even you. After you follow the steps outlined in this book, your work will impress your friends and will probably be at or above the level produced by your local newspaper. I'll lay out the formula for you with a significant amount of detail, including the equipment, a little theory, and a practical approach. So fear not—I want you to have a high level of confidence that you'll very quickly achieve great results. If you're ready to take a hard look at your gear and budget, you and I will take a journey together that will completely change your photographic skills and repertoire. It will open you to new aspects of your photography, and you'll produce work that approaches the level of some of the photos you may see in national sports magazines.

It will take practice, though. There are four pieces to the equation of producing great action photos: equipment, knowledge, skills, and practice. And there is no substitute for practice. I strongly encourage you to practice in a wide variety of conditions. In this book, one thing we'll talk about is how to shoot

and produce great results in ideal conditions. Using the right gear and the basic approach outlined in this book, you'll be able to produce amazing photos almost immediately when shooting under favorable lighting conditions. But one of the challenges of shooting sports in particular is being able to photograph regardless of whether the lighting conditions are favorable or unfavorable.

When you're shooting sports, not every environment will be ideal. There are many environmental challenges, depending on the type of sport and the lighting—an ever-present challenge for most types of photography. And so, to become a truly good sports photographer, you have to get out there and practice—make that commitment and see this as a long-term journey. You may choose to continue your newfound sports-photography skill as true amateur, using these photos for your own personal use and enjoyment, or you may want to take a commercial angle and profit from your photography. Either way, you will become better at what you do through consistent practice in a variety of conditions. That's really the last piece of the puzzle—equipment, knowledge, skills, and ongoing practice and development. If you have those pieces in place, then you're ready to start this journey, and I promise you it will be a great one.

Who This Book Was Written For

This book was not written for everybody. It was written for those who have a serious interest in developing their sports photography skills and having the right equipment to take great sports shots. As I mentioned previously, there are many challenges to shooting action photography, and having the right gear is one of them. I'll address the gear in detail later.

A wide variety of people may be interested in sports photography. You might have a child who plays baseball, football, or some other sport. You might be a photographer looking at adding sports photography to your repertoire as a natural extension of the work you already do. You might be an amateur who loves to take photos—I know many great photographers who started as simply general photography enthusiasts and who today primarily shoot sports and action. Many of them choose to shoot sports purely for its aesthetic elements. Others have leveraged this skill as a way to make extra money doing weekend assignments.

How This Book Is Organized

The material in this book is organized to lay the groundwork for a beginning sports photographer. First, we'll cover the equipment required to be a successful sports photographer, as well as some of the fundamentals and technical concepts you'll need to understand up front. Next, we'll cover how to capture your first action shots in ideal (or close to ideal) conditions. I'll present a number of more advanced techniques that will let you hone your skills. Then we'll talk about some of the challenging conditions especially common in sports photography and how you can deal with them. The later chapters of the book will discuss fundamental post-process concepts, such as file backup, organization, and preparing your images for print or electronic usage. We'll wrap up by discussing perhaps the most important detail of them all: your safety in this challenging shooting environment. I hope you're as excited about learning as I am about sharing my ideas with you. Are you ready?

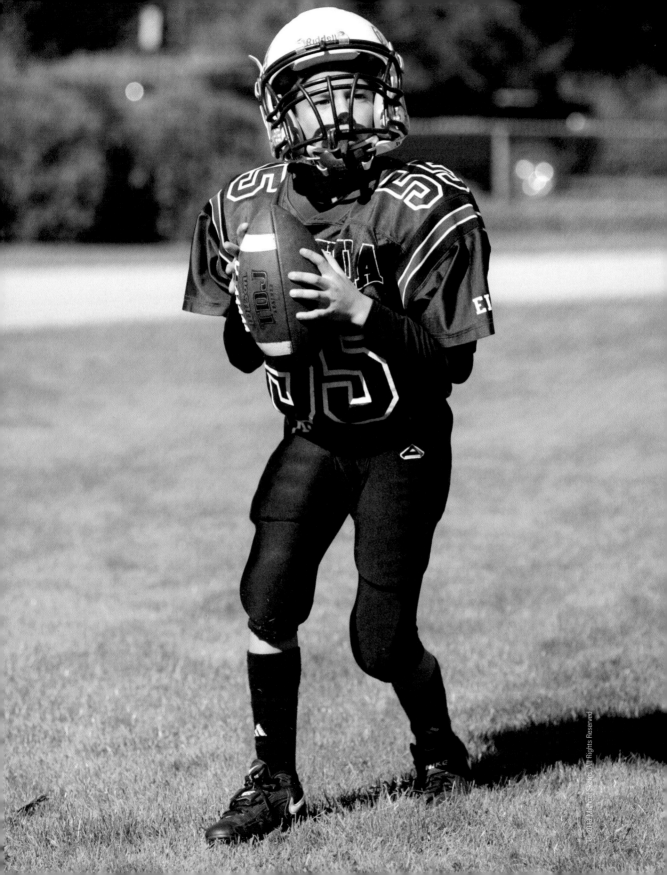

Great Sports Photographer

Since the beginning days of photography, cameras have steadily improved to capture better images at lower costs. Particularly in the last decade, when quality digital photography first emerged, we've seen prices drop and cameras get smaller. These days, digital cameras are ubiquitous, to the point that nearly everyone has a digital camera of some sort—your mother, your neighbor, and maybe even your kids. And with so many cameras in so many hands, it seems as if everyone taking a picture thinks he's a photographer. I think that's great. Having more people interested in photography and capturing images keeps the craft of photography moving forward.

But with all of the people whipping out their iPhones, point-and-shoot cameras, and even digital SLRs (dSLRs) at football games or other sporting events, surprisingly few are able to take *consistently good* action photos. Often, people produce photos that fall short of their full potential. So what's the difference between capturing mediocre snapshots and getting high-quality action photos? What are the photographers doing differently? How can you go from being a budding photo enthusiast to being a solid, capable action shooter?

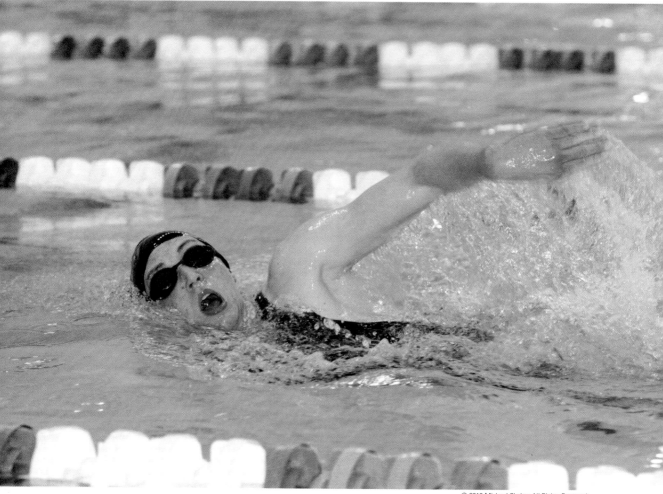

I've worked with dozens of budding photographers and seen them progress to become legitimate and accomplished sports photographers. In addition to shooting hundreds of events myself, I've worked closely with plenty of photographers and learned much from our collective experience. Over time, I've seen what works and what doesn't work in terms of equipment, style, and technical approach. In this book, I'll lay out a system based on the knowledge and experience I've acquired. I think you'll find this approach straightforward and achievable and that you'll be able to quickly develop the skills to take high-quality action photos of the events that interest you most.

To start, you should know that there are four components you need to become a capable and proficient sports photographer:

- The right equipment (see Chapter 4, "Camera Equipment")

- Knowledge of the basic approach and theory of sports photography (see Chapter 3, "Photography Concepts")

- Proficiency in shooting under different lighting conditions (see Chapter 9, "Shooting in Ideal Conditions," Chapter 10, "Low-Light

Photography," and Chapter 11, "Backlit Subjects")

- Commitment and practice

Most of the aspiring photographers I've known are missing at least one of these components. As a result, they never really reach their full potential when it comes to shooting sports. By reading this book, you've already shown that you have the level of interest it takes to become a successful action photographer. But to be a successful sports shooter, you'll need to meet *all* of these requirements.

The Right Equipment

I always tell aspiring photographers that if they have the right equipment and are armed with the right knowledge, they can progress to become a skilled sports shooter rather quickly. But the vast majority of cameras and gear out there are below the threshold that will allow you to consistently capture great sports photos. If your gear isn't up to this standard, your photos can only ever be so good, no matter what your knowledge level. Shooting sports requires you to use high-end photographic gear. Fortunately, capable dSLR gear has been around for nearly 10 years, during which technology has advanced.

"Shooting sports requires you to use high-end photographic gear."

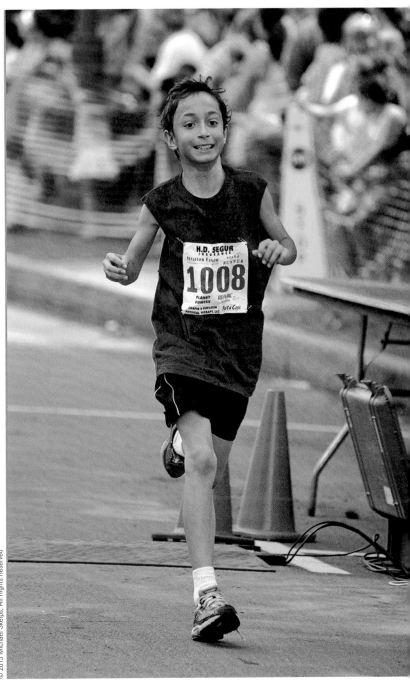

Where good-quality cameras and lenses are concerned, prices haven't dropped significantly, but at least they haven't really increased. Good equipment isn't cheap, but you can get it without spending a fortune. And the used-gear market can allow you to pick up entry-level equipment with a more modest budget. In Chapter 4, I'll suggest some capable equipment for a budget starting at less than $2,000. I'll also recommend some higher-end gear if your budget will support that investment. The higher range of gear will be more durable, will perform better, and will offer some features and functions not found in entry-level gear. Either way, you should know up front that you shouldn't skimp on gear if you want to be a good sports photographer.

The Basic Approach and Theory of Sports Photography

Too many people take their digital SLR to a sporting event and just start shooting without any knowledge of how to shoot action. It's not uncommon to see someone leave his camera in full-auto mode because he doesn't really understand fundamental photography concepts and how they apply to shooting action. In the end, it's not surprising that people end up with mediocre sports photos, at best.

No matter what type of photography you're after, you'll need to have working knowledge of some key concepts, such as ISO, shutter speed, aperture, and other settings to make your camera produce the best possible shots. Sports photography in particular requires you to be proficient in shooting under sometimes widely varying lighting conditions, so you'll need to have a good understanding of these technical fundamentals and how to use them to your advantage in each particular instance. The basics aren't that complicated, but for many shooters, it's knowledge they have never managed to learn.

I'll lay out these basics in an easily understandable way that will allow you to control your settings for the best results in sports photography. This knowledge is the foundation for progression as a sports photographer, and you don't want to miss it!

Proficiency in Shooting under Various Lighting Conditions

Probably more than any other discipline of photography, shooting sports requires you to be adept at shooting under different lighting conditions. This is one of the challenges that sets sports photography apart from other disciplines. In most other types of photography, you will have some level of control or influence over lighting conditions. You might be able to reschedule the shoot, add supplementary lighting, or change your subject's orientation for more favorable lighting. But these options are seldom available in shooting sports. The game won't be rescheduled just because the light's not right, and the athletes won't always be lit from the front when you're shooting. More likely, you may be shooting a game where the action is going back and forth between two ends of the field, one front-lit and one backlit. That can be a tough situation, but one you'll learn to manage with a little knowledge and regular practice. To be a consistently productive action shooter, you'll need to analyze and adjust for shooting in sunny or cloudy conditions, front-lit or backlit subjects, natural or artificial lighting, or any situation that man or Mother Nature can throw at you.

"Probably more than any other discipline of photography, shooting sports requires you to be adept at shooting under different lighting conditions."

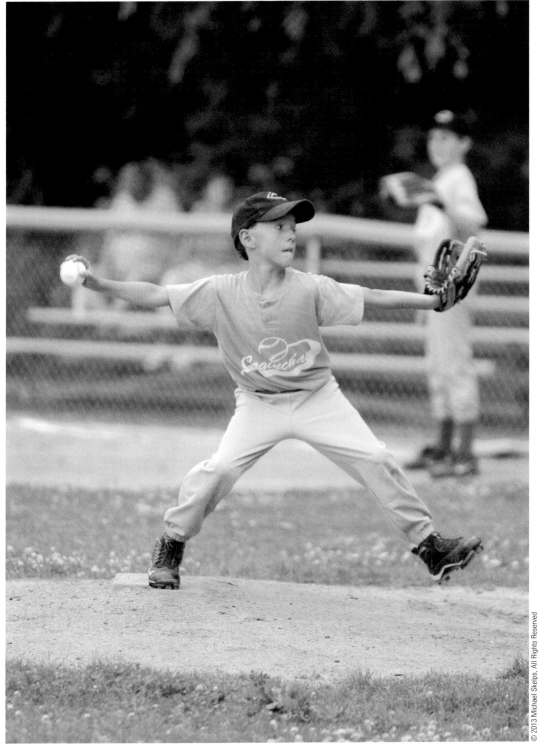

Commitment and Practice

Like almost anything in life, getting good at photography requires patience, commitment, and practice. Becoming a photographer capable of producing quality photos takes a lot of practice. Fortunately, shooting action is usually a rewarding activity in and of itself. As you start to use the techniques in this book, be ready to regularly hone your skills by shooting frequently. You'll want to regularly assess what's working for you and what isn't, constantly looking for areas you can improve. Your development as a sports shooter will come by repeatedly applying these techniques, and I think you'll

"Getting good at photography requires patience, commitment, and practice."

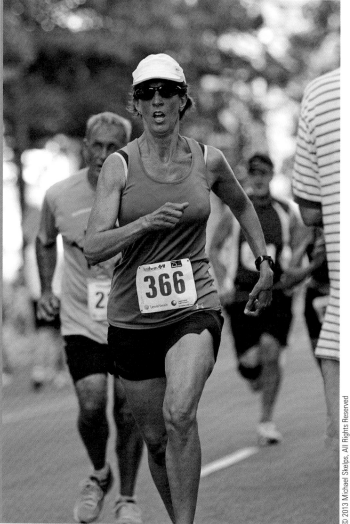

be surprised by how quickly you will advance your skills. Through practice, these methods will become more instinctive, and you'll be able to quickly make adjustments as conditions change without having to think so much about it.

In addition, regular practice is the only way to be fast at making changes to your camera settings when the situation calls for it. For instance, when you're just starting out, you may have to think for a few moments as you shift from, say, shooting front-lit to backlit subjects. But over time, as you gain more practice and experience, you'll be able to make the adjustments faster and with more confidence. Practice is your best friend as a photographer: The more you shoot, the better you'll become.

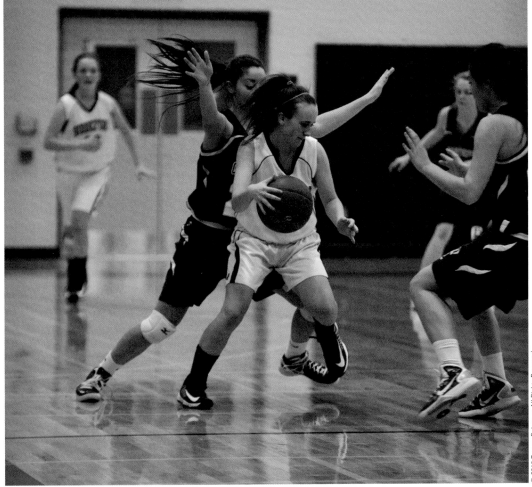

Are You Ready?

Great sports photographers are made, not born. Sure, some people have the "eye" for capturing more extra-special shots than your average sports shooter. But I've found that in most cases, anyone with the right equipment, a knowledge of the fundamentals, and the willingness to practice week in and week out over an extended period of time will become a rock-solid sports shooter.

So are you ready to invest in a good-quality camera and lens? Are you willing to learn the fundamental concepts necessary to become a good sports shooter? Are you ready to try your hand shooting in situations where the lighting is less than ideal? And are you willing to shoot regularly to improve your skills and keep them sharp? If the answer to these four questions is yes, then you're already on your way to becoming a good action photographer.

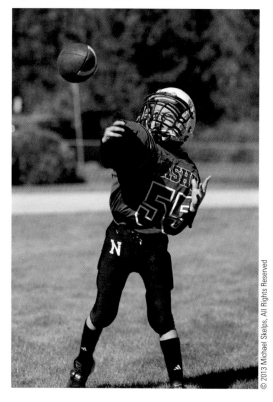

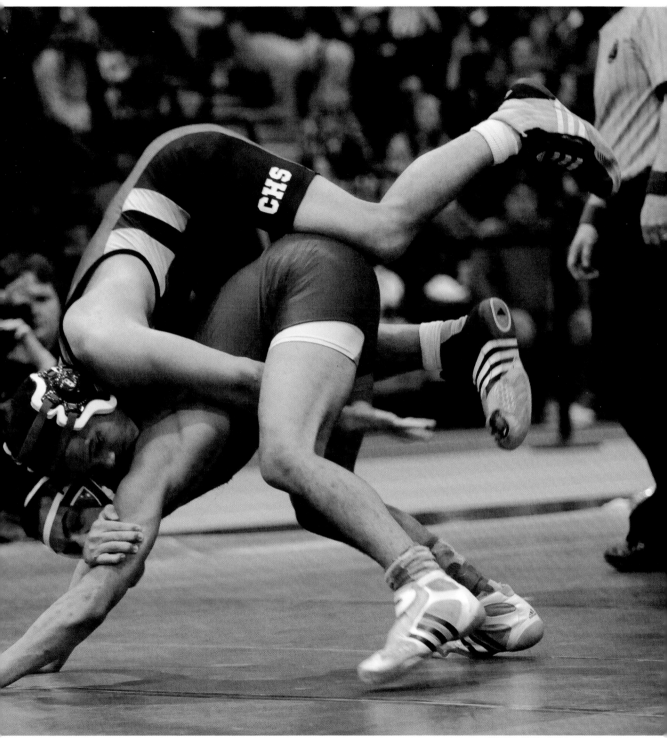

2 The Challenges of Sports Photography

Why Isn't Everyone a Good Sports Photographer?

Nothing worthwhile comes easy. Not in life, and not in photography. In fact, the most rewarding experiences in life are often those that we achieve through overcoming challenges. This is certainly true when it comes to capturing sports images. The results can be amazing, but to have the ability to take those photos, you must use the right techniques and have the right equipment. The good news is that these techniques and the equipment are within the reach of anyone committed to acquiring them.

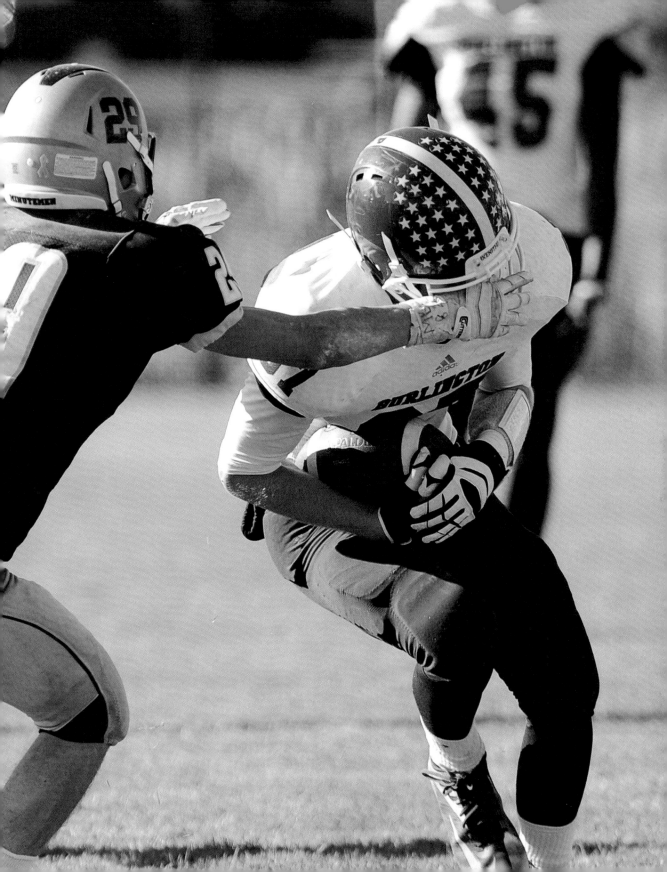

To become a capable sports shooter, you'll have to operate within a tighter set of constraints than those you'll find in other photography disciplines. When I say that sports photography is challenging, it's because a successful shooter will bring the skills, knowledge, and tools to deal with these challenges.

Available Lighting and Conditions

No matter what you're shooting, photography really comes down to capturing light. In most types of photography, you can often control—or at least influence and improve—your lighting conditions. For example, a portrait photographer may use strobes and light modifiers to cast an ideal light on the subject. A wedding photographer may be able to shoot with an on-camera flash or change the direction from which he shoots. A landscape photographer may be able to wait until the lighting conditions are just right before he begins shooting. In sports, however, you don't have that luxury.

There are a lot of reasons why having supplementary lighting is usually impractical for sports. The number-one reason is that you'll often be too far from your subjects for an on-camera flash to be very effective in lighting the subject. Also, you'll be shooting burst sequences of photos faster than a flash or an external strobe can cycle. In many cases where the athletes are moving quickly, their distance from you will change as the action progresses. Because distance is a primary factor in establishing the correct strobe power, athletes too close to you or too far away will result in underexposed or overexposed images. Finally, in many sports, your strobe will be viewed as a distraction and may not be permitted in the game area. As a sports shooter, you will shoot with available light only, with few exceptions.

Probably more so than in any other photography discipline, you'll be confronted with different lighting conditions in sports photography, varying from amazingly favorable to downright hostile. If you're lucky enough to shoot with the sun at your back or on a cloudy day, then count your blessings. On the other end of the spectrum, you may have to shoot into the sun, with the subject severely backlit. Almost as bad, you may have the sun coming from the side, resulting in extremely bright skin tones on one side and dark shadows on the other.

The nature of available light will have a big effect on the way you'll have to shoot. Indoor sports can be subject to poor lighting and/or unusual color casts. With outdoor sports, you're at Mother Nature's mercy—the position of the sun and the ambient weather conditions can wreak havoc on an otherwise well-planned shoot. Sometimes the sun and weather work to your advantage by providing you with nice, even lighting, producing warm, beautiful skin tones and allowing you to capture colors faithfully in all their original splendor. But, as often seems to be the case, you may also be presented with some difficult and/or uncomfortable situations in which to shoot. For example:

- Shooting nearly or directly into the sun, particularly late or early in the day

- Shooting with harsh, bright sun to the side of your subject

- Shooting when the sunlight has diminished considerably

- Shooting in cold conditions

- Shooting when it's raining or snowing and possibly windy

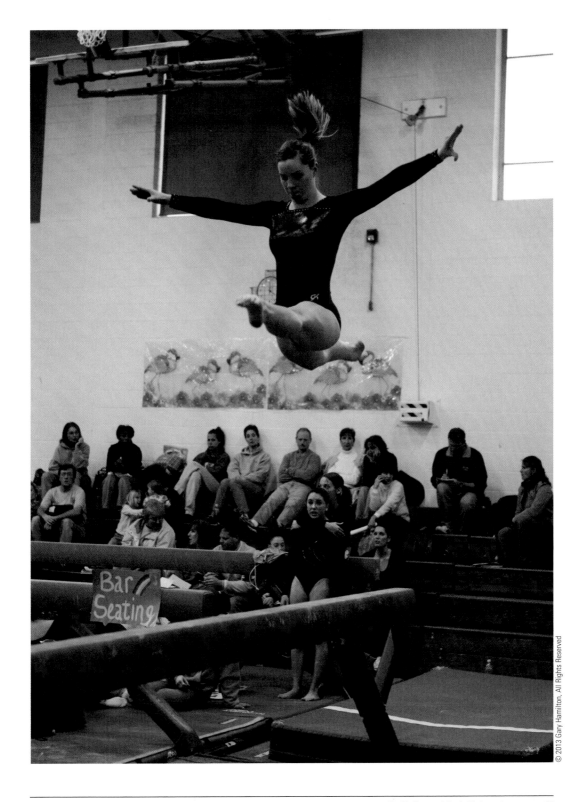

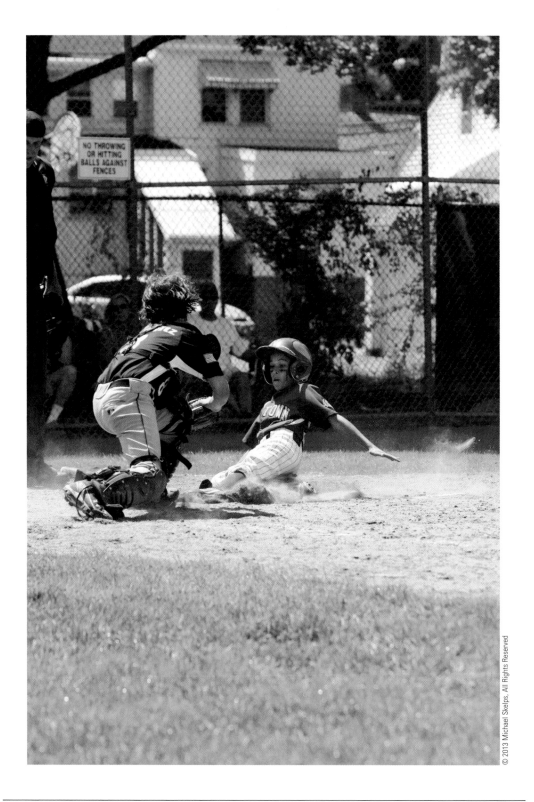

Weather conditions can also present a big challenge. I've had plenty of instances in which I've had to shoot in the pouring rain, snow, wind or a combination. Sports photography is not for the faint of heart, especially if you've made a commitment to shoot an event and others are counting on you. When you envision yourself as a sports photographer, don't just think about shooting on a beautiful sunny day or an evenly lit overcast day—think about shooting in the rain, when it's windy, or possibly even in snowy winter conditions.

Lighting and the conditions that affect it are really the biggest challenges when shooting sports. You must make the best use of whatever available light and conditions you're faced with. The good news is that occasionally, you may be able to improve your situation by shooting from a different location. For example, if you could shoot from a position with the sun at your back or shoot with the sun in front of you, you would certainly want to choose the front-lit scenario. And from time to time, you may have that option at a sporting event. But in most cases, you won't have that luxury. You simply must be able to capture quality shots, even in the worst lighting conditions.

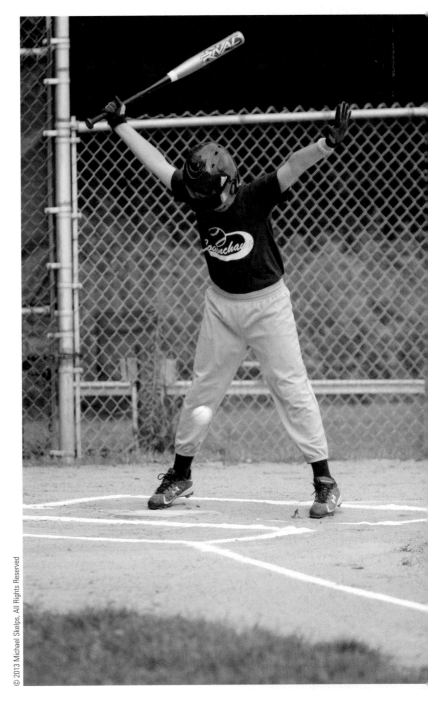

There's No Saying "Oops"

Another challenge in sports photography deals with the fact that action is happening *one time* at the event, and your job is to capture that action in real time. There is no saying, "Oops, I missed that shot. Can we do it again?" When the moment passes in sports photography, it is gone forever. This brings up two different aspects you have to consider in order to be successful.

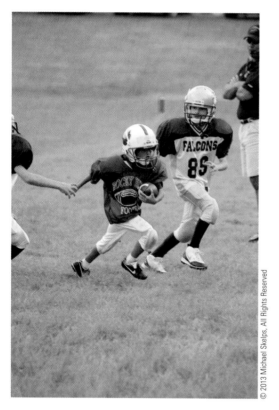

Be Alert and Interactive

One key factor to capturing action in real time is being alert. Sports photography is not the place for a casual, laid-back photographer. You're not just sitting on the sidelines, looking around and occasionally clicking your shutter. You need to be 100 percent focused and in the moment to make sure you capture the important shots.

When I'm shooting, I think of myself as being an active participant in the game. I'm ready to capture all of the action as it happens by rapidly adjusting and anticipating where I should be, where the action is at that instant, and where it will be a few seconds from now. I'm constantly adjusting my zoom and panning where I anticipate the action will occur. I'm also taking my face out from behind the camera frequently to get the "big picture" and to gain a sense of where the next great shot is going to be.

In sports photography, you must be extremely alert at all times. It's very active, not passive. So be ready!

Shoot a Lot of Frames

The other requirement for capturing sports action is to shoot a *lot* of frames. By a lot, I don't mean a few dozen; I mean hundreds if not thousands of frames at a typical event. Here is the reason: Take, for example, an athlete who is swinging a baseball bat at a pitched ball. Let's assume you want to capture that instant when the batter swings and makes contact with the baseball. That photo has to be captured at the precise moment when his bat connects with the ball. The duration of this moment is hundredths of a second!

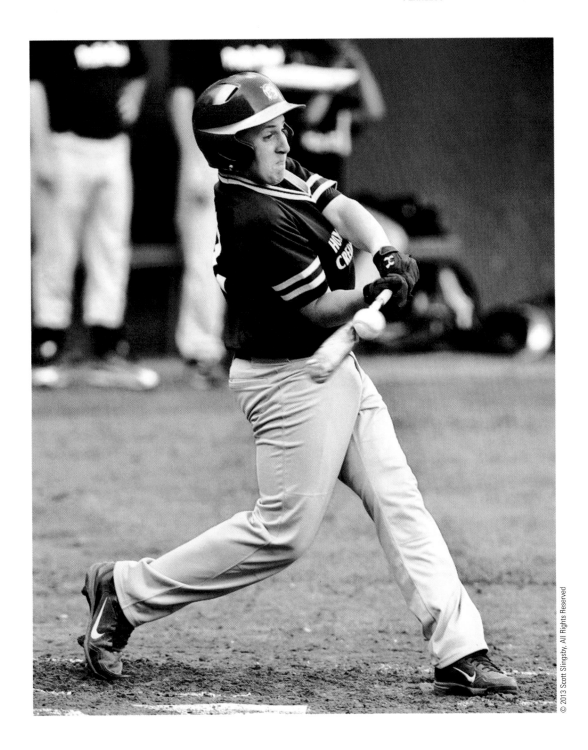

So how do you capture that single instant in time? Try to get it by pressing the shutter for one picture. Do you think you'll get it in the first shot? Not likely. That action happens so fast, you'll be lucky to get the ball in the air and the swing of the bat in the same shot. Even with your best effort to anticipate the precise moment of impact, it's very difficult to judge that moment and get the shot where the ball and bat will make contact. And if you're using a consumer-grade or a point-and-shoot camera, you have to figure shutter lag (the time between when you press the shutter-release button and when the shutter actually fires) into your equation. And while all this is happening, you're still thinking about other factors, such as how to compose the shot in your viewfinder, how to adjust for lighting conditions, and so on. The end result is that your odds of getting the perfect photo just by trying to anticipate and time a single shot are very low.

NOFEAR

There are many opportunities for you to start developing and honing your skills in action photography. Find a youth sports game, a road race, or another event near you and give it your best shot! By reviewing your work from each event, you may be surprised by how quickly you'll develop your action-photography skills.

Here's a quick and simple analogy: Suppose you're trying to produce an award-winning pumpkin to enter in a contest at the county fair. Would you start with just one pumpkin seed? Sure, you could water it regularly and give it the best treatment, and it would probably come out healthy and orange. But you don't just want a *good* pumpkin—you want the *best* pumpkin you can possibly grow, a real contest-winner. You'll want to stack the odds in your favor by tilling the soil, fertilizing it, and

giving your plant plenty of water and sunshine, but common sense says you'll have a better chance at producing that perfect pumpkin if you plant several seeds. If you can, you probably want to plant a *lot* of them. You want to have plenty of chances for the perfect situation to develop, and you may not be in total control of all the factors; thus, planting plenty of seeds gives you the best chance of having a great seed in the spot with the best soil in the garden.

The same is true in sports photography. To get that one amazing shot, you'll stack the odds in your favor—but you also need to give yourself plenty of opportunities. Plenty of opportunities means taking a lot of shots.

The best way to get that great shot is to take bursts of shots in a very short period of time, and also to take plenty of shots throughout the day. You'll still anticipate the moment you think an action is going to happen, and about half a second before that instant, you should start shooting a burst of 3 to 10 images with your camera. Three consecutive images is a good starting point because you're releasing the shutter an instant before you anticipate the perfect shot. But in my book, taking more than about 10 photos in a burst qualifies as "machine-gunning," where the photographer is shooting indiscriminately. Instead of machine-gunning your shutter, you should think about how to more accurately anticipate the action and take a more targeted approach to capturing action.

So, volume is key: The more images you have to choose from at day's end, the better your best pictures will be. This is another challenge that is rather unique to sports photography—most other types of photography don't require you to anticipate action as precisely and take such a large number of frames.

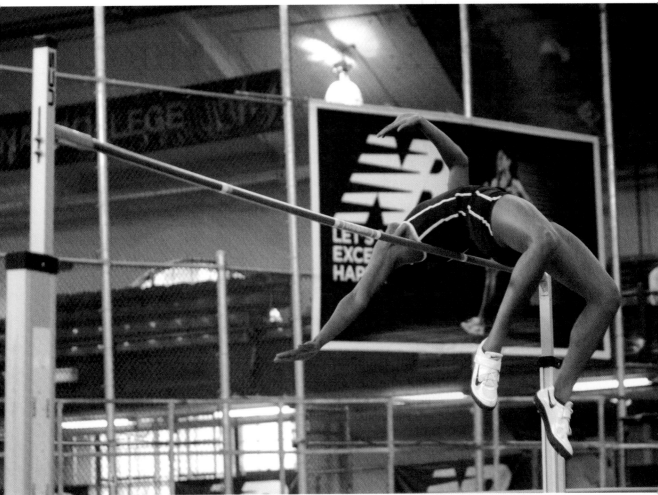

Fast Shutter Speeds

The next challenge of sports photography is shooting with a high shutter speed. Shutter speed is how long the camera shutter stays open—and that shutter will have to open and close very quickly to capture the action. Except for certain specific photography applications that require longer exposures (such as panning), most types of sports photography have a constraint on the minimum shutter speed you can use. In a lot of everyday photographic situations, photographers like to keep their shutter speed above 125 or at least above 60. At speeds slower than this, camera shake can ruin your photos, or if your subject is moving, you may see undesired motion blur in your images. But in sports photography, shutter speeds of 60 or 125 aren't fast enough. Typically in sports, you'll be looking for a shutter speed of 500 or faster. In some cases (gymnastics comes to mind), you will need an even faster speed. The required shutter speed for action photography is much higher than that required for other types of photography, where perhaps a tripod is used or the subjects are stationary. In sports, you don't have

the luxury of a slower shutter speed. This will all tie into the equipment requirements that I will lay out in detail in Chapter 4, "Camera Equipment."

A high shutter speed means you're letting in light for a shorter period of time, and that means you don't get as much light as with a slower shutter speed. So you may have to take other measures into account to get proper exposure of the subject, such as adjusting aperture or ISO. Why do you need such a high shutter speed? If you were shooting with a slow shutter speed, you'd get motion blur—where a subject's hands and/or feet appear to be sweeping as they move. This is different from being out of focus, which is another way that pictures can be blurry or soft. So the high shutter speed required in shooting sports is a major constraint, and it doesn't allow you all the broader flexibility that you might have in shooting slower-moving subjects.

Equipment Challenges

Just as you'd expect a professional musician or surgeon to use very high-quality instruments to perform his or her job, sports photographers need very good equipment. The list of gear that will allow you to reliably and consistently capture great action photos is an exclusive and fairly short one. If you're willing to get a good action photo "once in a while," then a lot more choices will open up to you in terms of camera hardware. But in this book, I'm going to present a systematic approach, including hardware, that will allow you to consistently capture quality action photos. And to have confidence not that you *might* get a good shot, but that you *will* capture a good collection of impressive shots, you'll need the right gear.

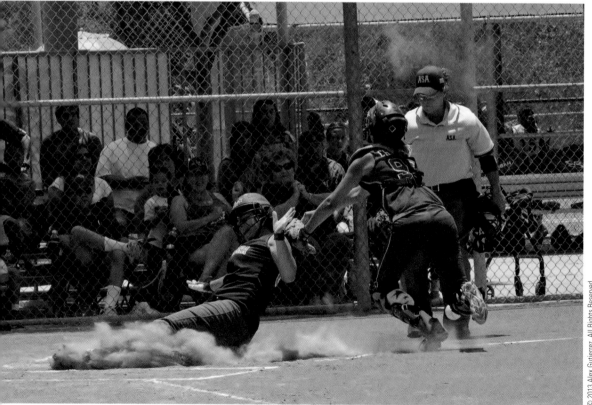

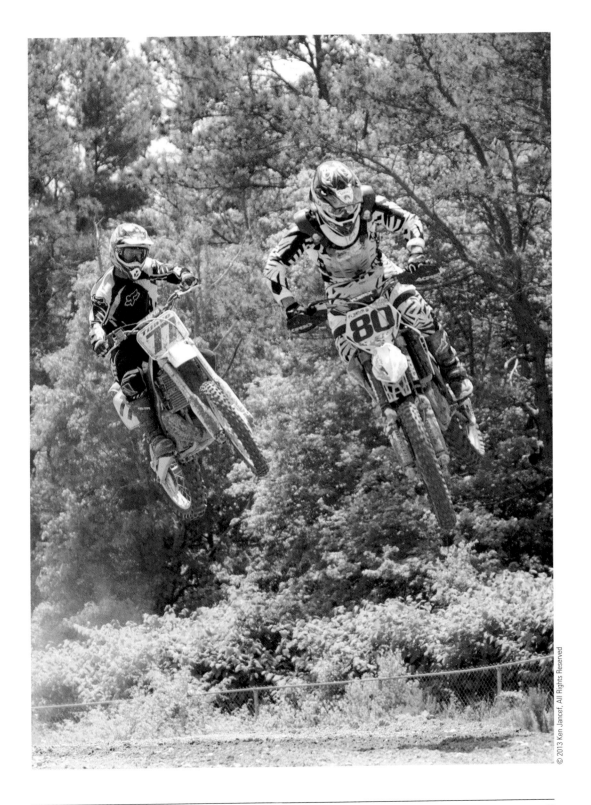

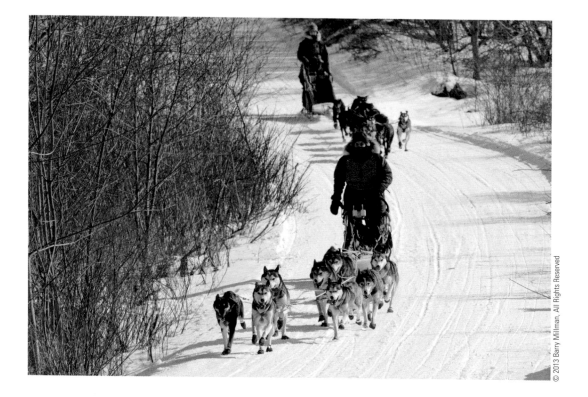

That gear will come from a fairly narrow set of hardware that I will recommend in Chapter 4. But it's not as dire as it sounds: We'll explore not only the specific equipment you may be choosing, but also some ways you can acquire that gear fairly affordably.

But however frugal you may try to be as you shop for gear, there really is a minimum standard that you'll need and a corresponding minimum budget you'll need to get started. Frankly speaking, if you're planning to shoot sports, you'll be looking at an investment of about $1,000 to $2,500 to get started with good, high-quality gear.

This cost threshold is a factor that actually keeps many people shooting with gear that might get a good shot, and it serves to separate you, the sports photographer, from your casual everyday consumer photographer. But of course, it requires a financial commitment from you to make this happen.

Conclusion

Shooting action is definitely one of the tougher photography disciplines, if not the toughest! You'll need the right gear, and you shoot within a wider range of conditions than some other photographers will. But the rewards of producing great action photos are worth it.

Now that you've read some of the reasons why capturing great sports photos isn't easy, I'm going to discuss how to overcome those challenges. But first, we have to establish some basic knowledge of the theory of photography, coming up in Chapter 3, "Photography Concepts."

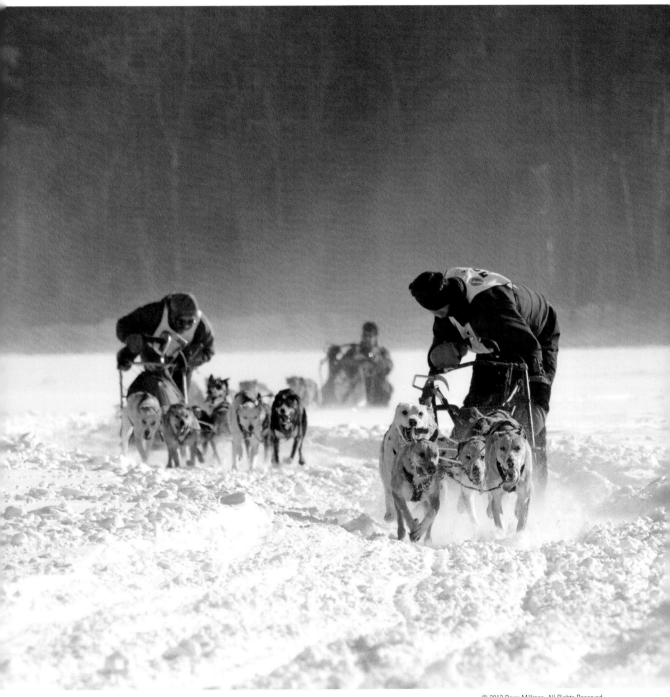

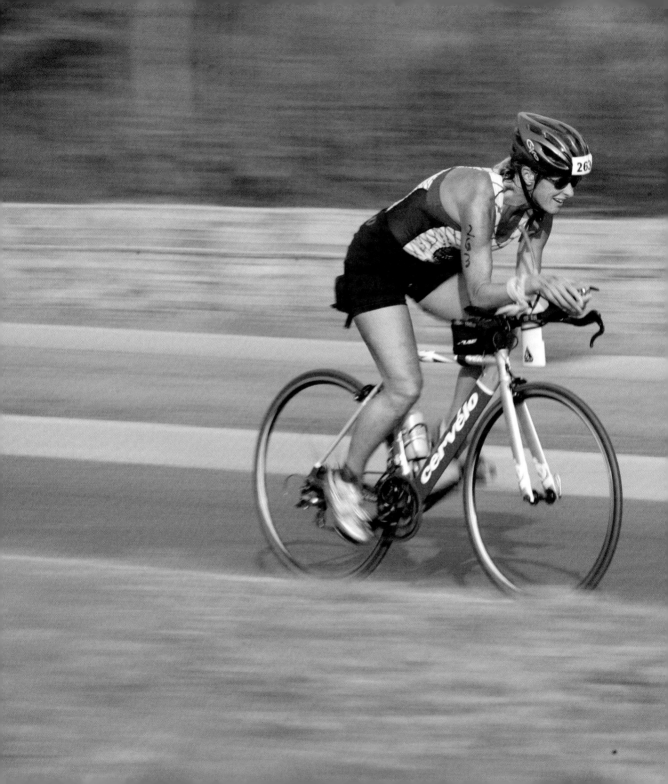

Photography
Concepts

3

In this chapter, I'll introduce fundamental concepts that you need to understand to be a successful sports photographer. This is not going to be an extended esoteric discussion of the photography theory. Instead, it will be much more down to earth. Let's approach these concepts as they relate to *practical* photography. It's a short list, and we'll move through it quickly. But take the time to read and understand each of these concepts.

If you are an advanced amateur or pro and you've very familiar with the concepts of ISO, aperture, and shutter speed, you might find this a worthwhile review of the basics. If you're more of a novice, then the concepts in this chapter will be very important for building a foundation for everything else you'll do in sports photography. With that said, on to our brief review.

Exposure

There are a number of things that a great sports photo always has, including sharp focus and good composure. But it also has the right brightness within the image—neither too dark, nor too bright. A picture with a "just right" brightness is *properly exposed*.

The word "exposure" refers to the fact that in all forms of photography, either ancient or modern, some recording medium (film or a digital sensor) is normally covered. But in the act of taking an image, the sensor is uncovered and exposed to light, usually through a lens. Beyond just meaning *the act* of exposing the sensor to light, photographers usually use the word "exposure" to describe the quality of the image with respect to the ideal, most visually appealing brightness within the image.

In every image, some areas are lighter and some darker (unless you're looking at a monochrome rectangle). It's the combination of light areas with dark that actually creates a distinguishable image. So what's the physical difference between dark and light in an image? Simply that the sensor collects more light in an area. A white shirt casts more light than a dark one. The bright sky casts more light than shadowed ground.

Shirt color and sky brightness are just two examples of environmental factors you have little control over. But there are several parameters you *will* be able to control, and you need a solid handle on those factors, how they will affect your images, and what you can do about them.

The result of these controllable and uncontrollable factors is how much light you are capturing in each image. This capture of light and the amount of light—*exposure*—describes the amount of light captured as compared to an *ideal standard*. It's difficult (if not impossible!) to define and describe exactly what that ideal standard is—it's very much qualitative. But defined or not, almost anyone looking at a picture will be able to tell you

whether an image is too dark or too bright. We all have a built-in sort of "Goldilocks" sense where we can sense when an image has just the right amount of brightness.

Several factors determine whether an image is underexposed (too dark), overexposed (too light), or properly exposed (showing a pleasing distribution of darks and lights in a way that also preserves the most detail). These factors include:

- How much light is available

- Lens design and construction, particularly the diameter of the objective (outside) lens and the size of the lens aperture

- The duration that the camera lens is opened

- The amount of amplification of the light signal as accomplished by the camera's electronic sensor

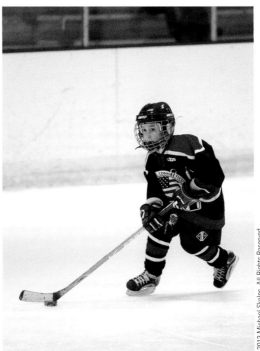

A properly exposed image doesn't look too light or too dark. It also shows skin tones in a pleasing way that allows details to come through.

An overexposed image is perceived as too bright; it is hard on the eyes and has lost detail. In particular, note the washed-out skin tones.

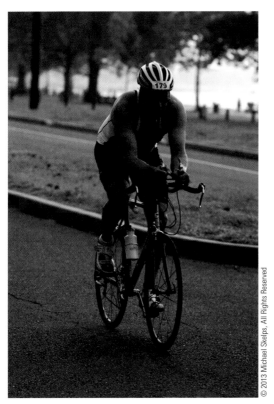

An underexposed image is perceived as too dark. Setting the shutter speed too high was a major reason why this image came out too dark.

As photographers, we control light. You've probably thought about light in the shots you've already taken. But if not, I want you to move beyond your old ways and start thinking about light in every shot you take. Light is everything in photography. Really, it's the only thing! Everything we do as photographers, from keying the shutter to editing photos, is really about capturing and presenting that light. And so, for every picture you take, I want you to think about the light and where it's coming from. (You may be surprised by how many people with cameras never even consider light.) Say it out loud: "Photographers control light." You can never forget this, and you must always think about it when you take a picture.

The first step in controlling light is knowing what light is currently available, in the form of either natural sunlight or artificial lighting. When you shoot on a bright day versus a cloudy day, there are obvious differences in the amount of light available. This varies as the time of day changes and as clouds come and go. It is a constant and critical factor in how much light you'll get in your images.

NOFEAR

With or without your camera, over a 24-hour period, start thinking about lighting throughout the day. Think about the different types of lighting you encounter and whether each type seems brighter or darker. In particular, think about changes to lighting—for instance, if you're outdoors in the morning versus daytime versus evening. Even pay attention to the type of lighting you see (for example, fluorescent lighting versus incandescent versus outdoor light on a cloudy day). You'll very quickly develop an awareness of the variety of lighting you may have to deal with as a photographer.

As the light changes, how do you compensate? There are several options. First, you could change the lens, but in our world of digital sports photography, that would mean physically removing the lens and attaching another. It's cumbersome, time-consuming, and impractical. Next, you could adjust the aperture, the physical mechanical "iris" inside your camera, which will limit the amount of light entering. You can expose the sensor for a longer or shorter period of time to allow more or less light to enter. And finally, you can crank up or down the electronic sensitivity of the camera sensor to make the captured image brighter or darker.

Those are the three main ways that you will control the light you're capturing. Those are the ways you'll achieve good exposure on your shots, and that's how I will refer to it going forward. Controlling the iris is called a*djusting the f-stop*. Changing the time is called *adjusting shutter speed*. And changing the sensitivity is called *adjusting the ISO*. These three parameters are central to everything in exposure management. And because photographers capture and control light, it follows that f-stop, shutter speed, and ISO are the center of everything we do. You can write that down, or repeat it over and over, or get it tattooed on your arm. But either way, get to know f-stop, shutter speed, and ISO. Learn them, live them, love them.

I use a visual image of an imaginary machine representing a camera. On one end, it has light coming in from the outside, which of course varies wildly depending on what or where I'm shooting. And on the other end is the image output. Between input and output, there are three levers (aperture, shutter speed, and ISO) that I can move back and forth to adjust the amount of light. My job is to adjust the image to a proper exposure level using these three levers.

NOFEAR

There are many different ways to shoot and get the right exposure. To quickly find settings that will result in good exposure, try putting your camera on full automatic mode (often indicated by the green rectangle or green camera icon on your camera controls). Make a note of the ISO, shutter speed, and aperture as a starting point for proper exposure.

Fortunately, today's cameras are very capable of helping you get good exposure. Their built-in light sensors can help you get shots that have good overall exposure. A camera in the automatic mode will manage the exposure level using the same three levers already discussed: aperture, shutter speed, and ISO. But rather than having the camera choose which levers to pull, you'll have better control and produce better images if you have the camera choose *one* of the levers and reserve the other two for your own control.

Getting proper exposure is absolutely critical, and sometimes it's not easy! But this is the most common area where budding photographers fall short, and if you improperly expose a photo significantly…well, there's really not a whole lot you can do with it (except try to save the image using software, as you'll learn about later in this book. But fear not, because a proper understanding of exposure, as well as a framework to manage exposure and some regular practice, will move you to the upper echelon of sports photographers in a very short time. Let's press on for a brief discussion of each of these levers and how they can be used to get the right exposure in almost any environment.

"Getting proper exposure is absolutely critical, and sometimes it's not easy!"

Shutter Speed

Shutter speed is a measurement of how long your shutter remains open to expose your sensor to incoming light. The first shutters on cameras were opened and closed by hand. Today's shutters are actuated electromechanically and can be very fast. That's a good thing, because sports photographers depend on a fast shutter speed.

The fundamental concept is simple: The longer the shutter is open, the more light reaches the sensor and the higher (brighter) the exposure.

"The longer the shutter is open, the more light reaches the sensor and the higher (brighter) the exposure."

Shutter speed really isn't *speed* at all, despite the name—it's really shutter *time*. Shutter speeds are expressed in fractional values, so a shutter speed of 500 means the shutter is exposed for 1/500 of a second. Likewise, a shutter speed of 4000 means the shutter is exposed for 1/4000 of a second. But having the shutter open for a shorter period of time intuitively makes sense to us as being *faster*, so we don't generally talk about shutter speeds as these inverted fractions. Instead, photographers refer to their reciprocal whole-number values and make that expression work for our understanding of how to control exposure. Conversationally, then, shutter speeds are 60, 500, and 4000, not 1/60, 1/500, and 1/4000.

Shutter speeds range from a high of 8000 down to the single digits, where a shutter speed of 4 means the shutter is open for 1/4 of a second. Shutter speeds slower than 1/4 second are typically expressed as seconds (0.3, 1.0, 2.3, and so on). However, these super-slow shutter speeds won't be part of your arsenal as a sports photographer.

Some techniques will call for slower shutter speeds on occasion, but we really won't go lower than 30. In fact, for sports photography, you will almost always be looking for a shutter speed of 500 or higher. That's a magic number that you need to commit to memory: 500. It's nice and round, easy to remember. Let's talk a little more about shutter speed and why 500 or higher works well for sports photography.

Sports photography is about freezing action. The actions you're looking at need to be frozen at the split-second level. With slower shutter speeds, images start to show motion blur. You'll see an athlete's feet, hands, or other elements of the photo revealing a sweeping motion as the athlete moves, and you'll start to lose the crispness of the action that you would otherwise capture with a higher shutter speed. For most sports, you'll find that 500 is enough speed to stop the action and capture the detail. Speeds above 500 can work if you have plenty of light, but once you go below this value, you can start to compromise your image quality in terms of freezing the action and preserving detail.

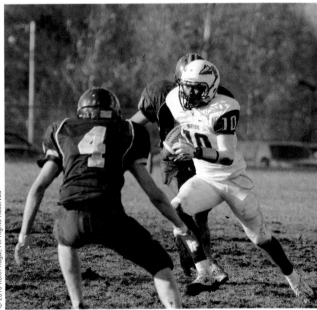

Shooting with a speed of 500 or higher results in freezing the motion of the athlete and preserving all the detail of his body parts in motion. Hands and feet are clearly defined.

In low-light situations, we'll talk about some cases in which you may need to shoot with a slower shutter speed, but in general, 500 is the minimum number you want to use for sports.

Minimum shutter speed = 500. Don't forget it. Got it? Good.

A photographer inadvertently shot with a shutter speed of 20 in this image. The result is the blurring of the motion of the athlete. In addition, this image also shows blurring from the camera movement. For these reasons, shooting with a low shutter speed is almost always undesirable when photographing action.

ISO

Ask a photographer what ISO stands for, and he may not know, but every good photographer knows what it does and how to use it. ISO stands for *International Standards Organization*, which is a group that determines a multitude of physical

and technical standards for many different industries, from military engineering to agriculture. Photography just happens to be one of the many areas in which standards have been defined by ISO. The International Standards Organization has calibrated exactly how sensitive light sensors in digital cameras are at each ISO value.

Back in the days of film cameras, you would select a film with a certain ISO or ASA value. (ISO and ASA are interchangeable terms—ASA stands for American Standards Association, which has since become ANSI, or American National Standards Institute. Getting a good helping of acronyms now, aren't you?) When shooting, you would choose a roll of film with an ASA value appropriate for the lighting situation you expected to encounter for that roll of film. Slower speeds, such as 100 or 200, did great in well-lit situations such as full sunlight. Faster films, with ASA of 800 or 1600, were better in lower-light situations. The drawback was that fast film was grainy. When viewed up close or blown up, the grain in the film was visible and degraded the image quality.

In principle, digital ISO values share a lot in common with the ASA and ISO film predecessors. At low ISO values, such as 100 or 200, you'll need plenty of light to get great shots, but the detail and color fidelity you capture will be at its highest. At much higher ISO values of 1000, 1250, 1600, or higher, you'll be able to achieve good exposure in much darker lighting conditions. However, at high ISOs, you will begin to see artifacts known as *digital noise* that will begin to worsen the quality of your images.

In practice, however, shooting digital compared to film has tremendous advantages, not the least of which is the ability to adjust your ISO from shot to shot. No longer do you have to finish out the roll before you get a chance to change your ISO. You can change the ISO at will, as often as you want and at any time you want. As we get further into talking about shooting in different environments, you'll actively control your ISO, and you'll find that being able to adjust this whenever you want will give you a *lot* more flexibility.

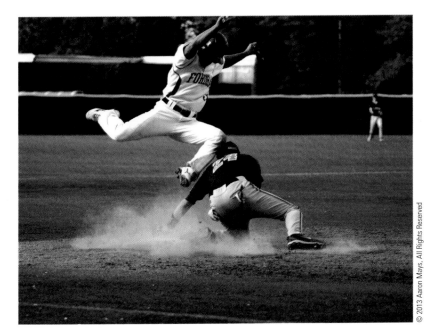

"You can change the ISO at will, as often as you want and at any time you want."

Another benefit of digital photography ISO compared to film ASA was hidden in plain sight a couple of paragraphs ago. Notice that you can make finer adjustments in ISO—say, from 800 to 1000—than you can with film, where in most cases you would normally jump by a factor of 2 or more.

Consider the following analogy to think about ISO and its relationship to digital noise. Your camera sensor measures and amplifies the signal of the light coming in. The ability to change ISO on your camera is a lot like the ability to change the amplification level (sometimes called the *gain*). It's sort of like a volume knob.

Take it a step further. Suppose you're talking into a microphone to get your voice above the crowd you're speaking to. Let's say you have a nice strong voice. In that case, you don't need the volume turned up too high—you can keep it fairly low. (You're just trying to get people to hear you clear-

ly—it's not a rock concert in this example.) And if the next person has a little quieter voice, you'll have to crank up the volume a bit so everyone can hear. And now imagine that the last person has laryngitis—she can barely speak above a whisper. You're going to crank that volume up as high as it will go. And you may be able to hear the person by means of all that amplification, but you're also going to hear a hiss of the background, which has been amplified as well. That hiss, or noise, really degrades the quality of the sound, but at least you'll be able to hear the person speak.

So in strong light, you don't need much amplification. A low ISO of 100 or 200 will do nicely while keeping the fidelity of the images. But in low light, you may have to jack up that ISO to 1000 or more to get a good exposure that's not too dark. The price you've paid is introducing noise into your image.

As a common rule, you should shoot with the lowest ISO that will allow you to achieve a sufficient shutter speed at a given aperture. You can use some software tools to minimize the effect of digital noise in post-processing, but as with other aspects of photography, it's best to get this right in-camera—and when I say "right," I mean "with as little noise

This photo was captured in dwindling light with an ISO of 800. Zooming in to the background, you can clearly see the digital artifacts collectively called noise.

as possible." For instance, you would never want to shoot at ISO 1600 on a bright, sunny day. It's simply not necessary, yet you would be surprised by how many photographers I have seen do this. Keep the ISO low until you have to go up.

Aperture

Aperture is probably one of the least understood photography concepts, but it's very important to comprehend so that you can employ it properly. Fortunately, it's really not that complicated. The first thing you need to know is, what is an aperture? Aperture comes from the Latin, meaning "opening." And that's really all it is. It's an opening in your camera lens.

Take a moment to think about the human eyeball. We have a pupil that expands and contracts in response to changes in light. When you're in a bright environment, the pupil gets smaller as the iris changes. It does this to limit the amount of light that gets into the back of your eyeballs so you don't burn out your retinas (ouch!). When you're in a dark environment, the pupil gets larger as your iris changes size. This is so you can capture as much light and view as much detail as possible in dark conditions. Intuitively, it makes sense. Make the hole smaller to reduce the amount of light coming through, or make it larger to allow more light in.

The aperture is a variable opening in the lens that opens and closes like a pupil to vary the amount of light that enters. The aperture is part of the lens, not part of the camera body. I think that is part of its mystery—many people have never seen an aperture function, as it's hidden inside the lens. It opens or closes by a set of blades (usually five to eight) that move in concert to open and close a roughly round opening.

Now here comes the (slightly) confusing part, and it's mostly confusing because of the nomenclature that has developed around apertures. Apertures are measured and discussed as *f-stops*, shown like this: f/4 or f/11. Similar to how shutter speeds are really reciprocal fractions, f-stops are also reciprocal, inverted values.

The best way to explain f-stops is through examples. When a lens aperture is set to f/4, it means that the aperture diameter is 1/4 the focal length of the lens. So, the more open an aperture is, the *smaller* the f-stop number must be. Likewise, hysically closing the aperture means increasing the f-stop, say from f/4 to f/5.6. Many quality lenses have aperture ranges from f/2.8 to f/22, while some have even greater ranges of f-stops.

If you're closing (or physically decreasing) the aperture, you're increasing the f-stop number. Photographers call this *stopping down*, and it's done primarily to reduce the amount of light coming into the lens. So decreasing the aperture, increasing the f-stop, and calling it stopping *down*—it's no wonder that some people find it unclear.

Personally, I prefer to avoid sources of potential confusion, so here is one area where I differ from other photographers in my nomenclature. I prefer to talk in terms of *opening* or *closing* the aperture by adjusting your f-stop. It helps me to visualize what's going on inside the camera and understand the effect that it has on exposure. And that's normally how I will refer to it in this book: as opening or closing the aperture to adjust the f-stop.

Adjusting the f-stop clearly has an effect on how much light reaches the sensor. You can quickly visualize how opening an aperture simply allows in more light. This will be particularly important during the discussion of low-light photography. But changing the aperture has another effect that is less intuitive. A smaller aperture will tend to keep more items in the photo in focus regardless of their distance from the camera, whereas a larger aperture has a relatively shallow depth of field (or depth of focus). Although you don't necessarily need to understand the precise science as a sports photographer, you do need to understand the basic concepts of aperture as they relate to the exposure: f-stop, amount of light, depth of field, physical aperture size, and the standard photography vernacular.

Table 3.1 Summary of Aperture-Size Effects

Terminology	Stopping Down	Stopping Up
Physical aperture size	Decreases	Increases
Amount of light coming through	Decreases	Increases
F-stop	Increases	Decreases
Depth of field	Increases (more areas in focus)	Decreases (more areas out of focus)

One way I visualize the effect of aperture on depth of field is by thinking about a pinhole camera. Even if you've never used one, you've probably heard about science projects where film is mounted inside a dark box and a pinhole is created. Light passes through the pinhole onto the film, creating an image. So even without a lens at all, a small aperture (high f-stop), such as f/32, will produce an image with a deep depth of field. The tradeoff? That little tiny opening doesn't let very much light through, so the camera shutter needs to stay open for a long time to get the image. This is how some of the earliest cameras worked.

You, fearless reader, are probably way ahead of me by now, thinking about that pinhole camera with the tiny aperture (high f-stop) and the resulting long shutter speeds that would be required to let in sufficient light. And you're probably thinking that with a small aperture and long shutter speeds, such a camera wouldn't be very good for action photography. Shooting with a high f-stop would produce *terrible* action photos. Shooting with a small aperture is the exact opposite of what you want to do for action photography. You want to shoot with a nice open aperture—say, in the f/4 range—giving you the ability to employ a fast shutter speed of 500 or higher.

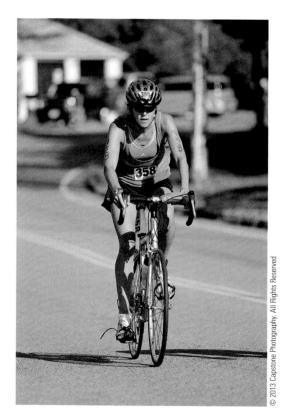

By shooting with a relatively open aperture, such as f/4, the background is pleasingly blurred and the athlete is separated from the background images.

"Shooting with a high f-stop would produce terrible action photos."

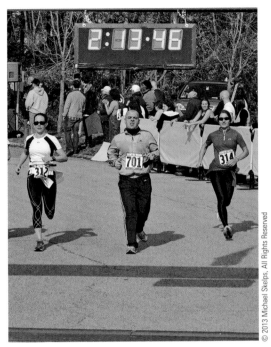

If the aperture is stopped down to f/8 or less, more elements in the image are in focus, resulting in less dramatic separation of the subjects from the background or foreground. Here the photographer intentionally stopped down the aperture to keep the athletes and the finish clock in focus.

Many things in photography involve compromising various parameters. For example, if your ISO is too low, it's not good in low light; but if your ISO is too high, you get digital noise. Or at low shutter speeds, you get plenty of light, but you also get motion blur. However, the interplay of shutter speed and aperture actually works in concert and allows you to get a double-benefit when employing a wide aperture and a fast shutter speed: The fast shutter speed freezes the motion, while the resulting shallow depth of field isolates the subject and really separates him from the background and foreground. The shallow depth of field results in a sharply defined subject, while items closer and farther than the subject are out of focus. Quality lenses usually render out-of-focus areas in a way that is pleasing to the eye, an effect known as *bokeh*. The word "bokeh" is borrowed from the Japanese, who first described the pleasing quality of out-of-focus elements in photos. This shallow depth of field will be one of your standard tools in sports photography, where you'll get a double benefit: Fast shutter speeds combined with amazing-looking shallow depths of field freeze the action in time and make the athlete "pop" in the photo.

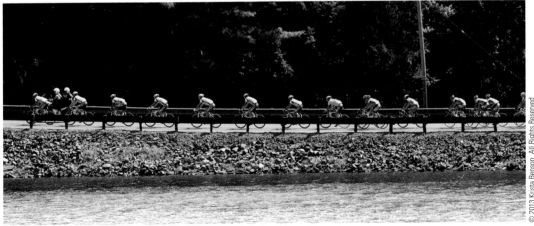

A Wide-Open Aperture Can Be Too Much of a Good Thing

I mentioned compromises and tradeoffs before, and it's worth repeating when talking about aperture. Even though a wide aperture generally gives much better action photos than a high f-stop would, there's a point of diminishing returns in practice. Many good-quality lenses have an aperture that will open up to a maximum of f/2.8. So wouldn't it follow that you should always shoot with the aperture wide open? Not necessarily.

Assuming you have enough light and you don't have to open the aperture fully to achieve proper exposure, I recommend shooting at f/4.0 and not opening up further. The reason is this: Whether you're shooting for that single greatest image of the day or you're trying to get a collection of photos from the event, shooting at f/2.8 yields such a shallow depth of field that you're less likely to get as many shots as you want in the sharpest detail. Don't get me wrong; I think the f/2.8 shots have an amazing bokeh that looks great. But unless the subject is stationary (usually not the case in sports photography), you're going to have an increased percentage of tossers as opposed to keepers. Shooting at f/4 still produces a strong, pleasing bokeh and isolates the subject from the foreground and background in the image, but it keeps the percentage of tossers down. Certainly, there is a matter of personal preference to consider, but I recommend shooting at f/4.0 to capture a generally stronger batch of photos.

Now, if the lighting is weak and you need to open the aperture wider to get more light, then all bets are off. I'll recommend some strategies for shooting in low-light situations in Chapter 10, "Low-Light Photography."

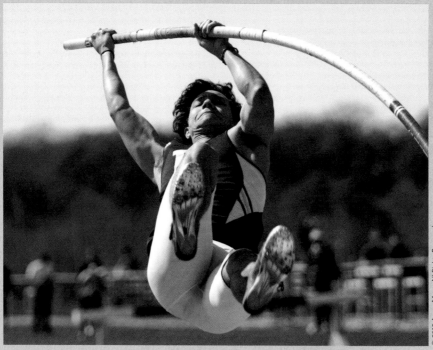

Conclusion

I would like to suggest a simple exercise for you to complete. This exercise will show you the effect that changing the parameters of ISO, shutter speed, and aperture will have on your images. You can choose anything at all for your subject matter. Just make sure the lighting won't change much over the five minutes it will take you to complete this exercise. And turn off your flash.

Let's say, for example, that you're taking a picture of a vase in the kitchen. First, turn your camera to Full Auto mode (green rectangle or camera icon). Make a note of your ISO, shutter speed, and aperture settings.

Now turn your camera to Manual mode. Dial in the same aperture, shutter speed, and ISO that your camera chose in Full Auto mode. Take a picture of the vase, look at your LCD screen, and view the histogram as well. In a properly exposed image, the picture won't look too light or too dark (though LCD camera screens can be deceiving at times), and the histogram will span from the far left side all the way to the far right.

Start by tweaking that first lever, ISO. Turn down your ISO to cut it in half and take another picture. Notice how the picture is darker than the first one and the histogram has shifted to the left.

Now turn up the ISO to twice its original value and snap another shot. This picture will be too bright, with a histogram bunched up to the right.

Bring the ISO back to the camera's Auto value and tweak your shutter speed lower and then higher. Again, notice the effect that changing the shutter speed has on the brightness of the images and the histogram.

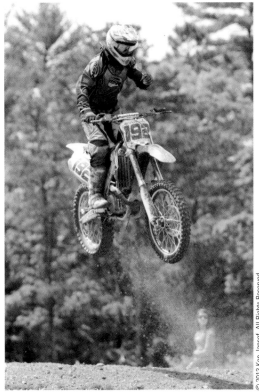

Finally, bring the ISO and shutter speed back to their original settings and stop down your aperture. Take a shot and then open up your aperture to a lower f-stop than you started with. The resulting images will differ in brightness, and you may notice that things in the background are in slightly better focus at higher f-stops and softer at lower f-stops.

Try practicing this exercise a couple of times, and you'll find that some of the mysteries of f-stop, ISO, and shutter speed will be removed. It may take you a moment at first to work out whether changing your f-stop from f/5.6 to f/6.3 will make your pictures brighter or darker (answer: darker!), but after some practice it will come naturally to you, and you'll be able to adjust all three levers with confidence.

4 Camera Equipment

We photographers love our equipment as much as we like taking photos. There's nothing like the moment of holding a new camera for the first time, whether it's a point-and-shoot, a consumer-grade SLR, or a nice professional-quality body and lens. Photographers also have a reputation, often well deserved, for spending money on their next photography upgrade or accessory at the earliest opportunity. There's always a valid reason, of course! In this chapter, I'll give you my best thoughts and recommendations on equipment and budget for a great startup rig for sports photography.

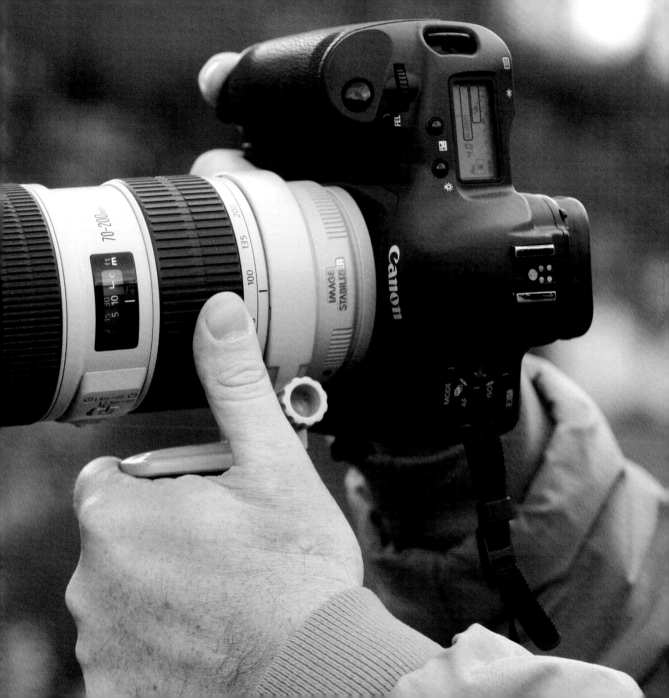

I'm probably going to make some enemies in this chapter. Don't shoot me—I'm just one guy with some knowledge and an opinion! I don't have a strong preference of one brand of camera over another, and I don't get a commission for recommending one particular camera or lens model. But as someone who has shot hundreds of events and, more importantly, worked with scores of other sports photographers (both pro and amateur) over hundreds and hundreds of shoots, I've come to develop an understanding of what equipment consistently can produce good results and what equipment is less successful. It's sometimes a touchy subject, as people tend to get very personally involved with their selection and purchase of photographic equipment.

True, camera equipment is rapidly changing and improving, so other camera bodies and lenses may need to be added to the list over time. I'm going to discuss the specific models and equipment (current as of this writing) that I have either personally used or that I'm familiar with. I'm going to suggest some good entry-level equipment as well as some equipment that you may want to avoid.

What's So Special about a Sports-Photography Camera?

Sports photographers are very demanding. We travel far, we're up at ungodly hours, and we shoot intensely. We push ourselves, we push our cameras, and we need high-quality gear that can deliver the high performance required.

In particular, we demand camera gear with the following characteristics:

- Minimal shutter lag

- Low noise sensor

- Low f-stop

- Fast auto-focusing

- Clear focus throughout the frame over a wide range of focal lengths

- High frame rate

- Long battery life

There may be more on an extensive wish list, but these are the characteristics I would put on my short list for sports photography. Let's explore each one in a bit more detail.

Shutter Lag

Ready, aim, fire. That's really what we do as photographers. I think the word "fire" is especially fitting to the world of sports photography. Like an expert marksman, an action shooter works to be precisely on target at the moment he pulls the trigger. When your subjects are moving, you need the shutter to fire exactly when you push the button. You don't have the luxury of waiting for the camera if you want to get that great shot.

Ever taken a picture with a point-and-shoot or camera phone and notice a brief delay between when you press the button and when the picture is taken? You can deal with it if your subjects are posing patiently. If you've ever tried to take an *action photo* with a point-and-shoot or camera phone, though, the delay can be extremely frustrating. That brief delay goes from a slight inconvenience in the posed photo to a missed shot in sports photography.

The delay, called *shutter lag*, may be a fraction of a second or longer, depending on the type of camera, and seems like an eternity when you're photographing moving targets. It can very often prevent you from getting the shot you're looking for. And if you try to fire off a few quick shots in a row, your intended rat-a-tat-tat burst of photos

becomes an agonizing rat…a…tat…tat, when you realize that with each shot you've already missed what you were trying to capture.

Good-quality cameras, such as the ones I will recommend, have no perceptible shutter lag. You press the button, and the shutter fires. That's the way you want it. No, that's the way you *need it* for sports photography. Shutter lag values aren't always present in the usual list of specifications for cameras—you may have to research a bit to find your camera's shutter lag time. I find that shutter lag of up to 0.1 second (100 millisconds) is acceptable—a lag of this amount is almost impossible to perceive. Our brains process that as essentially instantaneous.

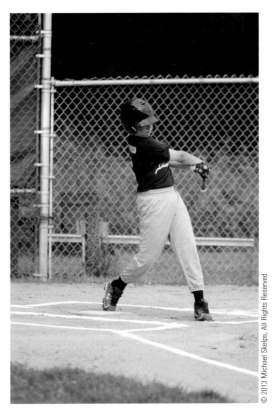

"You press the button, and the shutter fires. That's the way you want it. No, that's the way you need it for sports photography."

A camera with appreciable shutter lag will often result in you taking the picture immediately after the action.

Low Noise Sensor

Not all camera sensors are the same. There are many differences in the size, detail, and quality from camera to camera. Often, people assume a camera is better based solely on the number of megapixels. (Notice that megapixels didn't even make my list of key camera characteristics.) The fact is that a high-quality 8-megapixel (MP) camera will produce far better images than a

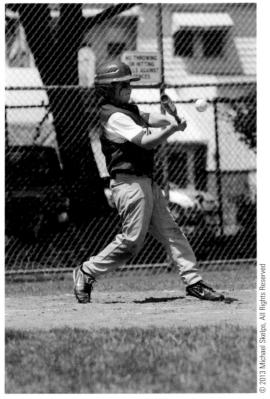

A camera with a fast shutter allows you to capture the image at the moment you want it.

12-MP point-and-shoot camera. For one thing, that point-and-shoot or camera phone almost certainly has a smaller physical sensor size. The result is an image with less sharpness and detail.

But there is another way that good, high-quality camera sensors stand above those of lower quality, and that's a lower amount of noise. What's noise? Audible noise consists of unwanted sounds you hear that are different from what you're really trying to listen to. The most common audible noise is a background hiss. The louder you turn up the volume, the more you notice the hiss. In digital photography, noise refers to visual artifacts that detract from the image you're trying to capture and see. The sound analogy is helpful, particularly in that the higher you turn up the ISO, the more the noise becomes apparent—sort of a visual tape hiss.

For example, take a close look at an image from a point-and-shoot camera by zooming in far enough to see the individual pixels. In particular, look at a mid-to-dark area of the image. Look *really* close. See those areas of reds, greens, and blues in a sort of random distribution? Viewed from a bit further, the general color looks reasonably accurate. However, when viewed close up, you can see all sorts of variations in color. That's the noise. It's a loss of detail of the image, and it limits, among other things, how much you can enlarge the image for printing or viewing before you impact its quality. A good-quality camera sensor will allow you to zoom in and consistently see the actual color being represented rather than a hodgepodge of red-blue-green.

As you shoot in darker lighting conditions, you will need the ability to shoot with a higher ISO (say, 800, 1600, or even higher), and this is where you will start to see the noise appear in your images. The better the sensor, the less noise you'll see. Having a camera with a good sensor will give you the ability to shoot in lower-light situations while knowing you're still able to capture good-quality shots. Unfortunately, the camera industry doesn't

do a good job of measuring or rating sensors for noise performance. Whatever camera body you use, be sure to research thoroughly to confirm that your sensor will be able to produce acceptably low noise levels, particularly at higher ISO values.

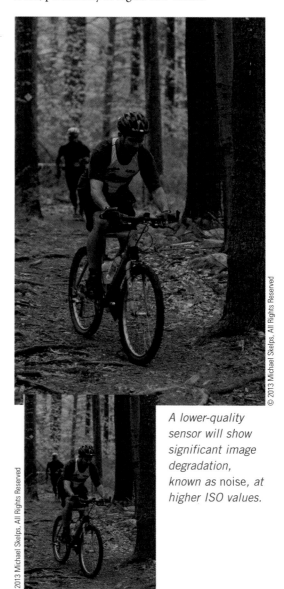

A lower-quality sensor will show significant image degradation, known as noise, *at higher ISO values.*

A high-quality sensor will operate at ISO values of 800 and higher with less noise and better image fidelity.

Low F-Stop

Recalling the previous chapter, you know that setting your f-stop to a low value (say, between f/2.8 and f/4) is a technique desired and frequently employed by sports photographers. A low f-stop results in a relatively wide physical aperture, allowing more light into your camera. With more light available for a given ISO, the resulting faster shutter speed is useful in freezing action in your images. Having a wide aperture also produces a visually pleasing *bokeh*, or blur of the background that visually separates the athlete from the background and foreground in your images. So the ability to open your aperture wide has two distinct benefits that act in concert—more light allows you

to shoot with a faster shutter speed to freeze the action, and the pleasing bokeh effect makes athletes "pop" in your images.

Fast and Clear Focus

This is almost self-explanatory. In sports, you've got subjects moving quickly toward you, away from you, and past you. Whatever the subject motion, you must be able to capture it with accurate focus. Great pictures must be sharp, so your gear must be able to track a moving target and quickly achieve an accurate focus throughout the range of motion.

High-quality lenses will allow you to capture images in sharp detail, even when your subject is moving.

High Frame Rate and Long Battery Life

Sports photographers are known for capturing massive numbers of images. In sports photography, it's not about taking one picture; it's about taking plenty of pictures and selecting those that best capture the essence of the event. And unlike the subjects in some other types of photography, such as landscape and portrait photography, sports subjects don't wait for you. You don't get a second chance at that perfect shot. So plan to take a lot of pictures, and then sort through your images afterward to find the best one. You'll need a camera that can fire in rapid succession for extended periods of time, producing a volume of images numbering in the thousands for a typical event.

I recommend considering only cameras with a capability of shooting 3 frames per second or faster. The faster your frame rate, the more likely you'll capture that perfect instant in time. Some of the better cameras can shoot close to 10 frames per second.

"In sports photography, it's not about taking one picture; it's about taking plenty of pictures and selecting those that best capture the essence of the event."

Gear I Suggest You Don't Consider

Today, everyone has a digital camera. The person you last spoke with probably has a camera phone, and the person you speak to next may have a point-and-shoot or camera phone in her purse. One of the great things about the evolution of photography technology is how accessible it has become. It's really a wonderful advancement that allows so many people to have the ability to capture images wherever they are.

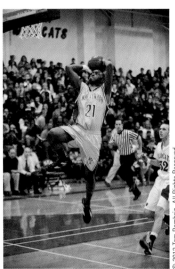

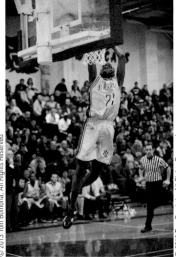

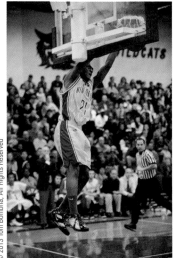

Even more important, the technology has consistently improved the quality of the sensors in consumer-grade devices. Some camera phones today can take really nice photos, particularly when the subject is standing still. But they'll almost never do a good job at capturing sports images. Going back to the seven characteristics of sports-photography gear I just outlined, it quickly becomes clear why a pocket point-and-shoot camera or a camera phone simply won't cut it.

Recommended Gear

In my professional opinion, only two brands will reliably produce good action photos: Canon and Nikon. Yes, technology is evolving, and some other companies are producing better and better gear. But at the time of this writing, and having worked with scores of professional photographers, it's clear to me that there are still only two true players in this business.

Although digital photography has been in existence for decades, it didn't advance to a practical state where the quality was sufficient for sports photography until about 2003. And with only two manufacturers producing this caliber of gear, the list of camera bodies and lenses I recommend is growing but still manageable:

Canon:

- 20D
- 30D
- 40D
- 50D
- 60D
- 1D (variants include Mark II, IIN, Mark III, Mark IV)
- 1D X

- 5D (including Mark II and III variants)
- 5D Mark II
- 7D

Nikon:

- D300
- D700
- D800
- D3
- D2X

Photography is a hobby (or profession) on which you can spend a lot of money. The bigger your budget, the more options are available to you. You may be able to buy better gear and more gear. You can certainly spend more than $5,000 on a camera body and $3,000 on a lens if that's within your budget. But you may be looking for a way to get into this type of photography with a more modest investment. I'm going to recommend some new, quality gear that will get you into sports photography for around $2,000. If you're willing to look at used gear, you may even be able to get a basic setup in place for around $1,200.

I happen to be a Canon shooter, so I know my way around that brand of equipment a little better. But that's not to say that I'm recommending Canon over Nikon. Five years ago, I did prefer Canon gear mainly due to the vibrancy of the colors and the better low-noise performance of the sensors that Canon produced at the time. But since Nikon introduced the D300 and subsequent models, I have been happy to recommend both brands for high-quality action photography. With the right combination of lens and body, Nikon gear can produce razor-sharp images with gorgeous colors. There has always been a rivalry between the two brands as well as the photographers who use them, but both brands earn my seal of approval.

"There has always been a rivalry between [Canon and Nikon] as well as the photographers who use them, but both brands earn my seal of approval."

Canon 20D–60D Series

In 2005, Canon introduced the 20D, an 8-MP prosumer digital SLR. This series has evolved significantly over time to the current model, the Canon 60D. This is a very good line of camera bodies with all the necessary functions to get going in sports photography. Each new model in the line has more and improved features than its predecessor. If your budget is a primary consideration, I suggest that you consider a model in this line. Used 20Ds are available in the $300 to $400 range, while new 60Ds can be had for less than $1,000. A comparison of individual models and their differences is beyond the scope of this book, but plenty of resources available online will spell out the features and differences for you. Note that cameras in this series include a 1.6x crop factor, essentially extending the focal length of any lens by a factor of 1.6. So a 70-200mm lens becomes 112-320mm.

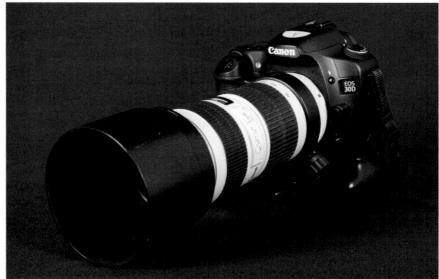

Canon 30D body with 70-200mm f/4 lens.

NOFEAR

Do your research before making your decision on whether to acquire Nikon or Canon gear. Lenses between the two brands are not interchangeable, so it's an important decision to make early in your photography career. Once photographers acquire a couple of lenses and a body or two, the cost of switching between brands becomes substantial. For this reason, photographers seldom go from Nikon to Canon or vice versa. Read online reviews and talk with other photographers to get their opinion and even give their gear a try for yourself.

Crop Factor

Crop factor indicates the size of the digital sensor with respect to the photography industry standard of 35mm. Photography is full of inverted values, and crop factor is another one of them. In sports photography, the most common crop factors are 1.3 and 1.6. A camera sensor with a crop factor of 1.3 means that the sensor has a diagonal measurement of 35mm/1.3, or about 27mm. A 1.6 camera sensor measures 35mm/1.6, or about 22mm. Cameras that have a crop factor of 1 are called *full frame*, having a 35mm sensor. The higher the crop factor, the smaller the camera sensor.

In a practical sense, crop factors are often referred to (or at least thought of) as a focal length multiplier. Consider a full-frame camera using a 200mm lens. By comparison, the same lens on a body with a crop factor of 1.3 produces an image with an effective focal length of 200×1.3, or 260mm. Likewise, a body with a crop factor of 1.6 has an effective focal length of 320mm. So the higher the crop factor, the more "reach" you have with your lens.

Canon 1D Series

In 2004, Canon brought to market the 1D Mark II, which I consider the first true professional sports photographer's camera. (The original 1D was only a 4-MP camera, so that model didn't quite make the cut in my book.) The 1D Mark II model had weatherproof seals, shoots 8+ frames per second, has an integrated camera grip, and holds larger, higher-capacity batteries than the cameras in the 20D series, making it ideal for high-volume shooting. The 1D Mark II has continued to evolve through the recently announced 1DX, which includes myriad new features, including an 18-MP sensor and HD video.

Budget is really a bigger variable in this line, with used Mark IIs going for less than $1,000 and a price of more than $6,000 for the new 1D X. This line is for the serious photographer; it doesn't even offer a fully automatic "green rectangle" option. Working with these cameras is a real pleasure in terms of how they work and feel, but obviously they come at a much higher price tag than their prosumer counterparts. The 1D series features a 1.3× crop factor, so a 70-200mm lens becomes 91-260mm.

Canon 1D Mark II with 70-200mm f/2.8 lens attached.

Canon 5D

Canon introduced two additional professional models that fall between the 20D series and the 1D series. In 2005, the 12.8-MP full-frame 5D was introduced. Its frame rate of 3 frames per second is slower than the 20D and 1D series, and the full frame size (1.0x crop factor) means that you don't get the additional reach that you would with the other camera lines. Generally speaking, the 5D is a

bit better suited to weddings, product photography, portraits, and so on than it is to sports photography, mainly due to the slower frame rate and lower crop factor. But if you're shooting events where you don't need a rapid frame rate, it is certainly a capable camera for sports, and it can double as an excellent general-purpose body. The current generation of this camera body is the 5D Mark III, featuring a 22-MP sensor and HD video. You can find used 5Ds for around $1,200, while new 5D Mark IIIs start around $3,500.

Canon 7D

In 2009, Canon came out with the EOS 7D, an 18-MP body that was introduced as a step up from the 20D series. Compared to that series, the 7D body includes HD video, 8 frames per second (fps) continuous shooting, an improved low-noise sensor, a heavier-duty shutter rated for 150,000 frames, and weather sealing. If you want top performance and features in a midrange budget, this is a great body to consider buying. Used 7Ds start around $1,200, while you can purchase new bodies for around $1,500.

Canon 7D body.

Nikon Bodies

At earlier stages in the game, Nikon lagged behind Canon in the high-end digital sports photography market. In the mid-2000s, the Canon gear had distinct advantages in terms of sensor size, frame rate, color fidelity, and low-noise sensors. I think this is one of the reasons why Canon shooters outnumber their Nikon counterparts today. And it is for these reasons that today I'm a Canon shooter. But in fairness, Nikon made significant upgrades to their technology, and today the "pro-sumer" and professional bodies made by Nikon are solid performers capable of fantastic action photos.

D2H and Other Older Nikon Bodies

This family of bodies came to market starting in 2001, with the introduction of two camera bodies—the D1X and the D1H. The D1X had a 5.3-MP sensor and a frame rate of 3 fps, while the D1H, which was more oriented toward sports, had a smaller 2.7-MP sensor but a faster frame rate of 5 fps. In my opinion, neither of these bodies was particularly well suited to high-quality sports photography; the D1X was limited by its slower frame rate, and the D1H had a sensor that was too small to capture sufficient detail.

In 2003 and 2004, the follow-up models D2H and D2X arrived with major technical improvements over their predecessors. The D2H featured a slightly larger 4.1-MP sensor and a faster shooting rate of 8 fps. And the D2X boasted a bigger 12-MP sensor and the ability to shoot 5 frames per second.

Of this set of bodies, the D1H and D2H were favored by sports photographers because of their higher frame rates, but with the tradeoffs of lower-megapixel sensors. The earthy colors produced by these sensors, as well as the noise at high ISO values and the low megapixel count, do not produce sufficiently high quality for action photography by today's standards.

D300

To me, the whole Nikon-Canon controversy became irrelevant with the 2007 arrival of Nikon's D300. This 12.3-MP body is capable of shooting 6 fps, making it the first Nikon body with sufficient resolution and frame rate. In addition, the upgraded sensor produces vibrant colors and has better noise performance at higher ISO values. This combination causes me to list the D300 as the lowest Nikon you should consider if you're getting into sports photography. It is currently discontinued and has been replaced by the D300s. You can find a used D300 for about $800, while new D300s bodies go for around $1,700.

D700

The D700 was brought to market about a year after the D300 and takes its place as the "big brother" of the D300. This body has a full-frame sensor, compared to the D300's crop value, resulting in less reach for the same lens. The noise performance is significantly improved, resulting in usable ISO values of 3200 or even 6400. And, when fitted with an optional camera grip, the frame rate of the D700 goes up to 8 fps. A D700 body currently lists for around $2,700 new or about $2,000 used.

D3

Nikon's flagship D3 competes with Canon's 1D series. It features an integrated grip, allowing you to shoot in either vertical or horizontal orientation, as well as a blistering 11-fps frame rate and improved noise performance compared to the D700. The 12-MP D3 has been replaced by the D3x, which doubles the sensor megapixels to 24. Used D3s in good condition start in the $2,700 range, while new D3x bodies retail for around $8,000.

Lenses

There is a dizzying variety of lenses available for photographers. The features, quality, and price range differ greatly and can be a source of much confusion. However, for sports photography, you'll use a much smaller set of lenses.

The workhorse lens of sports photography is usually the 70-200mm zoom lens. You can capture a lot of sports photography very well within this focal length. In the Canon world, the list becomes very simple: *Any* 70-200mm USM L series lens will be an excellent starting point. These lenses are available in older and newer versions (the newer version is designated as II), with and without image stabilization, in f/4 or f/2.8 maximum apertures. The price spectrum on this lens series runs from a used f/4 at around $600 to a new f/2.8 for around $2600.

Unfortunately, if you're looking for a price break by buying used, there is not a significant amount of depreciation in the cost of high-quality lenses such as these. On the bright side, when you purchase one of these lenses, if properly cared for, it will provide you with many years of shooting pleasure. You'll find that they hold their value very well should you ever trade them in or sell them.

The biggest differences in these lenses are as follows:

- **Image Stabilization (IS).** IS is great for allowing handheld shooters (using no tripod) to slow down their shutter speeds when shooting stationary subjects. Stationary subjects? Does that sound like sports photography to you? Me neither. If you have a big budget for camera gear or if you *know* you're going to be using image stabilization for something else, such as shooting weddings, then spring for the IS. But if you're strictly a sports shooter, you could forego the IS to keep your cost down. I have the IS feature on my lens, but when shooting sports, I almost always turn it off.

- **Old (I) versus newer (II).** The original 70-200mm f/2.8 lenses came off the assembly line as long ago as 1995. They were great lenses in so many regards, particularly in their sharpness and speed of focusing. Canon got a lot of things right from the get-go when these lenses were produced, so many of us fell in love with them. In fact, many of us professional photographers thought, "What could they possibly improve?" I've been shooting with my 70-200mm f/2.8 IS lens since 2005, and it has always performed flawlessly. But in 2010, Canon released a new 70-200mm f/2.8 IS lens at a price tag of $1,000 above its old counterpart. Its features include improved image stabilization (four stops versus three stops) and slight sharpness improvements over the old lens. This lens delivers slightly better focusing performance than its predecessor, resulting in a slightly higher yield of images

with sharp focus. My recommendation? If you need the biggest and the best and your wallet has too much cash in it, consider this upgrade. You'll definitely have the baddest lens on the block if you do! But again, if you're working within a budget, the old 70-200 f/2.8 is a great lens and performs admirably. You know how mattress salesmen have you sit on the most expensive mattress first so you keep comparing all of the lower-priced mattresses to it? I think it's the same with this lens. The old 70-200mm f/2.8 is such a great lens that I think it would produce excellent results for any photographer. Whether it's worth the extra $1,000 is really up to you, depending on how critical an eye you have and the size of your budget.

- **Aperture: f/4 versus f/2.8.** All other options aside, there are two primary variants of this lens: the f/2.8 (I call this the BIG lens) and the f/4.0 (the small lens). Positioned side by side, you can see their resemblance, but you can also see the size difference and feel the weight difference. Both are *great* lenses and will produce amazingly sharp images with a pleasing bokeh. Both also have excellent autofocus performance. The biggest difference is how much light they will capture. The big lens has a bigger physical opening for light to come in (77mm) *and* a bigger maximum aperture of f/2.8. The small lens has a smaller physical opening of 67mm and a smaller maximum aperture of f/4.0. Once you work out the math, you'll see that the f/4 lens can bring in only about 40 percent of the light that the f/2.8 can. And the original f/4 lens costs roughly half of what the original f/2.8 costs.

Three Canon 70-200mm L series lenses. Top: f/2.8 II. Middle: f/2.8 I. Bottom: f/4.

So here's the real question: Do you plan to do only outdoor daylight photography? Or do you think you'll sometimes shoot indoors or in lower-light conditions? If you're doing daylight photography only, I would be very confident in recommending the small lens and having you save some money. However, if that's the route you take, don't curse me when you bring your lens to a wedding and realize that you don't have enough light! Also, the big lens includes the tripod collar, and the smaller lens doesn't. If you buy the f/4 lens, be ready to fork over the better part of a hundred dollars for the overpriced piece of metal needed to attach it to your tripod or monopod. (You can buy a non-OEM tripod collar for significantly less.) As a sports shooter, you'll almost always be using a monopod, so consider this expense part of the cost of the lens. Finally, the f/2.8 version 1 lens has been discontinued, so you're looking at buying it used, which may also factor into your decision.

Nikon Lens Recommendations

Nikon produces lenses under the Nikkor brand. Similar to the Canon lenses I recommend, Nikon produces 70-200mm f/2.8 and 80-200mm f/2.8 lenses, each of which delivers fast autofocus

performance and produces razor-sharp images. These lenses are available with and without VR (Vibration Reduction, Nikon's name for effectively the same feature as Canon's Image Stabilization).

More Expensive Lenses

Out of the reach of most photographers starting out are a couple of monster lenses that will give you incredible reach. Both Nikkor and Canon produce a 300mm f/2.8 and a 400mm f/2.8 lens. These lenses have extra reach well beyond 70-200mm and produce gorgeous bokeh. But be prepared to open your wallet. Depending on which brand and focal length, these beauties will run between $5,000 and $10,000.

One drawback of using these beasts is that the fixed focal length doesn't allow the flexibility you get with a zoom. The extended reach of these lenses comes at the cost of not being able to zoom in or out. But if you pick your spot wisely, these great lenses will produce amazing action shots.

A practical alternative may be to rent one first, even though a weekend rental may still run you more than $100. Slower lenses with smaller apertures (f/4 and f/5.6) are also available, but those lenses aren't quite as fast and will hinder your action shots in lower-light conditions.

NOFEAR

Many online resources list specifications and reviews for digital cameras. Take some time to review them and learn what others have to say about specific camera bodies and lenses. You can even rent the equipment you're considering before you take the plunge and purchase it outright. Although renting gear becomes an additional expense, it can be a smart way to try before you buy.

New versus Used Gear

Purchasing your gear new or used is an important decision. And with the prevalence of online retailers and the prices they offer, the number of choices and options can be confusing. Obviously, it's a personal decision, largely driven by your budget and your risk tolerance, but let me offer a few thoughts to help your decision.

Find a Reputable Retailer

Even if you're looking at a used camera body, you're talking about a good chunk of change, so you want to be sure you're dealing with a reputable retailer. You definitely don't want to be high and dry after forking over more than $500 for used gear or more than a thousand for a new camera body. Many photographers find B&H Photo Video and Adorama to be reliable sources for gear, yet both still offer competitive prices. If you're buying used gear, it's even more important to make sure you know whom you're buying it from and that the person or outfit is a legitimate seller. Look for a reputable seller who provides some level of warranty for your used-gear purchase, such as B&H.

The free market for cameras in nearly all cases proves that you get what you pay for. If you see a deal that sound really amazing, maybe even too good to be true, guess what? You may be taking a real risk with your hard-earned money in the hopes of saving a few hundred dollars. To me, it's best to purchase a camera at or near the market value from a seller I know will deliver and stand behind the product I'm purchasing. If you're a pro, you have to depend on your equipment and know that it will be available and in good condition for your job. And if you're an amateur, you

just don't want to get ripped off. There are a ton of online sellers out there, some good and some not so good, so *be careful*!

> "The free market for cameras in nearly all cases proves that you get what you pay for."

There's another set of conditions you should understand when you make a purchase. Obviously, you can buy gear new from a reputable seller. These purchases will include the manufacturer's warranty and are generally the safest bets. If you come across an online seller you've never heard of, it can be hard to know the seller's reputation; even when you receive the product as advertised, the origin of the equipment may be in question. If you don't buy from a legitimate reseller, there's a real possibility that you may be buying stolen gear and that the warranty and/or the money-back guarantee won't be honored.

There's a third market somewhere in between new and used called the *gray market*. This typically involves purchasing new gear from a merchant in another country, often online. But even when a merchant is legitimate, warranties are often country-specific, so purchasing the same item from another country may or may not include the desired coverage to your purchase. In some cases, you can definitely save a little money by purchasing this way, but again it comes at a risk.

My bottom-line advice to you is this: Whether you're buying new or used gear, make sure you're buying from a reputable seller and that you're 100 percent clear on the warranty coverage of your gear. Check the online reviews and make sure the buyers' experiences have been overwhelmingly positive. Otherwise, if you're looking to save a few bucks, you can roll the dice with whatever deal you find online, but if it goes sour in any way, don't say I didn't warn you!

Is Used Gear a Viable Option?

Now that we've established some thoughts on *whom* to buy from, there is a very real question of whether buying used is a viable option. In a word, yes, if that helps you to stretch your budget. Reputable camera merchants can be a great source of affordable gear.

Let's talk about camera bodies for a moment. In my experience, quality camera bodies (particularly the specific models I have mentioned) are very durable and long lasting. The controls, displays, and internal electronics are quite reliable over time and have a low chance of failing. The one main component that has a significant likelihood of failing is the shutter. Yes, there are other physical and electronic elements in a digital SLR that can go bad, such as buttons and switches, but the shutter mechanism is the component that moves more than anything else in the camera and that, statistically, is your biggest risk of failure in the camera body.

Professional and prosumer shutters are rated between 100,000 and 300,000 cycles, depending on camera body type. Sounds like a lot, right? But if you get very active in shooting sports over a period of time, you can definitely exceed these numbers on your shutter. In fact, plan for it. It's not *if* you'll need to replace your shutter, it's *when*!

For consumer cameras, it's often not worthwhile to replace a camera shutter—the best option is usually to just throw away the entire body and head back to the camera store for a new one. But for higher-end gear, it's usually worth the cost to have the shutter replaced. Both Canon and Nikon have excellent networks of repair facilities. For $200 to $400 (depending on camera model), you can have the shutter replaced as well as the rest of the mechanism cleaned and inspected. It's almost

like getting a brand-new camera back at a fraction of the cost! I have a Canon 1D Mark II that I've used for more than seven years and for 500,000 shutter actuations; I've had to replace the shutter once. And I know a prolific shooter who has replaced his 40D shutter four times! With this caliber of equipment, the rest of the gear tends to hold together very well over time if you take good care of it.

So back to our used-camera-body discussion: If you buy a camera used with a 30-day guarantee from a reputable dealer, one of three things will most likely happen.

- It will have a problem in the first 30 days. Send it back and get it fixed for free. Everyone's happy!

- It won't have a problem in the first 30 days and is likely to work for a long while. Still happy!

- It won't have a problem in the first 30 days, but the shutter will fail shortly afterward. In this case, you'll have to pay a few hundred dollars for a new shutter. This is probably your worst-case scenario, and you still may have paid less than if you purchased new.

Admittedly, there's nothing like buying a brand-new camera body and knowing that you're the *only* person to have used it. And whenever possible, I definitely prefer buying new gear. But if you're prudent during your purchasing process, buying used gear can definitely be a viable alternative to help stretch your photography budget.

"If you're prudent during your purchasing process, buying used gear can definitely be a viable alternative to help stretch your photography budget."

Other Equipment Considerations

The camera body and lens are definitely the two biggest items on your photography equipment list, but it doesn't end there. You're going to need some other items to complete your photographic toolkit. The following sections will discuss a few other important items that you should plan to have in your toolkit.

Lens Filter

Many different filters are available: UV, polarizing, neutral density, and warming/cooling are just a few. I keep it very simple when it comes to filters for sports photography. I use a good-quality UV filter not so much for the optical benefits, but more for the protection of the outermost lens. (I've mainly used the word "lens" to refer to the entire lens assembly, but each lens you purchase is made up of several individual lens elements. In this case, I'm referring to the lens filter as protecting the outermost lens.)

In sports photography, you will be up close and personal with athletes and all the moving parts that come with the sport: flying balls and pucks, slinging mud and sweat, not to mention rain, sleet, or snow. A ball may come at you and your camera when you least expect it, and you may not have time to react and get out of the way. I've seen it happen. In some cases your filter can serve as a sacrificial component when a glancing blow from a stray ball strikes the front of your camera. You may not be happy when this happens. But on the bright side, you'll be considerably less unhappy knowing you only have to replace a filter that costs less than $100, compared to sending in a $1,500 lens for repair.

Aside from situations of clear destruction to your lens, a filter also affords protection in less catastrophic situations. If a spot of mud lands on the front of your lens, you can simply pop off the hood and use a lens cloth to clean the front of the filter. I try to touch my outermost lens as little as possible throughout its life, including cleaning it with a lens cloth. I'm much less concerned with rubbing the front of my filter out in the field than I would be with trying to clean the objective lens. And if you really can't get the filter clean, you can unscrew it and continue shooting without a filter (though the lens would be unprotected at that point—try not to catch anymore mud on the lens).

So I recommend purchasing and installing a high-quality UV filter on your lens and simply forgetting about it. It stays as a semi-permanent, removable part of my camera lens. This method has saved my lens (or at least my ability to complete the day's assignment) more than half a dozen times.

Hood

Professional lenses such as the ones I've suggested are almost always sold with a lens hood. A hood is a plastic cup-shaped device with a non-reflective interior that attaches to the end of your lens and filter combination. The hood serves two purposes. First, it blocks the sun when you're shooting in backlit situations, hence reducing glare. Second, it provides some physical protection from rain, flying mud, and so on to help keep your lens dry. Plus, it makes your lens look that much bigger if you're looking to impress people around you!

It's always a good idea to keep the hood on your lens while you're shooting. If your lens didn't come with a hood, I suggest buying one—name brand or otherwise. Replacement hoods cost $25 to $75 for most lenses, and along with a filter, I consider them inexpensive protection for your lens as well as your ability to successfully finish out the day's shoot.

The only time I don't shoot with my hood is when the camera flash casts a shadow of the hood onto the image. This occurs only when I'm shooting wide angle (around 24-30mm), and that rarely happens with sports. My advice is to leave the hood on and consider it a permanent part of the lens.

A lens hood is great for keeping stray light out of your shots, particularly when you're shooting backlit subjects. It's also good for giving your lens some added protection.

Camera Grip

High-end cameras, such as the Canon 1D series or the Nikon D3, have double grips integrated into the camera body. That is, you can hold the camera in portrait or landscape orientation and keep your hand in the same position (upper right of the camera body). But many cameras, such as the Canon 7D or Nikon D700, require you to reach over the camera to position your hand in the upper-left corner of the body, rotated 90 degrees counterclockwise. This might be okay for a few dozen shots, but when you're doing this for hours at a time, it will cause you a lot of discomfort.

The solution: Purchase a grip for your camera body. Each body has a grip specifically matched to it, so be sure to look for the one that corresponds to your particular camera. When installed, the grip delivers two benefits. It allows you to shoot from

the upper-right corner of the body, eliminating the need to uncomfortably reach over the camera body when shooting—a practice some call "chicken winging" because of the way it makes your elbow the grip accommodates one or more additional batteries, extending the number of shots you can achieve before you're out of power. And like the lens hood, the camera grip can serve to impress your friends by effectively increasing the size of your camera body. With the grip, hood, and lens attached, I can't count the number of times a passerby has said, "Wow, nice camera."

A grip will increase the weight of your camera slightly. Grips typically add one-half to three-quarters of a pound to your camera body. But the added weight will normally be offset by the shooting comfort, particularly in portrait-orientation shots.

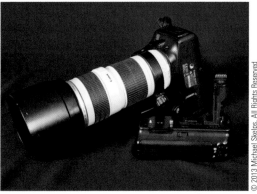

Camera grip (below) and with 30D body, separated (above).

Tripod Collar/Monopod

This device is called a *tripod collar* or *tripod ring*, even though as an action photographer, you won't use a tripod very often. A monopod is a much more practical way to support and stabilize your camera without significantly restricting your mobility. The tripod collar attaches around your lens and allows you to affix your lens to a monopod, tripod, or other supporting device. Many lenses come with the tripod collar, but certain ones do not (the Canon 70-200mm f/4 lens comes to mind in particular).

A monopod is basically an extendable stick that is vertically situated under your camera to support its weight. You can adjust the height of the monopod to suit your personal stature so that you can shoot comfortably. This simple device will make shooting much more comfortable, especially for longer events, by supporting the weight of the camera. Unlike a tripod, which is ideally suited for leaving the camera in a fixed position, a monopod affords you the ability to lean and pivot with your camera, while saving your arms from exhaustion.

A monopod also will stabilize your camera and lens, reducing camera shake. Plenty of different monopods exist, varying in quality and features, and most are less than $100. The main caveat for monopods, especially for taller photographers, is to get one that's tall enough for you. I'm 6'1", and some of the cheaper monopods just don't reach high enough, causing me to have to stoop a little to shoot. After a couple of hours bent over because of a too-short monopod, it quickly became clear why I needed one of the right height.

If you choose not to use a tripod collar and monopod, expect your arms to be very sore after your first long shoot. I've seen photographers without a monopod begin their day with perfectly aligned shots, plumb and level, but later on every shot has crooked frames. You can almost see the photographer's arms getting tired as you view the

progression of images. You may be shooting with a camera and lens that weigh seven pounds or more, and it won't take long before your arms get tired and you just can't support your camera properly and control your shots the way you would like to. Usually after that happens once to a photographer, they'll purchase a monopod and tripod collar right away. Please save yourself this unpleasant experience and purchase a collar and monopod along with your camera body and lens first thing.

Extra Batteries

As a sports shooter, you're likely to take more photos than your counterpart who shoots portraits, weddings, or landscapes. The batteries produced today have impressive capacities, and some can allow you to shoot thousands of pictures before recharging. As good as this sounds, though, you may be in situations where your batteries will fall short, and having a fully charged spare or two will be a lifesaver. Or your shoots will be long enough that you expect to go through more than one battery. So have an extra battery available with you at all times. I usually bring double the number of batteries that I expect to go through.

Note that your batteries will have reduced performance in cold weather, so in the wintertime, it's especially important to anticipate the shorter battery life. And now and then I inexplicably find that a fully charged battery isn't delivering a full charge, as it depletes faster than I anticipated—another reason to have extras on hand at every shoot.

One final word about batteries: They are available in name-brand and off-brand types. You may be able to save money by buying the knockoff brand. I've used them in the past and haven't had problems with them, except once. I recently purchased an off-brand battery, and when I charged it, it physically swelled up, luckily outside of the camera. The swelling was barely perceptible, but that

battery just would not fit into the camera. Worse yet, I made this discovery in the field, wasting valuable time during a shooting assignment. I'm just glad I didn't try to shove it into the camera body too hard, which could have caused costly damage. I simply pocketed the suspect battery and went on to the next fresh one. Personally, I have a low tolerance for risk, so I say, "Once bitten, twice shy." I now buy only OEM batteries. It's your call when buying batteries, of course, but with the cost of all your gear and the importance of being able to reliably complete your assignments, you should give your battery purchase careful consideration rather than just jumping to the cheapest online supplier.

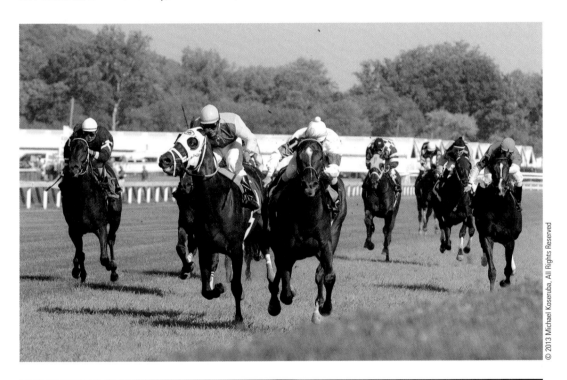

OEM

The acronym OEM stands for *original equipment manufacturer*. This term applies to auto parts as well as camera parts. An OEM item comes from the manufacturer, not from a third party. With OEM camera parts, you know that each part meets Canon's or Nikon's technical specifications. Non-OEM parts may or may not meet those standards. OEM parts often cost a little more, but having the backing of the manufacturer may give you a little more confidence in using them.

Memory Cards

This is going to sound a lot like my "once bitten, twice shy" comments of the previous section. I used to think that all memory cards were the same, and at one point I had a habit of purchasing the cheapest type of card I could find. But buying the cheapest brought me two problems. The first and most severe problem came from buying a set of cards from a second-tier manufacturer. In a batch of eight cards, one physically came apart when I inserted it into a memory-card case, a second card failed so I could no longer continue shooting on it, and a third card allowed me to shoot on it, but when I tried to download the images, none were there. Card-recovery software couldn't retrieve the images, either. Three out of the eight cards were bad—I couldn't believe it! I immediately discarded those cards and kept the other five cards at the back of the line, only to be used in an emergency. Years later, a colleague of mine who didn't know the story on those cards put one of them into a camera used for a sports portrait shoot, an important but less demanding assignment. Everything went well during the shoot until I tried to download the images and found that about two-thirds of the files were missing. Again, I had no luck with card-recovery software. I threw all of the remaining cards of that brand into the trash, and I've never looked back.

Today, I use only SanDisk cards, and I've had very few (but not zero) problems. Because my tolerance for errors is so low, any card that has a problem is either immediately discarded or put on probation, where a second failure causes me to throw it away. So it's clear to me that all cards are not the same, and name brand *does* matter.

The second problem I've run into with buying the cheapest memory cards—SanDisk or other—is the speed of the cards. What we do as sports photographers is very demanding, both personally and on our equipment. Sports photography is shot fast, and you need a card that can keep up. Slower cards, such as the SanDisk Ultra line, often won't be fast enough for you. You don't want to be waiting for your buffer to empty when you're ready for the next shot. Fortunately, memory cards have evolved in performance and cost over time. In 2006, I bought my first 8-GB card, an Ultra II, which in retrospect was painfully slow, at a cost of $650. That card today would retail for less than $50. That card still works, but it is agonizingly slow to shoot with. Today's cards with write speeds of $600\times$ and higher are much more capable media for your action-photography needs.

Gear You'll Have *Less* Success With

I've made some recommendations for gear in the previous sections. Maybe you have some of it. Maybe you're thinking about what you might buy. Or maybe you have some gear that isn't on the list. Don't be disheartened. The gear I've listed is not the *only* gear with which you can ever capture a great action shot. Sometimes, I see impressive photos taken by someone using consumer-grade gear. In fact, many of today's consumer-grade SLRs produce amazingly good photos, particularly of slower-moving subjects. They have improved low-noise sensors and great color fidelity. But if you're shooting with one of these bodies, you don't have a camera that stacks the deck in your favor to be able to capture sports shots consistently.

This book is not about how to *occasionally* capture a single great action photo; it's about how to *consistently and reliably* capture great sports photos wherever you are. And that means being able to shoot a high volume of photos and capture targets with sufficient light and a fast shutter speed.

"This book is not about how to occasionally capture a single great action photo; it's about how to consistently and reliably capture great sports photos wherever you are."

Consumer-Grade SLRs

Consumer-grade SLRs have come a long way in terms of their quality and capability. They're great for carrying around and capturing some quick snapshots. Some consumer-grade SLRs are brought to market with a lot of slick advertising and exaggerations of their capabilities and the types of photos they can produce. Again, I'm not saying you *can't* take a great sports photo with this type of camera. I'm saying you're *less likely* to come home with the great shot you're hoping to capture. Certainly, your batch of quality images will be considerably smaller.

If you have a consumer-grade SLR and you aren't ready to make the leap to professional or at least prosumer-grade gear, I still encourage you to use the principles outlined in this book to help improve your action photography skills, such as framing and exposure management. But as your skill develops, you will likely soon discover that your camera body and lens are limiting your photos.

Lenses

Lenses are some of the most expensive components you'll buy for sports photography, sometimes more expensive than your camera body. To keep costs down, it can be tempting to look at non-OEM lenses. Sigma and Tamron are two well-known names of off-brand lenses compatible with pro Nikon and Canon bodies. The rule that you get what you pay for definitely applies here, as the more expensive glass produced by these

manufacturers tends to deliver better performance. I find that the optical performance of the upper end of these third-party lenses is actually quite good. However, they sometimes lag behind Canon and Nikkor for fast and accurate autofocus performance. I think it's worth having the best lens my budget will allow to ensure that my images are sharp, regardless of the relative motion of the athlete when I click the shutter.

You might also be tempted to stretch your budget by using a Canon or Nikkor lens that isn't on my short list of recommendations. Often this comes in the form of a 100-400mm f/4-5.6 lens. After all, this lens offers a greater reach, a wider zoom range, and a lower price tag than the 70-200mm f/2.8. But with the smaller aperture and lower-end optics, your photography will be limited in comparison. The images often aren't as sharp, particularly in certain portions of the zoom range.

The choice is ultimately yours, but I suggest you make a prudent investment in the best photography gear you can afford. If you're serious about being a skilled sports photographer—even if you plan to remain an amateur—it just makes sense to have the best-quality gear you can.

Now that you have an idea of the equipment you might want to acquire, let's look at how to put that equipment to use. After all, your camera and lens may be the tools to conduct your photography with, but it's the knowledge of how to use those tools that will produce great shots. Let's first look at how to achieve proper exposure, the most important and sometimes challenging aspect of professional photography. Read on…

5 Understanding and Managing Exposure

Since the first photographs were taken in the 1800s, one thing has remained a constant challenge for anyone taking a picture: getting the exposure right. Whether you're shooting portraits, landscapes, or sports, your job is to produce an image that is neither too dark nor too light. Proper exposure is one of the most important aspects of action photography. It's also one of the most challenging to master.

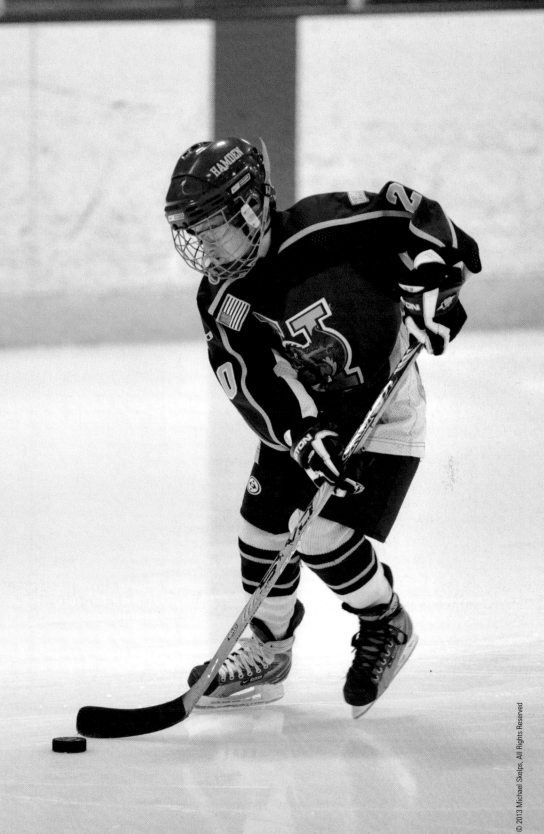

What Is Exposure?

In photography, the word *exposure* describes the relative amounts of light and dark in an image. In a properly exposed image, you'll see a distribution of darker areas (called *shadows*, regardless of whether they are actually in a shadow) and brighter areas, called *highlights*. In between shadows and highlights are areas of intermediate brightness called *midtones*. The most appealing images, or those that would be considered properly exposed, have a good mix of shadows, midtones, and highlights. Images that are too bright tend to have too many highlights and not enough shadows and are referred to as *over-exposed*. Images that are too dark are characterized as having too many shadows and not enough highlights; they are referred to as *underexposed*.

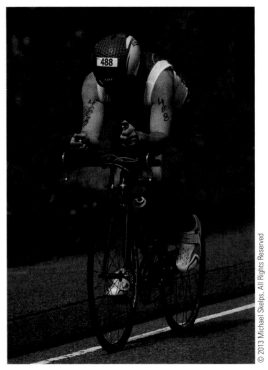

An underexposed image.

As a photographer, your job is to achieve the best mix of shadows, highlights, and midtones. Your camera has built-in tools that will aid you in achieving proper exposure. While it's true that you can adjust exposure post-capture using image-editing software, your pictures will always benefit from you obtaining the best exposure possible *in camera* when you're shooting. That's a basic principle of good photography: Do your very best to always get exposure right in camera, and do not rely on software to save your bacon. Relying on post-capture adjustments to "save" your images is generally a poor practice.

Editing your images is a legitimate way to bring out the best in your images, as we will cover later in this book, but it should never be used as a primary means of getting good exposure. For one reason, many images with significant exposure problems simply cannot be adjusted to achieve ideal results in software. For instance, images that are severely underexposed will show significant noise artifacts as you brighten them. The closer you come to ideal exposure in-camera, the more keepers you'll have and the better they'll look.

This reason alone is sufficient to always strive for proper in-camera exposure. But there's another equally important reason. By always striving to achieve proper exposure in camera, you establish a state of mind in which only the highest quality is acceptable. Just like a skilled craftsman or performer, I encourage you to always think about how to produce not just okay shots, but the best ones you can possibly generate. From picture to picture, review the histogram, look at the image, and ask yourself, Am I getting it right? What can I adjust to make my exposures even better?

Sports photographers, usually shoot in JPG rather than RAW. JPG images don't lend themselves as well to the range of post-capture adjustments that would be available if you were shooting in RAW. Some photographers use RAW as a "safety net" so they don't have to worry as much about getting the

ideal exposure. Other photographers may use exposure bracketing to make sure they're shooting their subjects with a range of exposures, just in case. In certain types of photography, you may have that luxury. But the speed and pace of sports photography usually dictates that you shoot in JPG and without exposure bracketing. Post-capture adjustments in JPG should be considered as a means to enhance an image with good (though not necessarily perfect) exposure. So it's especially important for sports photographers to get the best exposure possible when they're shooting.

RAW versus JPG

Most people familiar with digital photography (or even just computers) know at least a little bit about JPG images. The JPG image format is well known mainly because it is so widely used. Images on websites are in many cases JPGs, and your digital camera can produce JPG images as one of two output formats, the other being RAW. JPG images have an intrinsic benefit in which the image data can be compressed, one of the key benefits of using JPGs over other formats. In fact, many people regard the concept of electronic images and JPGs as one and the same, when in reality a JPG is only one type of electronic image.

When your camera captures a JPG, the image is a result of numerous adjustments and manipulations the camera makes to that image. Although you may not think of it often, the camera doesn't just detect and record the image. The camera may also sharpen it, apply the selected white balance, compress the image, and write it to your memory card, all at the click of the shutter. The sharpened, color-corrected, compressed image is recorded on your card while the original image is left unrecorded, leaving you with the JPG output only. (Some camera bodies do give the option of recording both the JPG and RAW format of the same image, but this is normally not a practical option in action photography, as you'll see in the next paragraphs.)

RAW images, on the other hand, represent the original data recorded by the camera sensor, with no automatic processing or changes performed. The RAW data also contains more detail, as many professional cameras will produce 2^{12} shades of each color rather than 2^8, which is the limitation of JPG images. RAW images, therefore, give you more ability to manipulate shades and colors during post-processing, so you can potentially save over- or under-exposed images. These advantages sound great, so why don't sports photographers shoot in RAW?

The main reason is that RAW images contain much more data than JPG images. A comparable image might be 20 MB in RAW and 2 MB in JPG. When shooting images in a burst series, the greater amount of data in RAW means that your camera buffer will fill faster. Also, you'll be able to fit fewer images on a single memory card. It also means that you can write fewer images per second to your memory card. In the world of high-volume action photography, shooting in RAW usually isn't practical because of the increased data transfer and storage requirements.

"As a photographer, your job is to achieve the best mix of shadows, highlights, and midtones."

Analyzing the Histogram to Determine Exposure

The first and perhaps most important tool in achieving proper exposure is *histogram* analysis. In general terms not specific to photography, a histogram is a type of chart that shows the amount of something broken down by categories.

In digital photography terms, a histogram is an analytical representation of the mix of shadows, midtones, and highlights in an image. The left-hand side shows the shadows, the right-hand side shows the highlights, and the middle shows the midtones. When you take a photo, you can analyze the relative exposure by looking at the histogram.

A good image will have a histogram that extends from the left-hand side to the right-hand side. You'll see variations in the curve reflecting the relative amounts of shadows, midtones, and highlights. What you *don't* want to see are significant ranges of zero values in either the highlights or shadows. Such a range of zero values indicates an underexposed image (zeros in the highlights) or an overexposed image (zeros in the shadows).

Another thing you want to avoid is *clipping*, where the shadows or highlights are at or near a peak at the end of the histogram. An image with high values at the left side of the histogram is usually underexposed, and an image with high values at the right side of the histogram is usually overexposed. It's common to see pairs of peaks on one side and zeros on the other side of a histogram in under- or overexposed images.

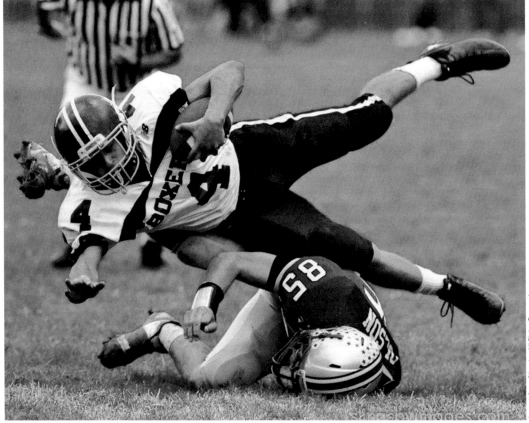

It's important that you practice interpreting the histogram. You can view a histogram in the camera and in software such as Photoshop, Lightroom, or Photo Mechanic. I suggest you take some practice photos, look at the images, and compare them to the histograms. You might even intentionally take some pictures that are too dark or too bright to get an idea of how the histograms will look for those images. After a while, you'll become skilled enough to identify which part of the histogram corresponds to which part of the image (for example, an image of a runner on road might contain a peak in the midtones that would correspond to the gray asphalt on which he's running).

Chimpin' Ain't Cheatin'

One of the powerful tools made available by digital photography is the ability to see your image immediately after capture. Some photographers use the term *chimping* to describe the practice of using the LCD screen to frequently review the images taken immediately after capture. The word "chimping" sometimes carries a derogatory connotation, commonly applied to less experienced photographers who frequently review each image after they take it. The origin of the phrase isn't exactly clear, but it seems to come from comparing inexperienced and overly enthusiastic photographers to chimps as they look at their pictures and then ooh and aah over the results.

Don't let anyone tell you that reviewing your pictures in your camera is a bad thing. It's not! In my opinion, there is tremendous value to be gained from using the information available from your camera's LCD screen. In fact, I think the benefits

of using this information to your advantage far outweigh any drawbacks, so I generally reject the negative connotation to the practice. I prefer to avoid the term "chimping" all together; instead, I just call it "reviewing my LCD screen."

Yes, a photographer can overdo it by looking *too* frequently at the LCD. In sports photography, if you looked at every shot you took, you would risk missing valuable photo opportunities. But the ability to look at your photos immediately provides an indispensable benefit to you as a photographer, so I don't believe there's anything negative about checking your pictures in the LCD to see how they look. You certainly don't have to look at every image after you take it. The key to effective use of this information is to critically analyze it. Ask yourself, Does my histogram look right? Are there exposure problems that I need to compensate for, such as any blown-out highlights on the subject's skin? Your review of those photos should be an opportunity for a quick inspection of your work, including framing and exposure. If you're on assignment, this is not a chance for you to spend lots of time admiring your work—you can do that at home or in your office. Your review of photos should be for the purposes of either making adjustments to your pictures or continuing to shoot with your current settings.

Most cameras will let you review your picture and its histogram simultaneously. Let me be clear: Histogram analysis is generally more valuable than just looking at the picture. Brightness of LCD screens may vary, and if there is strong sunshine above you, you may not be able to see the picture very well to eyeball the exposure. The histogram is a quantitative tool to determine the exposure of the image. In most cases, histogram analysis should be considered your primary means of assessing the exposure of your images.

NOFEAR

Using photo-editing software on your computer, take a few photos and open them without showing the histogram. For each image, try to anticipate what the histogram will look like. Is there a bright sky that will make a large highlight area on the right of the histogram? Are there large areas of midtones, such as skin tones or the field surface? Are there dark areas that will show on the histogram's left side? Or are there exposure problems that will cause the histogram to shift heavily to one side or the other? Now view the histogram and see how it compares to your prediction.

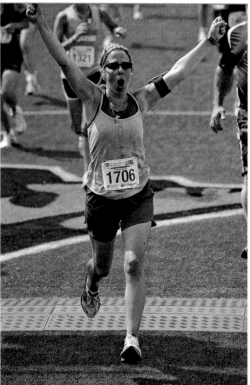

Achieving optimal exposure is really an art and a science. Histogram analysis is the science part of that. Viewing the LCD and simply asking yourself how the image looks is more the art part of it.

Proper exposure management is best achieved by using tools and analyzing your in-camera exposure both qualitatively and quantitatively.

"Achieving optimal exposure is really an art and a science."

In addition to reviewing the shape of the histogram on the LCD, be sure to zoom in to see the faces in the image. Look at the skin tones carefully. Are they washed out (overexposed) or too dark (underexposed)? Get in the habit of occasionally reviewing both the histogram and the preview image to assess whether your exposure is accurate.

A great feature you'll find is that your LCD screen will show blown-out highlights as a blinking area on the image. Pay special attention to any areas that are blinking. In all likelihood, you *won't* be able to save any blinking areas post-capture. Some areas in which highlights are blown out may be tolerable, such as a white uniform or the sky in a backlit shot. But certain areas are automatically a problem if they're blown out, particularly any skin tones. If you're shooting an athlete and any of her skin areas blink, you know that you need to immediately back down your exposure a bit. Take another shot and see whether the skin tones are still too hot. When they are no longer blinking, you're probably good to go.

This feature of the LCD alone makes it worthwhile to review your shots. It's not cheating, and it's not a crutch. It's just good use of your photography toolkit. The trick is to use the LCD information to analyze your images, make any necessary adjustments, and then resume shooting. You'll develop your own pace of shooting for a few minutes, assessing your exposure for a few seconds, tweaking your settings as necessary, and then going back to shooting. Get in the habit of checking every few minutes—say, once every five minutes. Try to find a happy medium between checking your exposures too often and not often enough.

Adjusting Camera Exposure

When shooting in Aperture Priority or Shutter Priority mode, the most straightforward way to increase or decrease your exposure is to use manual exposure compensation. Each camera model is slightly different, so consult your owner's manual for the exact buttons and dials to use. Manual exposure compensation is a way of overriding the camera's exposure logic and causing the entire image to be made brighter (positive exposure compensation) or darker (negative exposure compensation). Most quality cameras will offer manual exposure compensation adjustments in 1/3 stops, though you may find that some cameras allow for only half-stop increments. Exposure compensation is measured by EV (*exposure value*), so you might see a slight negative exposure compensation written as −1/3 EV or a larger positive exposure compensation written as +1 2/3 EV.

Keep in mind that a histogram can be misleading when severe lighting differences exist. One example is in a backlit situation. The histogram may show a broad range from shadows to highlights. At first glance, you might think your picture is fine based on histogram analysis alone. But if you zoom in on the LCD and look at the athlete's face, you will realize that the subject is far too dark and that you need to increase the exposure.

There's no substitute for practice. As you take shots, look frequently at the picture and the histogram until you get proficient at assessing the picture's exposure based on both the quantitative and qualitative aspects.

"There's no substitute for practice."

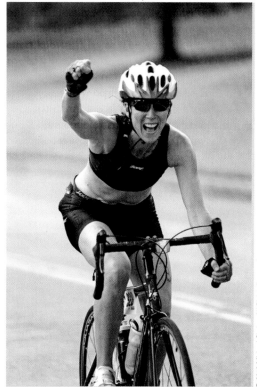

Underexposed versus Overexposed

Obviously, it would be ideal if every photo were perfectly exposed. That would mean you would never have any clipped highlights or shadows. But in the real world, it just won't always happen. You may find yourself in situations where parts of the image are too bright or parts of the image are too dark.

I said before (and I meant it) that your goal should be to get good-quality exposures in the camera so you don't have to save them using software. But if you're going to have images that are either too dark or too light, you'll almost always be better off erring on the side of slight underexposure. If an area of an image is a little dark, you can make modest adjustments in image-editing or post-production software without a lot of difficulty. But that is not as true when all or part of an image is too bright. So, the rule of thumb is that it's better to slightly underexpose an image than it is to overexpose it.

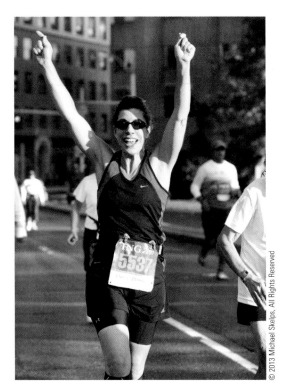

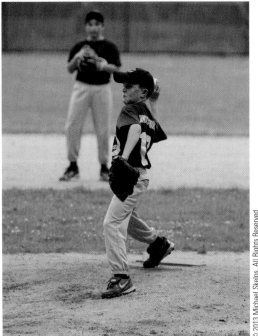

NOFEAR

Start thinking critically about exposure whenever you take pictures. As you look through the viewfinder, try to anticipate areas that will represent the dark and light sides of the histogram. Practice reviewing the camera histogram and try to identify the areas in your image that represent shadows, highlights, and midtones. In a short while, you'll start to develop an uncanny ability to analyze the histogram as it relates to each image.

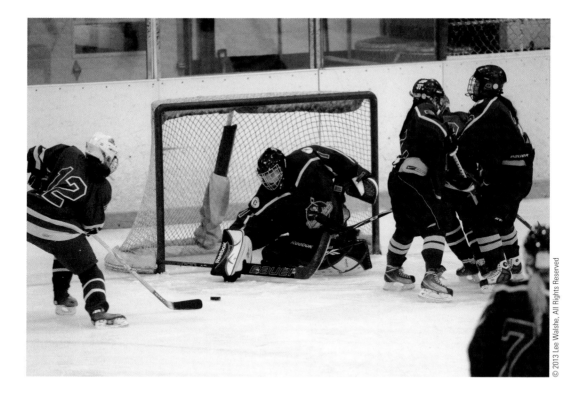

Conclusion

A fun way to think of exposure management is to think of the story of the three bears. I think Goldilocks would do a great job of exposure management. She sets a good example of what to do by recognizing when something is too cold, too hot, or just right. She uses different clues, such as the temperature of her porridge or the softness of a bed, to know when she has things just the way she wants them. So, be a Goldilocks photographer: Review your LCD frequently to give you clues to when your image is too dark or too bright and adjust your manual exposure compensation to help you achieve ideal exposure. Evaluate your histogram and look at the skin tones in the photos. In many cases, your camera will do a fine job with 0 EV. If you have to adjust the exposure, go ahead and tweak it. And, like Goldilocks, when your image exposure is "just right," you'll know it.

6
Understanding and Managing
White Balance

If you haven't thought about white balance until now, your world is about to change forever. From now on, when you look at a picture with a color cast, you'll think about white balance, which is a simple but important concept. It relates to how colors look under different light sources and conditions.

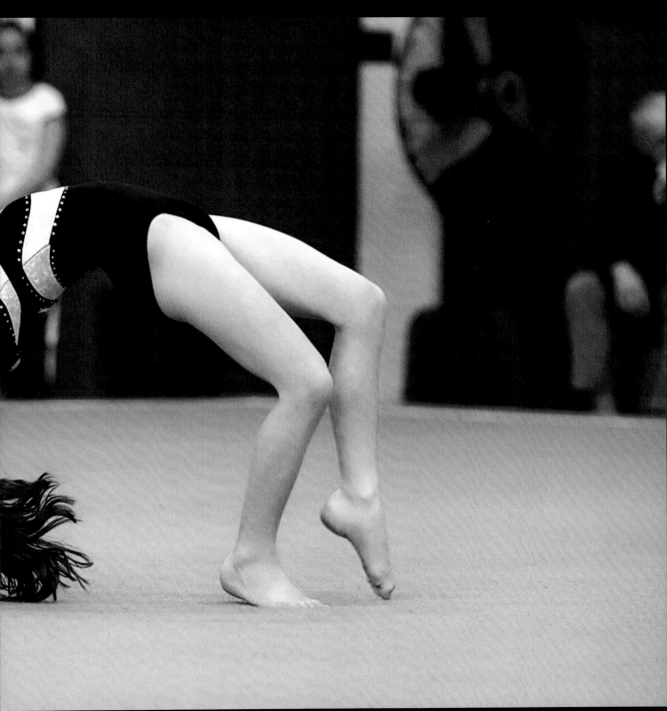

Light and Color

We don't often think about it, but all light sources have a color. When you're outside on a sunny day, you're lit by a yellowish-orange light from the sun. When you're in the office under fluorescent lighting, you're under a relatively "white" color. Okay, so white's not really a color, but you get my point. The color of lighting sources differs.

Beyond that, everything illuminated projects different colors depending on the light source. However, humans don't really perceive this very much as we encounter different light sources. Our eyes and brains do a great job of working together to normalize our perception of colors through a wide range of light sources. A red shirt, a blue chair, and a yellow flower all seem to still be red, blue, and yellow to my eye, whether it's sunny or cloudy, or whether they're in the shadow of a tree or building. Under extreme lighting-color variations, such as under a bug light or a deep-fryer light, this effect starts to become apparent; you might lose the ability to recognize the specific colors you're looking at. They start to look more yellowish or orange-ish. But under most everyday lighting conditions of sunlight, clouds, shade, and incandescent or fluorescent lighting, your brain and eye work together to more or less keep your view of those colors consistent.

White Balance in Digital Photography

The problem is, your camera, computer, monitor, and printer don't have that same inherent way to make blue always look like the same blue under different lighting conditions. In digital photography, the color cast by different light sources becomes an immediate and apparent issue that will degrade the quality of your images if you don't manage it. So, photographers shooting outdoors

need to develop a keen awareness of the lighting conditions. In the previous chapter, we talked about the amount of light (exposure). Here, we're talking about the color of the light.

An outdoor photographer who is unaware of his lighting conditions will see that some images tend to have a bluish hue and others may appear more yellowish as the color of the lighting source changes. Your camera has the ability to compensate for variations in the color of your source lighting through a function called *white balance*. Effectively using your white-balance setting will result in images whose colors appear true, regardless of your light source and its color.

Consider the lighting sources for most sports photography. In the vast majority of cases, you'll be shooting outdoors, most often in daylight. Outdoors, you may shoot in direct sunlight or beneath an overcast sky, or your subject may occasionally be in the shade of a large object, such as a tree or building. In the less frequent situation of shooting indoors, you'll encounter an artificial lighting source. Let's concentrate on the outdoor scenarios, since that's more common.

In outdoor sports photography, your white-balance selection is very simple. Three white-balance presets will be the mainstay of your color-management strategy: Sunny, Cloudy, or Shade, corresponding to the available lighting type. If it's a sunny day, select Sunny. If it's a cloudy day, select Cloudy. And if you're shooting athletes who are in the shade, select Shade.

These white-balance presets are quite good at accurately capturing the colors in your images, as long as you select the right one. On days with consistent lighting, selection may a simple matter, consisting only of choosing the right white balance at the beginning of your shoot. But those days are surprisingly few and far between. Be especially alert if there are small clouds creeping into your sunny day. You may be surprised by how often you need to change your camera settings due to intermittent clouds.

The Sunny and Cloudy presets by Canon and Nikon are incredibly precise for fully sunny or fully overcast conditions. When thin clouds come in, sunny skies will gradually experience a change in color. I still recommend using one of these two presets, but you'll have to use your best judgment about when to shift from Sunny to Cloudy. Be vigilant and aware of your color source throughout the day as it changes, and be ready to adjust white balance accordingly.

Avoid Auto White Balance

Why not just use your camera's Auto White Balance (AWB) setting? You cannot rely upon AWB to consistently apply the right color adjustment from image to image. AWB has its benefits in specific applications—it can be convenient when taking casual snapshots. But for quality sports photography, I always take white balance into my own hands and manually adjust the setting. Here's why.

In AWB, the camera analyzes each image and runs the colors through a mathematical calculation to determine what mix of colors is present. From this mix of colors, the processor calculates the "right" white balance for that image and immediately applies it to the JPG output. The sophisticated algorithms in your camera's firmware use this mix of colors to determine a "best guess" color adjustment to your images. But think about the colors you're capturing in sports. Instead of having a full range of different colors, you may have a preponderance of specific colors. Your sports shots may include the playing field, background objects, skin tones, and uniform colors. With all other factors being equal, shots of athletes on grass would already get an unwanted automatic adjustment to tone down the amount of green in the image. This alone is a sufficient reason to avoid AWB over the manual presets.

But there is another big reason that is especially an issue in sports photography. Nearly any game or sports competition involves athletes in different-colored uniforms. As you shoot images of an athlete from one team and then immediately switch to an athlete on a different team, the camera is looking at that mix of colors and working to adjust those colors to some calculated reference point. Remember, in AWB your camera is making these calculations for every single image you shoot. If you shoot pictures in sequence of athletes in, say, red and blue uniforms, the color adjustment will be different even though your lighting is consistent. It's unnecessary and easily avoidable. Just say no to AWB!

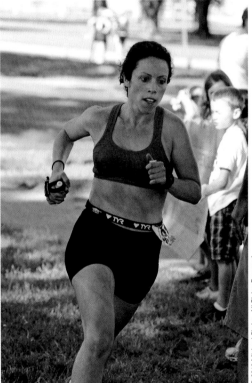

Custom White Balance

If you're shooting indoors, or if artificial lighting makes up the majority of your available light, you might find that neither Sunny, nor Shade, nor Cloudy will produce accurate colors in your captured images. In this case, the best alternative is to shoot with a custom white balance. This means instead of your camera using a mathematical algorithm to guess what color to use as a zero reference point, you provide an image of a color to use as the reference.

How do you provide that image? Simple. You take a picture of it. Gray cards are available for just a few dollars and are made specifically for this purpose. Just take an image of a gray card and then select that image as your reference point for your custom white balance. Make sure the gray card fully fills the frame. You don't even have to focus! Just be sure to get a good exposure somewhere in the middle of your histogram when taking a picture of your gray card.

If you happen to be shooting hockey or figure skating, a neat trick is to take a picture of the ice surface and use that instead of a gray-card image. Try to avoid taking a picture of the ice where colors, lines, or logos are present; just look for a big patch of ice and shoot that image for your custom white balance. Consult your camera's manual for detailed instructions on how to use a custom white balance on your specific camera body.

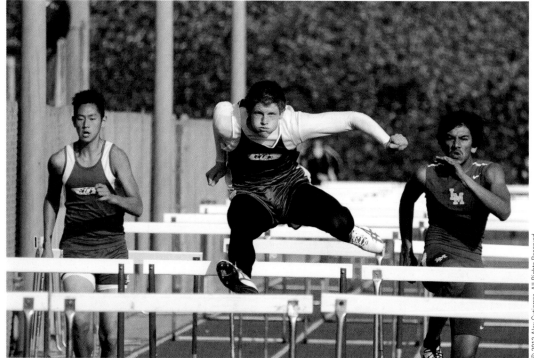

NOFEAR

Be vigilant about the light sources around you and make a mental note as the light changes. The better you know your surroundings, the more potent your photography skills become. So keep a constant eye on what your light source is and select the right one for your situation. Light conditions regularly change, especially outdoors, so get in the habit of regularly assessing your white-balance choice for variable lighting conditions.

Gray Cards and Other Custom White-Balance Tools

A gray card is an inexpensive photographic accessory designed to help you establish a precise and correct white balance under any set of static lighting conditions. Although the factory white-balance presets for Sunny, Shade, and Cloudy are very good for most outdoor photography, there are cases (particularly indoors) where the light source doesn't neatly fit into one of these categories. For example, you may have a mix of tungsten and fluorescent lighting, or you might have sodium lighting, which casts a yellowish-orange hue. In these cases, a custom white balance will bring your colors back to a neutral hue.

A custom white balance depends on a true reference point with respect to color. Images used to establish a custom white balance must be, by definition, something truly gray. Your gray card serves as this reference. A typical gray card is about the size of an 8×10, though you can purchase them in different sizes. Gray cards are printed with great precision to be truly color neutral, not simply like some random gray sweater or gray carpet—those could both be perceived as gray by our eyeballs but may be different colors from each other. A photographic gray card is a true, accurate gray color; science and manufacturing controls have been built into the product to make sure it is a perfectly neutral gray.

By taking a picture of the gray card under your current lighting conditions, you're telling your camera, "No matter what this picture looks like under the existing light source, it represents a true gray. Shift your colors accordingly, using this as a reference point for all colors."

Key points about shooting gray cards:

- Once you've taken a picture of a gray card as your neutral color reference, you have to choose Custom for your camera's white balance setting. You also have to select the image of the gray card you just shot. In some cameras this is two different steps—taking the image that will be used as a gray reference point and then choosing Custom for the white-balance setting. Be sure to complete both steps!

- If your lighting conditions change, or if you shoot in different areas with different lighting, you'll need to shoot a gray card again in the new lighting conditions and select that image as your neutral reference point.

- There are also alternative products you can affix to your camera lens to produce an image of a neutral color reference point, essentially fulfilling the same function as a gray card. The choice to use these versus a gray card is a matter of preference. The important thing is to be aware of color sources that require the selection and proper use of a custom white balance.

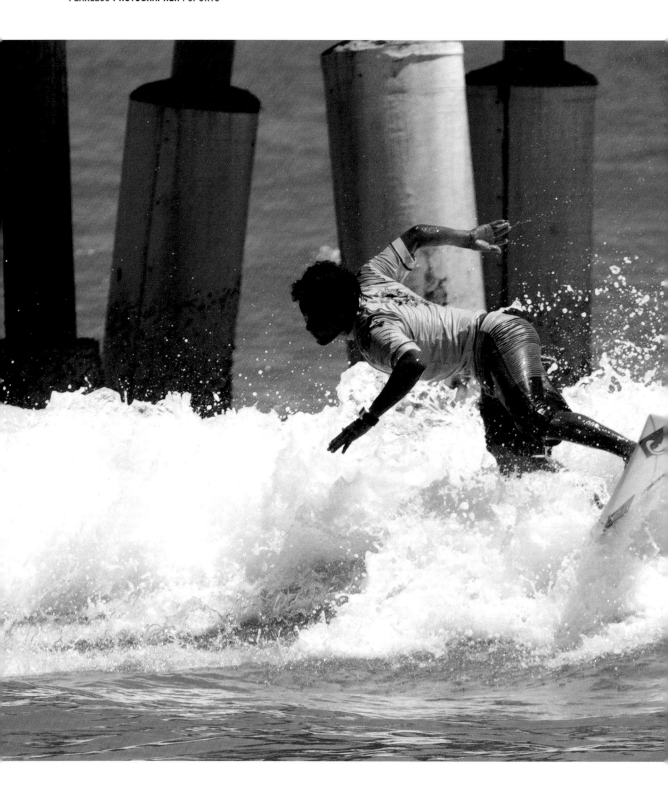

NOFEAR

Experimenting is a great way to learn quickly. Go ahead and play around with white balance. Take a batch of pictures with an intentionally incorrect white balance and then pull up those images as JPGs in photo-editing software. Note the white balance setting versus the actual lighting, as well as the effect on skin color. It is usually possible to correct color issues in software, but it's a step you can avoid by selecting the right white balance.

One more word on white-balance selection: For backlit subjects, I usually use the Shade setting. The rationale is that the sun is behind the subject, providing the majority of light (so normally you might be tempted to use the Sunny setting), but his face is in a shaded area—the shade provided by his own head!

Conclusion

White balance is a simple but important concept to understand and appreciate. As you progress through this book, in each chapter are more and more factors to consider. Rather than reading from cover to cover and then trying to remember and incorporate all of them at once, grab your camera and try out some photos using different white-balance settings. Intentionally take some photos with the wrong white balance and review the results.

The only bad thing about understanding white balance is that it will turn you into a white-balance snob. Every picture you look at that has the wrong white balance will jump out at you as too yellow or too blue. Try to resist the urge to tell everyone else what they're doing wrong. Let white balance be your little secret!

7Focus

If I could specify only one way in which sports photography differs from almost every other type of photography, it would be this: When shooting sports, your subjects are almost always in motion. Achieving focus on moving targets presents unique photographic challenges, but with the right gear, a little knowledge, and a lot of practice, you will quickly become proficient at it.

Like a skilled marksman, a good photographer develops the ability to track moving targets, anticipate their movement, and time his shot perfectly. The metaphor of marksman and photographer is actually a

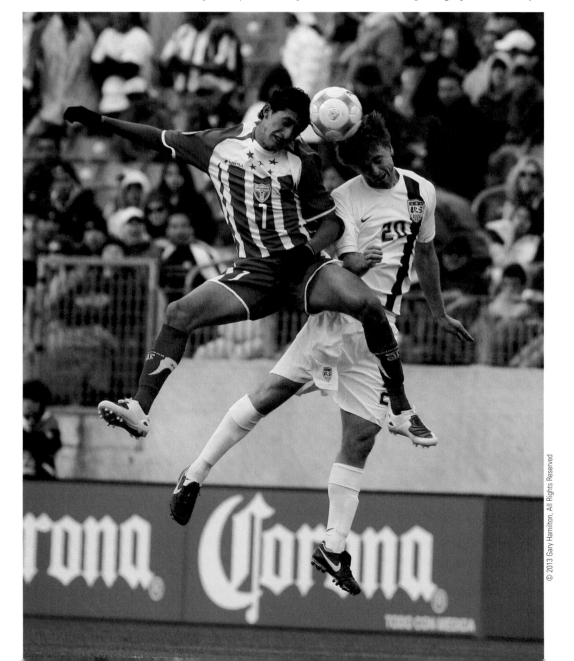

very useful one in several different ways. The marksman has a carefully selected, high-quality rifle, specifically designed for the day's intended purpose. He also has the ability to visually filter out things he doesn't want to shoot, such as trees in the foreground or perhaps other objects in his field of view.

To be a great sports photographer, you will need to become a skilled marksman. You'll need to develop a steady hand as well as the ability to quickly train your focus on a specific person or thing, such as a player running with a ball. These skills come easily with practice to most budding photographers.

In many action photos, you'll have a lot of things going on in the frame. You may have an athlete's face with an opponent's arm in the foreground, and a ball moving at yet another distance in the photo. Considering the concepts presented in Chapter 3, you should expect to shoot sports with a relatively wide aperture, such as f/4, which will produce a shallow depth of field. Not everything in that image will be in focus. So, how do you determine which item in view should be the subject of your focus? Given the choice of an athlete's face, an opponent's arm, and a moving ball, the best choice would normally be to focus on the athlete's face. Sports are about emotion and intensity, so the face is where you should focus your attention and your camera. It's great if you can get the ball in focus as well, but generally speaking, if the athlete's face isn't in focus, you won't have an appealing photo, so the face should be your priority.

"Generally speaking, if the athlete's face isn't in focus, you won't have an appealing photo."

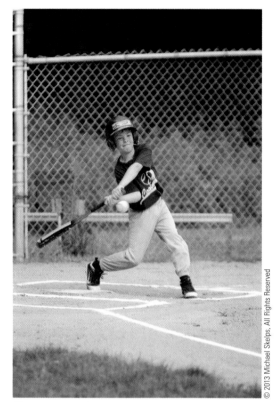

The athlete's face is in focus, while the ball is slightly out of focus.

Camera Auto-Focus: Shotgun or Sniper?

I'm going to return to the marksman analogy for a moment, because it will be helpful in illustrating a point. Shotguns produce a spray of small lead balls in a cone-shaped pattern of some width. Rifles, on the other hand, shoot a single projectile, precisely shaped and exiting the barrel with a specific rotation designed to maximize accurately. Shotguns are used when you want to hit something, but you don't know what exactly you might hit. Rifles are used when you have chosen some specific target you want to shoot.

Your SLR has settings corresponding to either shooting with a shotgun or shooting with a rifle. Looking through your viewfinder, you will see multiple auto-focus points available. Your pattern will vary from as few as 7 to as many as 61 auto-focus points, depending on your camera. By default, most cameras are set to use all auto-focus points. This is what I consider akin to the shotgun setting, where the camera will use an algorithm of some type to determine what items in the frame should be focused on. Just as the shotgun will surely hit something, the camera will try to focus in on something in the frame, but you just don't know what that will be. And at a low f-stop, the images will pay a heavy price if the camera decides to focus on the wrong thing.

I always think that the camera should assist me, but not make critical decisions that will affect my work, such as choosing what item to focus on, so I *never* tend to let the camera determine which auto-focus point to use. If you let the camera choose, it will tend to lock in on the nearest object in the shot. The last thing you want is for the opponent's arm to be in focus but his face to be out of focus. So, you should always select a single auto-focus point, effectively switching your camera from a shotgun to a rifle and putting you in control of exactly where you focus.

NOFEAR

By selecting a single auto-focus point, you can effectively "thread the needle," focusing your camera on your intended target and leaving items in the foreground out of focus. The ability to thread your photographic needle is very powerful in shooting sports, and you'll find that it becomes a technique you'll use frequently to achieve focus on your intended subject.

So which auto-focus point should you select? Quite simply, the center auto-focus point will be the most useful in the vast majority of cases. The center auto-focus point will tend to produce images that have a balanced composition, as long as you actually manage to get the subject in the center of the shot. And when your subjects are moving quickly, targeting them in the center of the frame will give you a bit of room to crop as necessary, should you get them slightly off center in the shot.

Your single selected auto-focus point will display in red through your viewfinder (in most cameras) as you look and focus through it. Ignoring everything else in the frame, background and foreground, you can use that red square like a sniper, threading through other players and objects to shoot and focus on exactly what you intend to shoot. You have much more control if you use this pinpoint to steer onto your subject, rather than relying on the broad swath of auto-focus points and hoping the camera will make the same decision as you would.

Lens Auto-Focus

Now and then I run into the occasional old-school shooter who doesn't fully trust auto-focus, surely due to some bad experience in the past. But today, technology had advanced to the point where quality brand-name lenses do an amazing job of quickly focusing on moving targets. It would be an exceptionally rare circumstance that I would even consider trying to capture a sporting event by focusing manually. A Nikkor or Canon L-series lens is so much faster and will so much more accurately achieve and track focus that you should rely on it instead of trying to keep up with the varying distances yourself.

"It would be an exceptionally rare circumstance that I would even consider trying to capture a sporting event by focusing manually."

Aside from auto-focus point selection, there are a few other auto-focus settings that you'll want to be familiar with when shooting sports.

First, make sure the lens's auto-focus is turned on. This may sound silly, but once in a while it gets overlooked. And looking through your viewfinder, it's not always visually apparent that auto-focus isn't operating. You turn auto-focus on or off by a switch on your camera lens. Be sure to add this to your checklist of routine parameters to review when you're setting up your camera, and don't just assume that it's already on. Second, you need to set auto-focus mode to track your subjects while they move. This is a setting called Auto-Focus Mode on your camera body, not the lens. There are probably at least three auto-focus modes on your camera. On Canon cameras, you'll generally see three settings:

- **Canon: One Shot / Nikon: AF-Single.** This is the mode you want to use for stationary objects and is not generally applicable to sports. The camera locks onto an object and won't readjust until you release the shutter-release button, recompose, and refocus on a new subject. Again, this is *not* the mode you'll use during sports photography.

- **Canon: AI Servo / Nikon: AF-Continuous.** This is the mode you want to use for moving subjects. Canon's name of this mode is a little cryptic. AI stands for Artificial Intelligence, and the word Servo means a mechanical control that moves with great precision. In this mode, the hardware and software in the camera will track the subject's position and motion, predictively and continuously focusing the subject as it moves, making small corrections along the way to keep focus locked on the moving target. It's kind of amazing just how well Canon and Nikon have produced gear that delivers solid auto-focus tracking and performance. AI Servo

and AF-Continuous are the modes you must select when shooting sports. Find one of these settings in your camera and stick to it.

- **(Canon Only) AI Focus.** This is an intermediate mode between One Shot and AI Servo. In this mode, the camera determines whether to use tracking or fixed focus. Consistent with my philosophy that the photographer should be making most decisions, rather than the camera, I avoid this mode.

Just to repeat and be perfectly clear, when setting up your camera for sports, you need to be in AI Servo for Canon or AF-Continuous for Nikon. Forget the others.

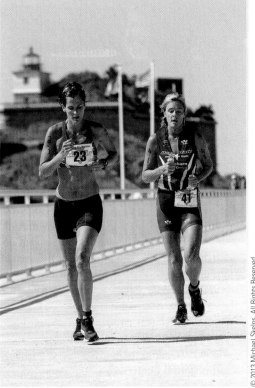

After you set your single auto-focus point and ensure that you're in AI Servo mode and your auto-focus is set to On, you'll quickly develop some technique with practice. Your shutter-release button typically pulls double duty by also acting as an auto-focus control. Looking through your viewfinder, and with a single auto-focus point selected, press the shutter button halfway and watch the auto-focus quickly shift to your subject. Point to something different to focus on, preferably at a different distance from the first object, and press the shutter button halfway again. Watch how the auto-focus adjusts to the new object. This will work whether your subjects are moving or stationary.

Particularly when focusing on a moving subject, give your camera a moment to track the subject before you fully press the button to release the shutter. Try saying to yourself, "Track, focus, shoot" while you practice following moving subjects, letting the camera take focus and then taking the shot.

One common mistake that photographers make while they're learning is to press the shutter-release button too quickly, with a bit of a jerking motion—without giving their camera the opportunity to track the subject. It takes only a fraction of a second, but when you're shooting, it may seem like a long time. You have to be a little patient and learn to give the camera an opportunity to achieve auto-focus. Track, focus, shoot.

"Track, focus, shoot."

While you're tracking and the subject is moving, you'll want to maintain your auto-focus point continuously on the athlete. It's best to keep the point targeted on the same part of the body—say, the head or the torso. It's easier said than done, but the better job you do at tracking, the better your focus will be and the more great shots you'll capture.

There's no substitute for practice. So go out there and practice making the auto-focus function of your camera work for you!

NOFEAR

If you're looking to reduce the load on your index finger during a hard day of shooting, here are two tips: Nikon shooters can take advantage of the Continuous-Servo AF (AF-C) setting, where the lens will seek focus continuously. Just be aware that this may drain your battery. Canon users, look in the Custom settings for your camera. You will be able to reassign one of the thumb buttons on the back of the camera to activate the auto-focus. Some photographers swear by this as a better method that is also less taxing on your trigger finger.

Panning

In sports, the goal is almost always to freeze the action so there is no motion blur. However, there is one specific technic called panning where you can shoot to intentionally capture the motion blur in an action image. When performed properly, the panning technique can dramatically emphasize the motion of an athlete differently and really convey the sense of motion and speed to your audience. Panning is the rare exception to keeping your shutter speed above 500.

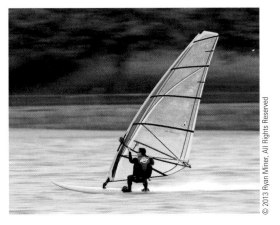

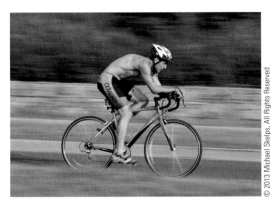

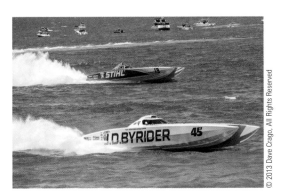

Panned photos stand in stark contrast to standard action photography. Using the panning technique is not simply a small tweak from normal action photography. Instead, it's a radical departure from the high-shutter-speed/low-f-stop norm. It's an entirely different approach to conveying action in a photo, and your decision to do some panning work should be a deliberate one. This technique is most effective when your subject doesn't have a lot of intrinsic motion (such as hands and/or feet moving), but they do have a lot of translational motion (moving past you). For this reason, panning is often reserved for shooting bicycle and auto racing. You may see panning used occasionally in shots of running or other sports, but in my opinion those panned images produce far less aesthetic value, and the percentage of usable shots is very low.

"Using the panning technique is not simply a small tweak from normal action photography. Instead, it's a radical departure from the high-shutter-speed/ low-f-stop norm."

The panning technique is straightforward, and with a little practice, you can produce good results quickly. But be forewarned: Your percentage of "keepers" when panning likely will be much lower than when you're using a standard high shutter speed. I only pan when I'm sure that I've already gotten enough good shots that I want at a shutter speed of 500 or higher.

The main difference in capturing panned photos, is to shoot with a lower shutter speed. Try a shutter speed of 30, for starters. Set your camera to Shutter Priority mode (Tv, which stands for Time Value, on Canon bodies, or simply S, for Shutter, on Nikon), and dial in a speed of 30. With the shutter speed set so low, you'll see the aperture automatically stop down to maintain a proper

exposure. (The f-stop increases, while the physical aperture size gets smaller.) Therefore, your depth of focus will increase, which means you won't have much bokeh. But that's okay, because you're not going to rely on the bokeh to make the subject "pop" in the image—the subject will stand out in contrast to the motion. The f-stop may even reach its limit, such as f/22 or f/32. On a well-lit day, you may actually still get too much light in the image. Setting your ISO as low as possible will help in preventing your camera from producing overexposed images without maxing out your f-stop.

NOFEAR

As action photographers, we don't often shoot with a high f-stop. In addition to producing a deeper depth of field, shooting with a high f-stop has one other distinct drawback: It makes any dust or debris on your sensor much more visible in your images. (Shhh...don't tell other photographers, but action shooters actually can get away with a bit of dust on their sensors because they always shoot with low f-stops.) So get in the habit of checking your sensor for dust and cleaning it periodically, especially if you're planning to pan.

When you pan, you're looking for relative movement usually from side to side in the frame. You won't get this if the athlete is coming toward you. To pan, you want to get the athlete going *past* you, ideally traveling perpendicular to your line of sight. A classic application is to photograph a bike or car going past you.

Practice tracking your subject, moving your camera and keeping the athlete centered in the frame as you time your shot. Try to anticipate the moment when your subject is nearest you and is in his or her peak movement past you. You want your motion to be smooth as you track your subject. Don't whip or jerk the camera around. Try to keep it smooth and steady. For that small fraction of a

second that your shutter is open when panning, it's the photographer's job to smoothly track the subject in the same position in the viewfinder. The better you do at accurately tracking the athlete, the better the results will be. The better lenses have stabilization features to help you capture panned shots, effectively smoothing the photographer's motion as you track the subject. Although image stabilization isn't required to get these shots, it does make it a bit easier, so plan on using that feature if you have it available. For Canon L-series lenses, use Mode 2 of image stabilization, which is specifically designed for panning. High-quality Nikon lenses with vibration reduction have built-in panning detection. Using these lenses and the appropriate stabilization settings, you'll have even more success in producing stunning panned shots.

Because you're usually capturing horizontal movement in these photos, it's often best to shoot these pictures in the landscape orientation.

When you practice shooting in this mode, be patient while you develop skill and experience. Look at your LCD screen frequently to see how your images look. The most common mistake is to not track the athlete smoothly and evenly, so you may see motion blur of the subject in these images. Of course, the whole point of these photos is the motion blur—but of the background, not the subject.

NOFEAR

Try a number of different shutter speeds as you conduct your panning photography. Too slow a shutter speed, and the motion blur will appear on the subject, reducing the image's appeal. Too fast a shutter speed, and the motion blur will become less noticeable. The faster your subject, the lower shutter speed you can use. Work to find the right shutter speed to produce the best panning results for your specific situation.

When you've practiced and developed some skill in this panning technique, you'll definitely give your friends something to ooh and aah about. In fact, I think panning photos are some of the most dynamic and visually appealing photos you can take.

Conclusion

Achieving sharp, crisp focus is one of your most important tasks as a photographer. Stick to the following summary points for focusing, and your results will far outpace those of your point-and-shoot and even consumer-SLR counterparts.

- Ensure that your lens is set to auto-focus, not manual.

- Ensure that you have the right auto-focus mode selected.

- Choose a single auto-focus point, usually the center.

- Learn to patiently track your subject for a moment before releasing the shutter.

If you're shooting bikes or cars and you want to try something different, panning adds an element of variety to your sports portfolio, but at the risk of producing fewer keeper images. It's best to shift to panning shots only after you've gotten a satisfactory number of tradition stop-action photos. Slow your shutter speed and use the image stabilization in your lens if you have it, and you will produce some really cool shots that convey and accentuate the sense of motion in your images.

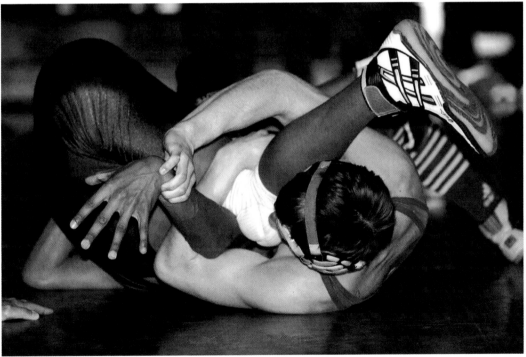

"When you've practiced and developed some skill in this panning technique, you'll definitely give your friends something to ooh and aah about."

8 Framing and Composition

The terms "framing" and "composition" describe what you capture in the viewfinder through zoom and orientation and where you position the subjects within your image. What's included in the shot and what's excluded? These questions are asked of the photographer in every shot taken, action or otherwise.

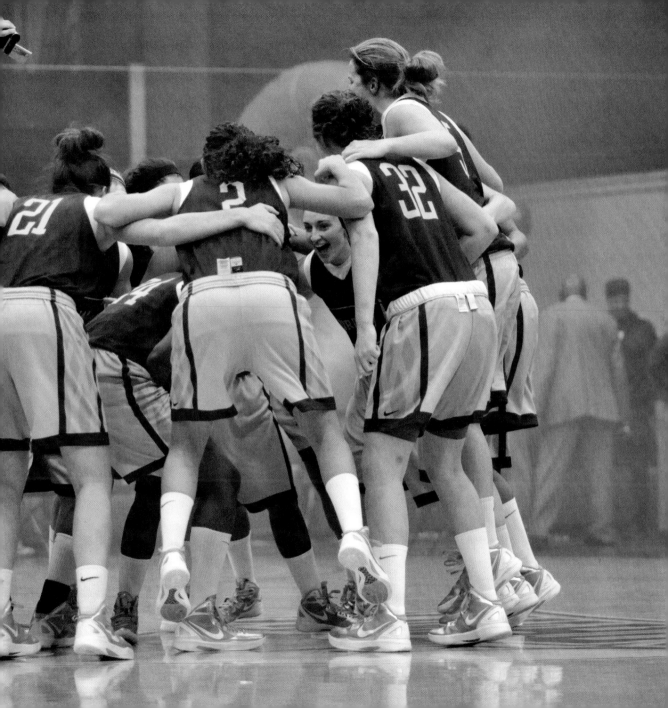

In the worlds of portrait and landscape photography, you may spend a lot of time making decisions about framing and composition based on many different artistic considerations. You might want to convey the essence of the location, if you regard the context of the location or background as a particularly important element of the photo. In many types of photography, you will have the opportunity to explore creative framing techniques. You may invoke the Rule of Thirds, in which the subject is positioned in one of four positions slightly off-center, one-third the distance from the right or left and top or bottom. In sports photography, the most common approach is even simpler. Seldom is there a need to apply the Rule of Thirds or to creatively compose the scene. The simple, straightforward approach is to center the athlete in the viewfinder (with some room above and below for cropping). It's *simpler* but definitely not easier! Remember, in sports, your subject is moving. It can be difficult to keep the athlete centered in your eyepiece.

Why limit sports photography to this type of framing? The simple answer is one of pragmatism, having to do with your camera's auto-focus points. As discussed in the previous chapter, the ability to isolate a single athlete depends largely on your ability to "thread the needle" using a single auto-focus point. Though you can change the auto-focus point, it's inconvenient at best to do that, particularly in a sports-shooting environment, where things are moving rapidly. In most cases, when a great shot is developing in front of you, you really won't have time to adjust the auto-focus point. That's not to say that you never will, but as you begin to develop your sports-photography skills, I suggest you build your foundation upon the simplest and most flexible technique of using a single auto-focus point selected—the center one. And because you're using the center auto-focus point, it naturally lends itself to shooting the athlete centered in the frame.

Go Vertical

For thousands of years, we human beings have stood upright. That is, we're naturally vertical creatures, more so than horizontal ones—at least when we're active. And while some of us may tend to prefer relaxing horizontally, that's less often the case for the athletes we're shooting. Whether you're taking your first picture with a point-and-shoot camera or you're taking a professional photo using a $6,000 rig, I offer the same advice: Shoot the athlete in the vertical orientation in most cases. That means rotating the camera 90 degrees counterclockwise from its default horizontal position so that the longer dimension of the viewfinder is oriented vertically and the shorter dimension horizontally. This new orientation is called "vertical" or "portrait" and will be used in the majority of your action shooting.

"Shoot the athlete in the vertical orientation in most cases."

Shooting vertically allows you to zoom in closer on the athlete, having her fill more of the frame. If you shoot an athlete in landscape orientation, you necessarily wind up leaving a lot of margin on the right and left sides of the image. By rotating your camera and shooting vertically, it leaves less of the peripheral elements in the photo, which usually don't add to—and may even detract from—the overall photo composition. It surprises me how many people hold their cameras in the horizontal orientation. Maybe this is because when you turn the camera 90 degrees, everything on the back (text, controls, LCD) is sideways. Also, the shutter-release button becomes a bit less comfortable to reach when shooting vertically. If you follow this one basic principle, the quality of your everyday action photography will improve dramatically! Of the key concepts I hope you'll take from this book, this is one of the most important: Go vertical!

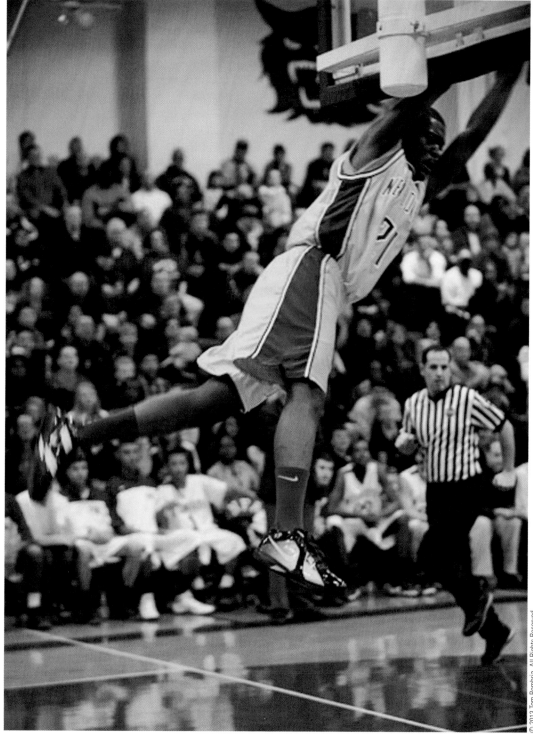

Framing

The most common framing approach for sports photos is full-body framing—that is, capturing an athlete from head to toe in the frame. There's a reason why this framing is so common: It captures all the action and movement of the athlete. A great action photo often includes the feet in the frame. Sometimes the athlete's feet are off the ground. I love that!

In most sports photography, it's a good idea to go for full-body framing, where you include the athlete's entire body in the shot. The question is how far to zoom in or out. Clearly you don't want to cut off the athlete's head or feet in your shot, so that establishes a maximum zoom from which you should zoom out a bit if possible. So what's the minimum zoom, or how far out can you zoom before it's too far out?

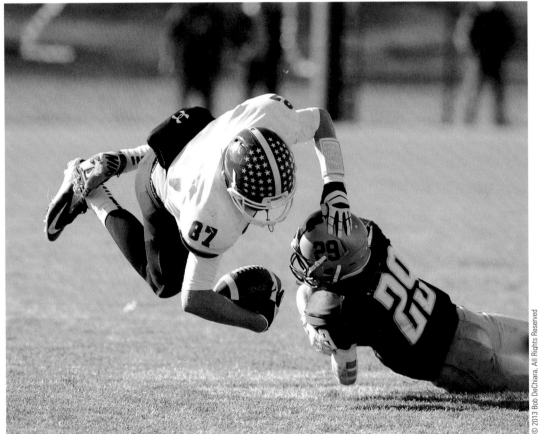

"A great action photo often includes the feet in the frame."

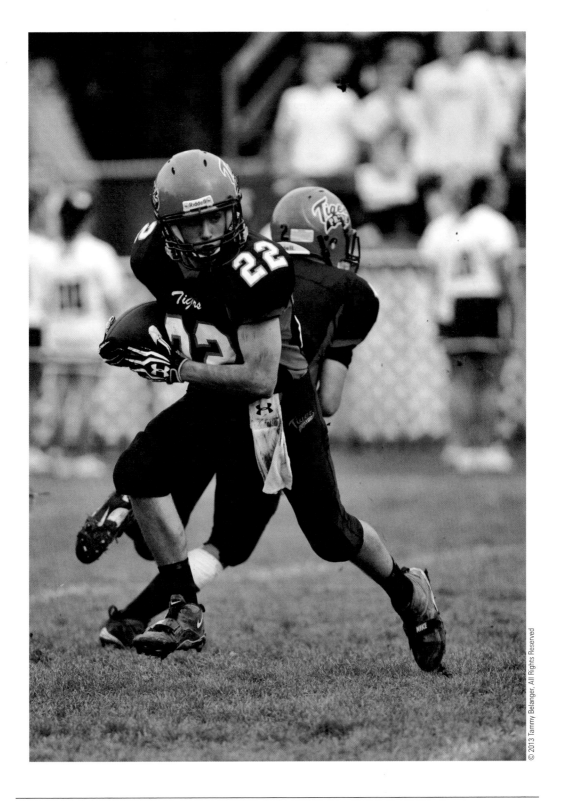

I use a rule of 2/3—that is, the athlete should take up 2/3 of the frame from head to toe. That leaves about one-sixth of the frame above the athlete and one-sixth of the frame below. You can use the landmarks in your viewfinder to help you determine when you're zoomed for roughly the right proportions of your subject. It's not an exact science, but try to get a rough estimate of where the middle 2/3 of your vertical frame is and use the overlay on your viewfinder to help you achieve that general framing.

One of the biggest mistakes I see budding sports photographers make is capturing the athlete too small in the frame. Sports photography is about capturing energy and emotion, freezing a moment in time, capturing details unseen by the naked eye in real time. So, zoom liberally and be patient about waiting for the action to get close to you. Your best shots will happen with the subject large enough in the frame to get plenty of detail. Two-thirds—no less! Remember the motto from your history books: "Don't fire until you see the whites of their eyes!" The same applies in sports photography.

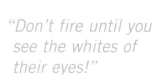

"Don't fire until you see the whites of their eyes!"

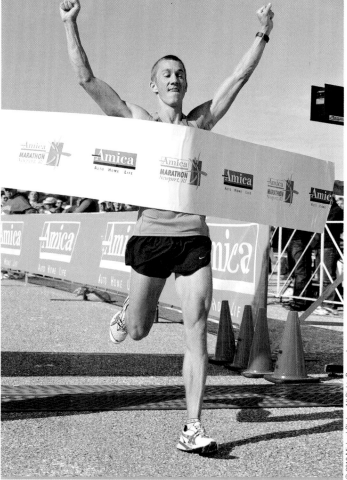

When you're shooting sports, think ahead a bit. As you look through your eyepiece, think about not just how the shot looks in the viewfinder, but about the final output of the image. You may not know exactly where and how your image will show up—it could be on a small print, such as a 4×6 or 8×10, or it could even become a magazine cover. Recognize the different potential output shapes and sizes and anticipate the requirement to crop your images.

Try to ensure that the picture you take has enough room to be cropped, and leave a little margin accordingly so that feet and heads aren't cropped.

For this reason, don't get *too* close in full-body framing, as you anticipate cropping in the final product. As a rule of thumb, I assume that anything I'm photographing will be cropped as an 8×10—usually a worst-case cropping situation. Most cameras have an aspect ratio of 1.5 (height divided by width), and an 8×10 has an aspect ratio of 1.25, so the original frame is more rectangular and the finished product will be more square in shape. If your photo is taken to accommodate an 8×10 crop, then less-obtrusive crops, such as 5×7s or 4×6s, won't present a problem.

Aspect Ratio

Aspect ratios occur in various technical disciplines, including photography. You'll find aspect ratios in televisions and airplane wings, among other places. Regardless of the application, an aspect ratio is the length divided by the width of an object. A perfect square has an aspect ratio of one, whereas objects with a rectangular shape, where the length is greater than the width, have an aspect ratio greater than one.

In photography, you'll commonly encounter two aspect ratios. The first is the aspect ratio of the viewfinder. Most digital SLRs have a 3:2 ratio of width to length (landscape orientation). This is normally referred to as a 1.5 aspect ratio. Many print shapes have a different aspect ratio. For instance, the standard print sizes of 5×7 and 8×10 have aspect ratios of 1.4 and 1.25, respectively. Notice how these two print sizes have a lower aspect ratio than the viewfinder, and they are closer to a square in shape. Understanding aspect ratios of potential print sizes is an important consideration as you frame images in your viewfinder and anticipate the possible need to crop your images.

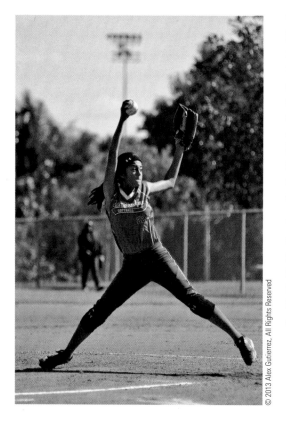

When you intentionally frame athletes for full-body shots, anticipate the need to crop a vertical rectangular frame closer to a square, and know that you'll have to do some trimming off the top and/or bottom. Obviously, you don't want to crop someone's head, but if the shot doesn't have enough margin, you'll have to crop out the feet, even though you made a special point of including them in the shot. By planning ahead and framing your shot to include some margin at the top and bottom, you can eliminate the need to crop out key parts of the photo.

You actually have a fairly narrow range in which to operate. Shoot too loose, and the subject will be too small, and you will sacrifice detail and visual interest. Shoot too tight, and you risk compromising the overall shot by having to crop out the feet. Practice your framing, and you'll learn the ideal amount of margin in no time.

"Practice your framing, and you'll learn the ideal amount of margin in no time."

Don't Shoot the Head

If you've already taken to heart the previous section, then this may be a bit redundant. But too many new photographers make this mistake, so it bears mentioning here. We all realize that faces are important in action photography, but that does not mean that a face has to be in the center of the frame. If you put the center auto-focus point smack-dab in the middle of an athlete's face, that means the upper half of the shot will be just background, often empty sky. It's essentially wasted space in your image, as you have filled only half the frame with your subject. If you're shooting with full-body framing, you should be aiming the center auto-focus point at the athlete's belly button—or at least where you think the belly button would be. If you're shooting with upper-torso framing, then you can aim at the upper chest (think of the collarbone area). If you happen to make this mistake, you'll quickly realize it when you're reviewing the pictures. This is an easy adjustment to make as long as you're conscious of the fact that you don't want to leave the top half of the frame empty.

Upper-Torso Framing

If you're really close to the action or if you're shooting with a long prime, such as 300mm or 400mm lens, you may find yourself too close to capture head-to-toe shots. Or, during a break in the action, perhaps you want to get a closer shot of the athlete, concentrating more on his face and expression than on his action. In these cases, a good alternative is to frame your shots to include the athlete's upper torso. This approach will capture more detail of the athlete's features, and it's often a great way to convey his concentration. Because the athlete is necessarily large in the frame, upper-torso framing is very difficult to achieve for athletes in action.

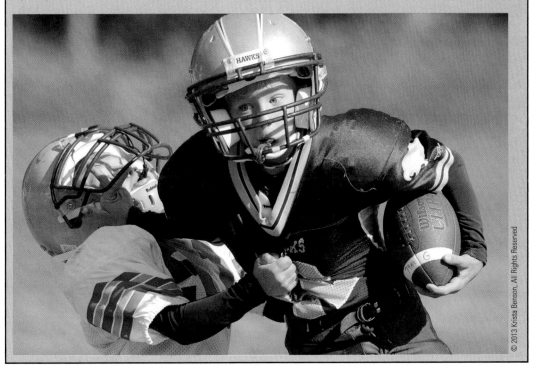

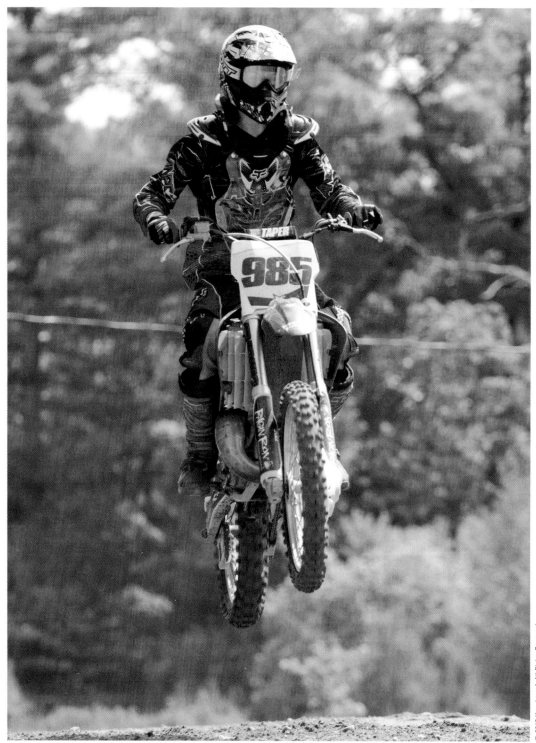

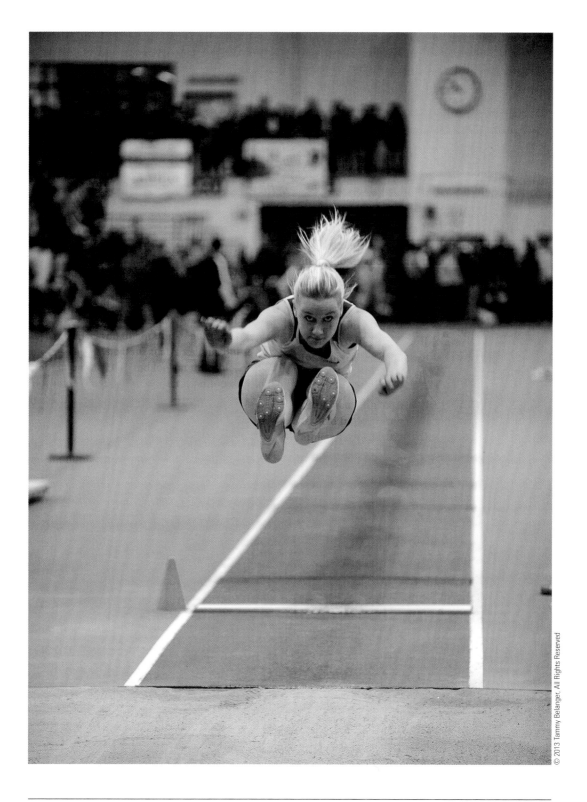

Tracking a moving target can be tough at first. Your best friend is practice. You'll be amazed by how quickly you'll develop proficiency, even during your first shoot. Concentrate on keeping your center auto-focus point locked on the center of your subject, anticipating the athlete's motion. In a fast-moving sport, it's very difficult to follow the action and try to capture it with proper framing. But the fact that it's difficult is one of the reasons why I love to do it.

Landscape Framing

In the vast majority of sports photography, I recommend using portrait orientation, as you'll capture the human body in its vertical state. However, there are certainly instances when a landscape orientation can be appropriate for sports. Particularly when you're photographing a scene with multiple athletes, landscape images can be a better framing choice. Landscape framing can also be helpful when you want the image to contain the context of the background.

NOFEAR

Keep an eye on the other parameters in your viewfinder, even as you're moving the camera to keep your subject properly framed. There's quite a bit to keep track of: shutter speed, aperture, exposure compensation, and number of frames remaining in the buffer. Train your eye to scan these parameters periodically. In particular, keep your eye on shutter speed and make sure it doesn't go below 500.

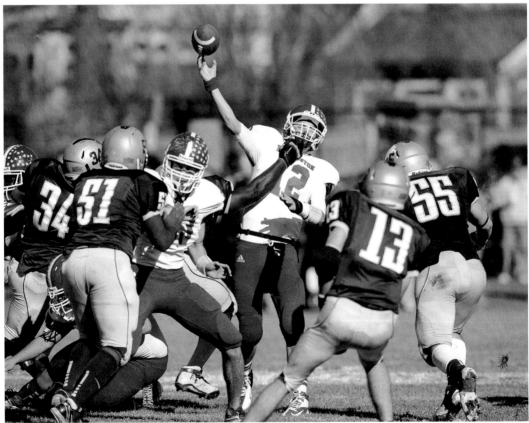

When you do shoot in landscape orientation, one of the challenges you may encounter is where to put the auto-focus point. If you're shooting landscape to capture two players in the scene, a center auto-focus point often becomes problematic. If the center point of the image is between the athletes, then you may find your camera focusing on something in the distance. The solution: Switch your auto-focus point to an off-center point that will lock on one of the athletes. This will let you achieve focus on one athlete while maintaining better balance in your photo's composition.

I suggest leaving it off-center only for the specific shot you're trying to get and then moving it back to center right away, as the center point leaves you the most flexibility and margin as the action quickly unfolds before you. For this reason, I usually shoot individual athletes in a portrait orientation and with a center auto-focus point selected—this approach usually yields a better batch of quality photos than shooting in landscape. Landscape framing is also called for when you're shooting a large number of individuals, such as in a team photo.

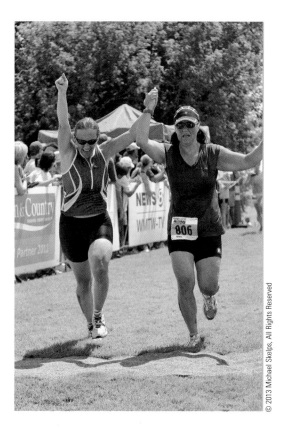

NOFEAR

When you're shooting multiple athletes, you must be able to select an off-center focus point quickly. You'll also need to be able to switch it back quickly. Familiarize yourself with your camera's controls for auto-focus point selection and practice switching that point. Switch it off center. Take a few shots. Switch it back to center. Repeat. After a little practice, you'll be able to switch back and forth with little effort.

Conclusion

As you take pictures, always think ahead about the best way to frame those athletes in your viewfinder. As you practice taking shots, think about ways to avoid wasted space (portrait orientation), leaving sufficient margin for cropping. Also, think about where your auto-focus point is set, and if you have time, consider shifting that point to lock focus on one of the subjects in an image that includes multiple athletes.

Now it's time to take all the advice and theory presented so far and put it to practical application. Your homework assignment is to find something outdoors in motion to shoot. A pickup basketball game, a local road race, a youth baseball game— anything will do. Grab your camera and let's talk about shooting in ideal lighting conditions.

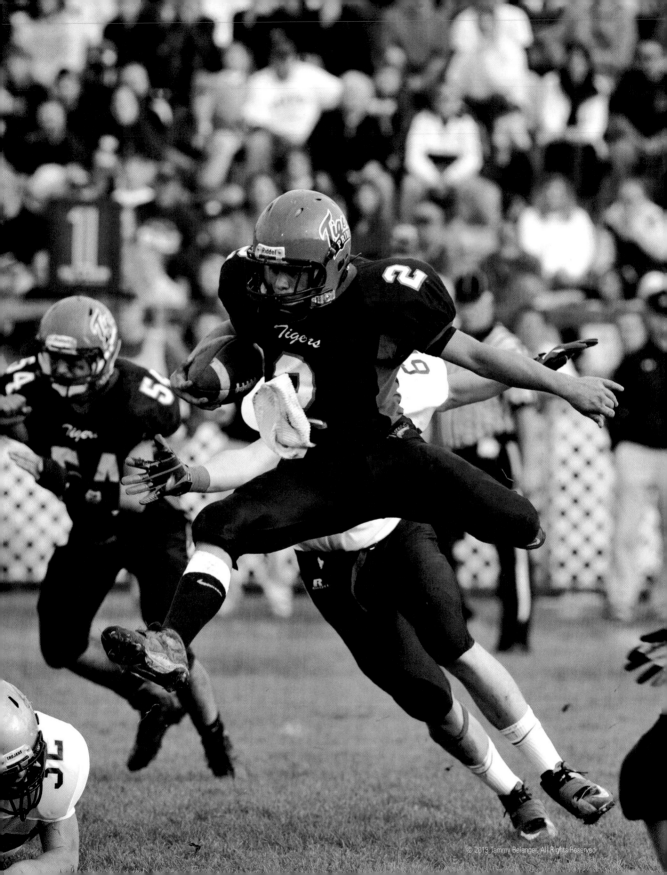

Shooting in Ideal Conditions

9

Congratulations! You're at an exciting point in the process—your first bona fide action-photography shoot. You've brought quality equipment that's capable of capturing high-quality action photos, and you understand the basic technical aspects of shutter speed, ISO, and aperture. Now it's time to get to work on your first sports photography assignment.

Your Subject Matter

This chapter is about applying your knowledge and equipment to shoot moving subjects, maybe for the very first time. Developing your action photography skills is a journey that you'll take over time. During each step of the journey, you'll practice, learn, have some successes, and make some mistakes. While you're developing fundamental action photography skills, I strongly recommend that you take frequent opportunities to shoot action wherever you can. Make this a frequent hobby. Have some fun with it! Each shoot might only be for a few minutes. What's important is that you regularly create opportunities for yourself to hone your sports-shooting abilities. Shooting a few times a year won't really give you the chance to experiment, learn from your mistakes, and become a capable action photographer. If you're near a high school, college, local park, or sports facility, you should be able to find plenty of opportunities to shoot athletes in motion.

I strongly recommend seeking out permission to photograph the event first. Find out who the league president, school representative, or event director is. In my experience, it is generally very easy to get permission to photograph an event. A simple introduction and explanation that you're taking sports photos go a long way with most people. If you're open to sharing your images with them, you'll have an even better chance. With school and recreational sports, it's an easy sell. Sometimes I just wave to one of the coaches and say, "I'm going to get some shots from over here!" Works almost every time. In the rare case that you get shot down, thank the person for his time and look for another opportunity.

Depending on what you're looking to photograph, such as a football or baseball game, permission also usually gets you a better location, such as beside the dugout or a great sideline position. Asking permission is usually a first-time-only requirement. If you shot last week, no one will

question when "the guy with the camera" shows up next week. You'll probably make some friends in the process! So for sports with a formal schedule, such as the local high school team or sports league, if you're in once, you can usually get in whenever you want. After coaches, players, and spectators see you a few times, your newfound identity as the "camera guy" (or gal) will help you build opportunities to photograph other events.

Before you even take off the lens cap, survey the situation, making particular note of the lighting. You always want to be aware of and thinking about the lighting, in particular three questions: What is the source of the light, how bright is it, and what direction is it coming from? To the extent that you can, put yourself in a position where the primary light source (usually the sun) is at your back.

This is one of the most important things you will do as a photographer. You should always be thinking about this. Look for situations where the lighting is in your favor. As you gain experience, you're likely to find yourself shooting in both favorable and unfavorable conditions. But as you start out, let's stack the deck in your favor and look for a situation that is favorable to photography. There are two conditions that I consider more or less ideal: front-lit subjects where the sun is at your back and also subjects under cloudy or overcast skies. As you're scoping out possible situations in which to shoot, check the weather forecast and see whether one of these ideal situations will present itself.

If you choose to do your first action photography under less than ideal conditions, that's fine. But starting out with favorable lighting will let you get some quick positive results that help you build

confidence. It's always good to start out with a small success so you feel good going forward. Shooting in ideal conditions will also let you concentrate on some of the more basic skills, such as tracking and framing your subject, without having to worry so much about other aspects, such as how to get proper exposure. The two lighting scenarios, cloudy and front-lit, should both be explored and practiced. So plan on at least a couple of different days to try out your skills. Be aware of the weather, and when there's a chance to shoot under different conditions, grab your camera and find something in motion to shoot.

Front-Lit Conditions

To non-photographers, it's often surprising to learn that a bright, sunny day can provide some of the most difficult lighting conditions to shoot under. Depending on the angle of its location, the sun can be your worst enemy at times, but at other times it can be your best friend.

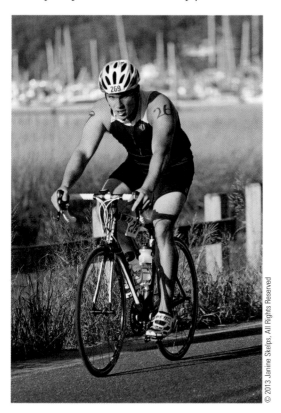

"Depending on the angle of its location, the sun can be your worst enemy at times, but at other times it can be your best friend."

Early or late in the day, as the sun moves low in the sky, it's a great opportunity to shoot. With the sun relatively low at your back (in other words, *not* high noon!), you'll be able to capture amazingly warm skin tones. In the first or last three or four hours of the day, put the sun at your back, and your shadow will be cast in front of you. However, that doesn't mean you have to shoot in the exact direction of your shadow. I would consider anything within about 30 degrees left or right as ideal. This is absolutely critical to great photography, and you should consider it at *every* shoot, starting with your first one. As a sports

shooter, you'll have other factors to consider, such as where the action is taking place and what your best position is with respect to the athletes and the field. You'll often have to make your best decision about where to shoot, taking into account both the angle of the sun and the best position at the field. But especially for your first shoot, do your best to obtain a position with the sun at your back that still gives you a good view of the athletes as they play.

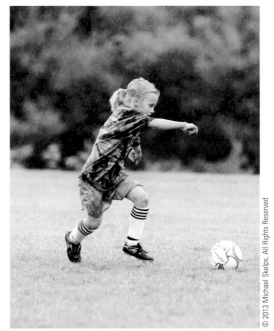

On a cloudy day, shadows are virtually nonexistent. With the proper white balance selected (cloudy, of course), colors can be quite vivid.

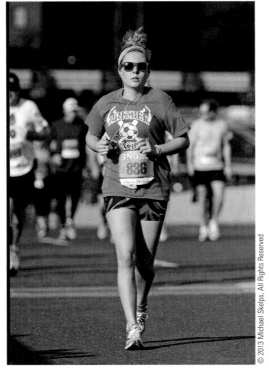

A front-lit shot taken with the sun behind the photographer and just a little to the left. Note the rich skin tones and vibrant colors.

Shooting under front-lit conditions with a low sun not only produces great shots, but it also is one of the *easiest* situations you'll find yourself working in as a photographer. I wish every event I cover could be like that. Under such ideal conditions, the camera settings will be very straightforward. I suggest the following:

- Mode: Aperture Priority

- Aperture: f/4.0

- ISO: 100 to 200

- Shutter speed: Monitor to keep it greater than or equal to 500

- White balance: Sunny

- Auto-focus: AI Servo

- Exposure compensation: 0

When you're set up in this situation, you'll be successful very, very quickly. Just wait and see. Take some shots and see how they look—even a stationary subject, just to check out your exposure. Take a look at your histogram, which should span the entire width from shadows to highlights. Zoom in and check out the skin tones. See the amazing richness of the colors in your shot.

Once you've established that your camera is producing correctly exposed images, start shooting the athletes, trying to stay within the 60-degree cone around your shadow for now. Every sport is different, but each one will have motion. Try to anticipate the action a bit, such as a baseball batter swinging or a runner in motion or a player jumping. As the game occurs, try to predict the moment that you want to capture, such as the ball contacting the bat. Practice tracking the athletes as they move, paying careful attention to framing the athlete properly and leaving some room for cropping. It will take practice, but don't worry—you'll quickly establish some basic skills, and you'll improve consistently over time.

Work your zoom to properly frame your subject, remember to let the auto-focus take hold, and press the shutter-release button fully. Let your camera take a few images in burst mode. Especially at this early stage, take advantage of the opportunity to look at your images on your camera's LCD screen. Zoom in and look at the details of the image. Critically assess the histogram and, if you need to, make the necessary exposure-compensation adjustments.

By following these settings, you may be surprised by how quickly you'll be able to capture images of impressive quality. You should see sharp focus and details of the subject. You will also see a separation of the subject from the background as a result of shooting with a wide aperture. You'll see a soft, blurry background in contrast to the sharp focus of the athlete.

The moment of taking your first high-quality action photos is a special one. It can be a real awakening when you view your photos for the first time on the camera LCD. And if you think they look good on the back of your camera, just wait until you see them on a computer screen or, better yet, in a high-quality print. Take some time to savor and reflect on this. This is a moment that many photographers remember for the rest of their photography careers—the first time they captured high-quality sports images.

"This is a moment that many photographers remember for the rest of their photography careers—the first time they captured high-quality sports images."

While you're admiring all the things you like about your pictures, you will probably see some things on which you'll want to improve—for instance, your framing or your ability to maintain focus on a moving subject. I've seen photographers get good at action photography very quickly, but I've never seen anyone shoot so well so early that there weren't any aspects of their photos on which they wanted to improve. I hope that the things you like about your early sports images are sufficient to motivate you to want to improve. But don't let the problem areas of your photos discourage you. Seeing things that can and should be improved is all part of the learning process. How quickly you identify these aspects and how quickly you can learn from them and make the appropriate adjustments will determine your speed of progression as a sports photographer.

As you're viewing your images, you may want to ask yourself:

- Is my subject properly exposed? Or is he or she too bright or too dark?

- Is my subject centered in the image?

- Is there too much empty space in my images?

- Have I left sufficient room for a worst-case crop?

- Are my images sharply focused?

Remember, becoming a good sports photographer takes time. Consider that a good sports photographer must be adept at shooting in a wide variety of conditions. It stands to reason that it will take some time to learn to shoot in the wide gamut of lighting conditions, not to mention to learn how to make adjustments and improvements before shooting in those conditions again.

Cloudy/Overcast Conditions

Another ideal lighting scenario is shooting under cloudy or overcast skies. I'm not talking about partial or intermittent clouds—I mean full clouds across the sky. These are actually my favorite conditions under which to take photos, as long as it doesn't rain!

Think of a portrait photographer who uses a large softbox or perhaps multiple softboxes or umbrellas. He wants to get the light coming from as broad an area as possible, to have the light coming from a wide variety of directions. That's just what an overcast sky does. It smooths out the light and makes it come from a wide variety of directions, effectively serving as an infinite softbox with light coming from every direction. The result is that shadows are virtually nonexistent, and you won't have to deal with any harsh bright and dark areas in your photos.

The only downside to these conditions is that clouds reduce the amount of available light, so you'll need to shoot with a higher ISO, such as 400 or 800. With the state of current dSLR sensors, this usually won't be significantly detrimental to your photos. Only if the clouds are extremely dark and thick or you're shooting very early or late in the day does this become an issue. In these cases, the issue becomes one of very low available light. We'll address those situations in Chapter 10, "Low-Light Photography."

To shoot on an overcast day, try the following settings:

- Mode: Aperture Priority

- Aperture: f/4.0

- ISO: 400 to 800

- Shutter speed: Monitor to keep it greater than or equal to 500

- White balance: Cloudy

- Auto-focus: AI Servo

- Exposure compensation: 0 or +1/3

Again, in this ideal lighting situation, you'll get some great photos very early on. Just remember to increase your ISO to get your shutter speed at 500 or higher. I typically find than an ISO of 400 is sufficient in many cases. Push it a little higher if your shutter speed is too low, but no higher than necessary to get 500.

Also, make sure your white balance is set to Cloudy. Shooting under cloudy skies with the right white balance can produce true, vivid colors. Don't squander this opportunity by shooting under the wrong white balance and having a weird color cast on your photos.

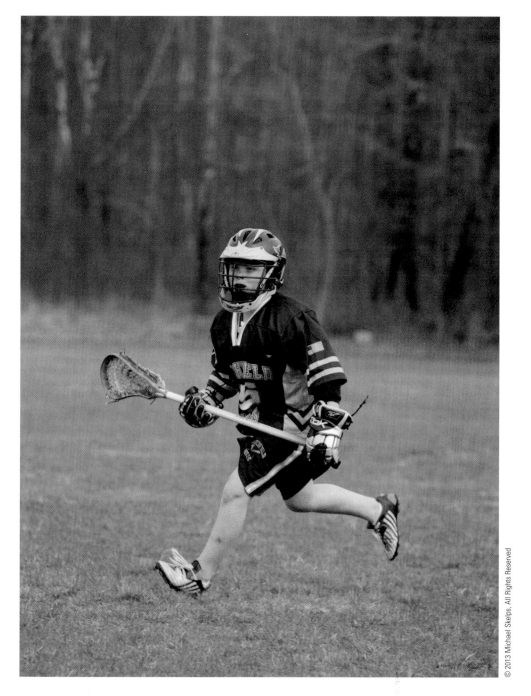

"Shooting under cloudy skies with the right white balance can produce true, vivid colors."

I have also noticed that on some cameras, shooting under cloudy skies results in a slightly underexposed photo as compared to shooting with the correct settings under sunny conditions. A good look at your histogram and preview image will clue you in as to whether your images are too dark. In theory, the camera's light sensor and exposure algorithm should adjust to give you properly exposed images under these conditions. However, if you're seeing a general darkening of images taken under cloudy skies, it's easy to fix. Simply apply some slight positive exposure compensation, such as +1/3, and you should see your images brighten up. Just make sure that doesn't knock your exposure below 500—increase your ISO to account for that if it does.

Photographers love to have either front-lit or cloudy/overcast conditions when they're working, because these conditions can result in some of the best action photos possible. When you have opportunities to shoot in conditions like these, take advantage of them and be grateful.

Conclusion

You'll achieve your quickest and best success by shooting when the lighting conditions are most favorable. Weighing all other factors, do your best to put the sun at your back. Though it isn't always possible to do so, you should quickly get in the habit of looking for the best opportunities for great lighting. And by shooting under ideal lighting conditions when you're starting out, you'll have a chance to concentrate on your fundamental skills, such as framing and tracking your subjects. And all other things being equal, the photographer who positions himself with better lighting will always produce better results.

But such isn't always the case. Sometimes there's just not going to be as much light available as you would like to have. So in the next chapter, we'll discuss how to make the best of the challenging situation of low-light photography.

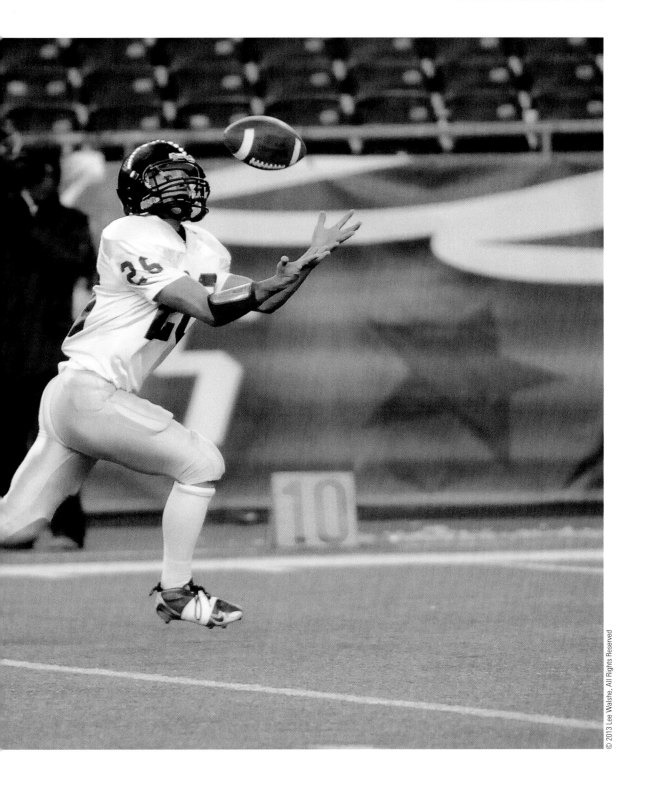

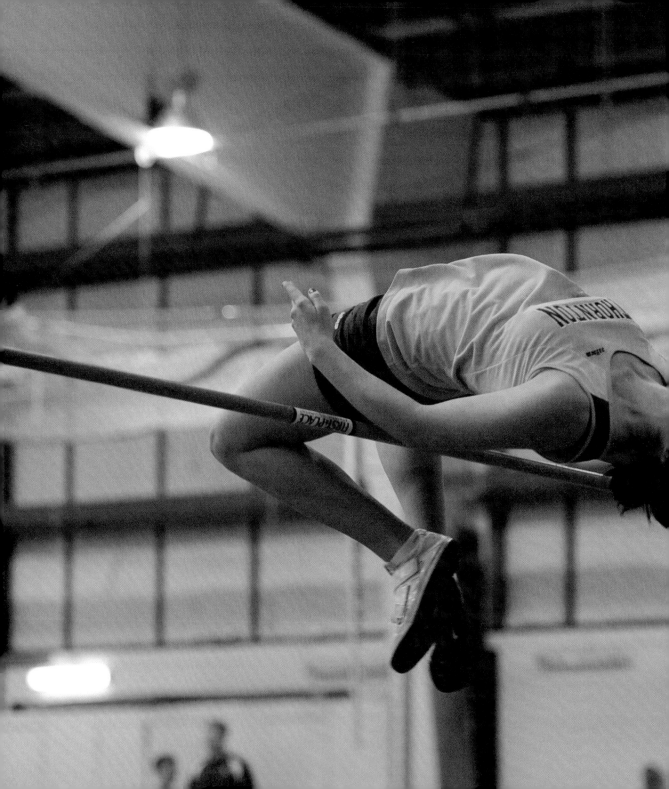

10

Low-Light
Photography

I've already mentioned that you
should always be thinking about light.
What is the primary light source?
Where is it coming from? And how
much light is there?

Sports photographers often shoot outdoors in daylight and therefore have plenty of light. But what happens when we just don't have enough light? Let's talk about a case where you're shooting an event and the light is gradually diminishing— say, a game that starts in the late afternoon and extends into early evening. Let's say you're shooting in Aperture Priority mode, and you're letting the camera control the shutter speed. As the evening wears on, your camera will leave the shutter open longer and longer on each shot as it became progressively darker. If you aren't a conscientious photographer (even though I know you are!), your shutter speed will continue to drop from 1000, past our minimum action value of 500, to lower values such as 100, 60, 20, or whatever is necessary for the camera's circuitry to believe it is achieving proper exposure. As the shutter slows, you will begin to actually hear the separate motions of the shutter opening and closing. (As a sports photographer, you should never hear the shutter open and close as two distinct sounds. You want to hear one smooth motion including the shutter's open and closing actions.) If you were to review the series of images shot during the evening, you would witness gradual progression from sharp stop-action to substantial motion-blur as the shutter slowed to unacceptably low speeds.

As an alert and conscientious action photographer, you'll never allow that to happen. You know that your shutter speed should always stay above 500 for you stop the action in your frame with no motion blur.

"You know that your shutter speed should always stay above 500 for you stop the action in your frame with no motion blur."

Obviously, you can use your levers of exposure— aperture, shutter speed, and ISO—to deal with a situation in which there is limited light by opening your aperture, reducing your shutter speed, and increasing your ISO. However, you should consider the clear tradeoffs and concerns when using aperture, shutter speed, and ISO as tools to gather more light.

- Opening your aperture (lowering your f-stop) will result in a shallower depth of field and may cause you to have a higher percentage of "tossers" in your action-photography shots.

- Lowering your shutter speed will eventually introduce motion blur to your subject. The faster your subjects are moving, the more noticeable the motion blur will be for a given shutter speed.

- Increasing your ISO value will result in more digital noise, particularly at ISO values of 800 and higher.

So the question becomes, in what sequence should you make these changes? Is it better to open your aperture first, before increasing your ISO? When does it make sense to start letting your shutter speed dip below 500 as a means of capturing more light? The answer is: It depends. Primarily, it depends on the noise profile of your sensor at higher ISOs. It may also depend on the nature of your subject and whether its motion will allow you to decrease the depth of field by fully opening your aperture or slowing your shutter. You'll need to be familiar with your particular camera's sensor so that you know at what point digital noise becomes a concern. For many cameras, an ISO of 800 is where the noise in the images starts to become noticeable. For other cameras—particularly recent models—you may be able to go up to 3200 or 6400 before noise becomes a factor. So, a simple first measure will be to start bringing up your ISO, particularly if you're starting from a nice low ISO, such as 100 or 200. Increasing your ISO is a simple and practical way to capture more light as long as noise isn't a factor at the ISO in question. I'll increase my ISO to 400 without even considering any noise issues, as they're completely unapparent from 100 to 400.

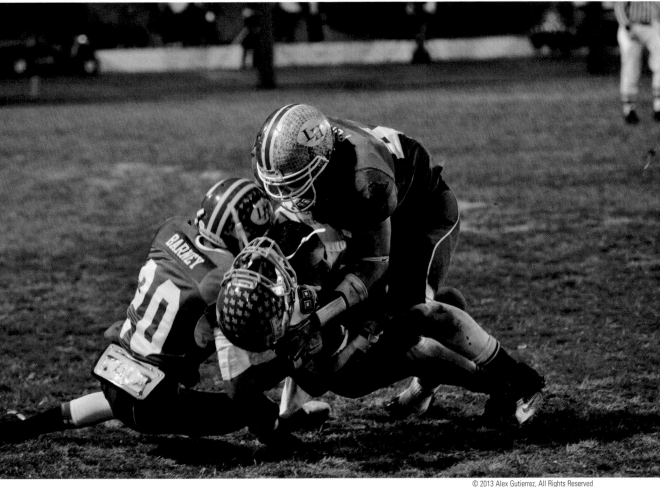

After you've moved your ISO into the noise-apparent range to capture more light, you need to start looking at other approaches. As the light continues to diminish, you still have two other tools at your disposal before you push your ISO into high-noise ranges. I suggest keeping the ISO constant to limit the noise to a moderate level, and opening the aperture next. In steps, adjust the f-stop from f/4.0 to f/3.5 to f/3.2 and finally to f/2.8. (If your lens has a maximum aperture of f/4.0, you won't have this luxury.) From f/4.0 to f/2.8, you can gain an entire stop of light at the expense of a narrower depth of field. Depending on how fast my subjects are moving, I usually adjust ISO, then f/stop, then ISO, then f/stop, working my way to reach my maximum ISO and maximum aperture at roughly the same time. When you're maxed out on both ISO and aperture, usually your only alternative is to allow the shutter speed to drop. In rare applications, you may also be able to use a flash as supplementary light, but in most sports photography the athletes' distances vary rapidly, and a flash becomes too difficult to control effectively. (Flash photography is sometimes prohibited at certain events.)

Let's look in a little more detail at a case where your event changes from broad daylight to almost complete darkness.

Stage 1: From Very Bright to Just Bright

When you start shooting, the sun is bright, so your ISO is nice and low—say, 100. Your shutter speed is fast, maybe 2000. And of course your aperture is at f/4.0. As you move from midday to late afternoon, you will see that you have a little less sunlight than you started with. No problem for now at least! Your camera is doing nicely at controlling the exposure. In Aperture Priority mode, you've picked the ISO and the aperture, and the camera is simply adjusting the shutter speed. You've had plenty of light so far, and your camera is simply tweaking the shutter speed to keep the right exposure. You'll see it drop from 2000 to 1600 and eventually to 1000. As the light is reduced through this range, simply keep an eye on that shutter speed and monitor it as it drops. Easy, right?

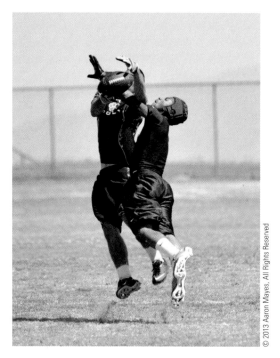

Stage 2: From Bright to Moderate

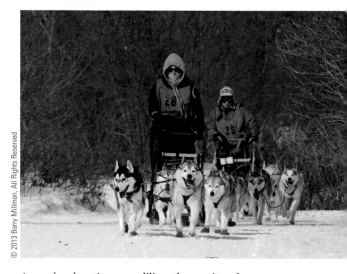

As you're shooting, you diligently monitor the shutter speed as you look through the viewfinder. Once the shutter drops below 1000, you'll want to watch things a little more closely, because you'll have to make a change soon. During the course of normal shooting, you'll see that from shot to shot the shutter speed selected by the camera will vary slightly. So if the average shot has a shutter speed of 1000, you may see some shots with a shutter speed of 800, some with 1200, and some in the middle. You'll want to keep an eye on the lower shutter speeds, as this is where you'll see motion blur first. As long as your lowest shutter speed is at 500 or higher, you're good to go. But when you start to see some images below 500, you know that unwanted motion blur is just around the corner.

So once you start seeing your average shutter speed around or below 800, you're going to make your first change. Which one? ISO, naturally. If your ISO is currently set to 100, then you can crank it up to 400 without any perceptible effect on your photos. While I always encourage shooting with the lowest ISO possible, the range of 100 to 400 ISO is very forgiving in terms of image

quality. In most cases, you won't see any noise difference in images at 100 versus 400 ISO. So when your average shutter speed is at 800 or below, just push up your ISO a little to 200 and then 400.

Stage 3: It's Starting to Get a Little Dark

The sun's a little lower, and you've been diligent about watching your shutter speed. It's down to 500 again, even with your ISO cranked up to 400. At this point, you have a few decent options left to get more light. You could continue increasing your ISO, or open your aperture, or let your shutter speed drop.

There's no universal answer here; you'll apply these principles in the sequence that fits you best. Generally, I'll crank up the ISO to 800 before I start moving to the other options, because I know

my particular camera bodies don't produce significant noise until above 800 ISO. Once I'm at 800, I think about noise in my images before I go any higher with ISO. (Because more recent camera models have better noise profiles, owners of newer cameras, such as the Canon 60D or 1DX, may choose a slightly different sequence from owners of older cameras, such as the 30D. You may be able to push your ISO to 1600 or 3200 before you start seeing any significant noise.) Once you're at your tolerance for noise, you'll start to think twice about going much higher with your ISO.

If you happen to be using an f/2.8 lens, this is a great time to consider opening your aperture a bit. In fact, if you know in advance that you'll be shooting in lower-light conditions, you should start with an f/2.8 lens. Most photographers who purchase the f/4.0 instead of the f/2.8 do so to save money, so I realize you may not have both lenses available. But if you have access to both lenses and you're planning to shoot shoot in lower light, leave the f/4 at home and bring the f/2.8!

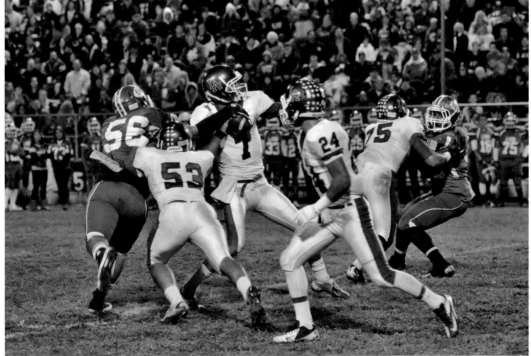

The best option at this point is to start opening up your aperture (dialing your aperture value to a lower number). You'll get a little more light, while actually increasing the bokeh, but the tradeoff is the shallower depth of focus, which may result in fewer in-focus shots of moving subjects. I suggest you follow this to its limit of f/2.8 to keep your shutter speed at 500 or higher.

Stage 4: Okay, It's Really Dark Now!

Now you're at the point of pulling out all the stops. Your aperture is open fully, your ISO is as far as you can push it without serious noise, and your shutter speed is at 500 and dropping. At this point, you have expended all your good. You are really down to your measures of last resort. You can start compromising your shutter speed a bit by letting it drift down to 400 or so. Yes, you may get a little motion blur, but at least you're still shooting. Motion blur will gradually become more noticeable as your shutter speed drops, but it's not as if photos at 400 are immediately unacceptable.

Your other option is to crank up your ISO into the "noisy" range. You can take out some of the noise with software, which we will discuss in a later chapter. While I prefer to keep my ISO at 800 or lower, the diminishing light means it's crunch time, and something's got to give. I suggest working these two factors in tandem: gradually pushing the ISO higher and gradually accepting lower shutter speeds as conditions darken. Try pushing the ISO a little higher, letting the shutter speed drop a bit, and pushing the ISO some more. Your pictures won't be all that you'd like them to be, but they'll still be better than what everyone else gets with their point-and-shoot cameras.

When you've maxed out your ISO and your shutter speed has dropped to unacceptable levels (say, 100 or lower), you've really gone as far as you can go. If you have the chance to use your flash, that

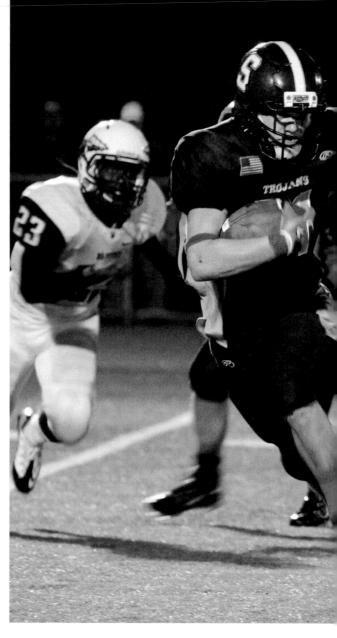

would be a possible option, but most sporting situations won't put you close enough to the subject for a flash to be effective. And in some sports, flash photography may be expressly forbidden. Fortunately, events where the lighting is this bad are few and far between. In these rare instances, just bite the bullet, pull out all the stops, and shoot for as long as you can. When it's so dark that you're no longer capturing quality shots, it may be time to pack it in for the night.

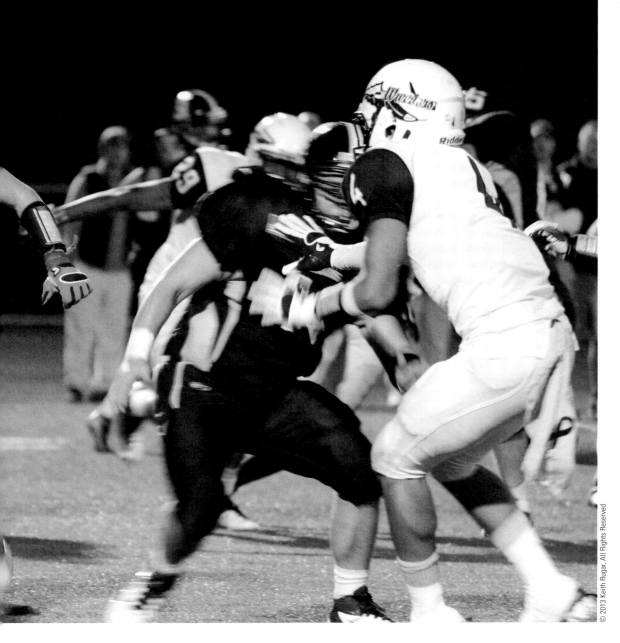

Conclusion

Successfully shooting in low light requires a good knowledge of your camera's noise profile to know the ISO value where noise becomes an issue. It also requires a full understanding of ISO, shutter speed, and aperture as tools to adjust your exposure in situations of diminishing light. Don't be afraid of shooting in low light. Consider it a challenge and an opportunity to hone your skills. Practice with the controls on your camera so that you can change your ISO, aperture, and shutter speed quickly, without having to figure out how to change it in the heat of battle. When you can quickly access and adjust these parameters, you'll be able to make your adjustments on the fly and shoot more effectively in low-light situations.

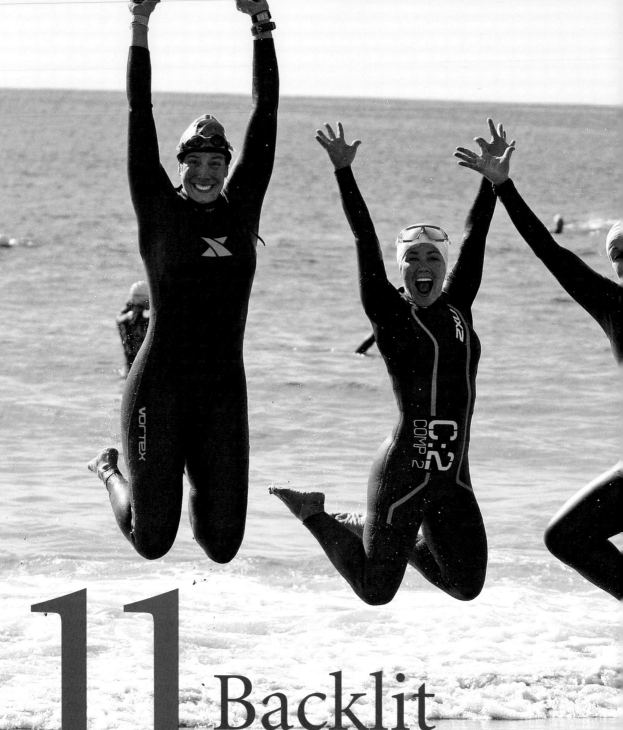

11 Backlit Subjects

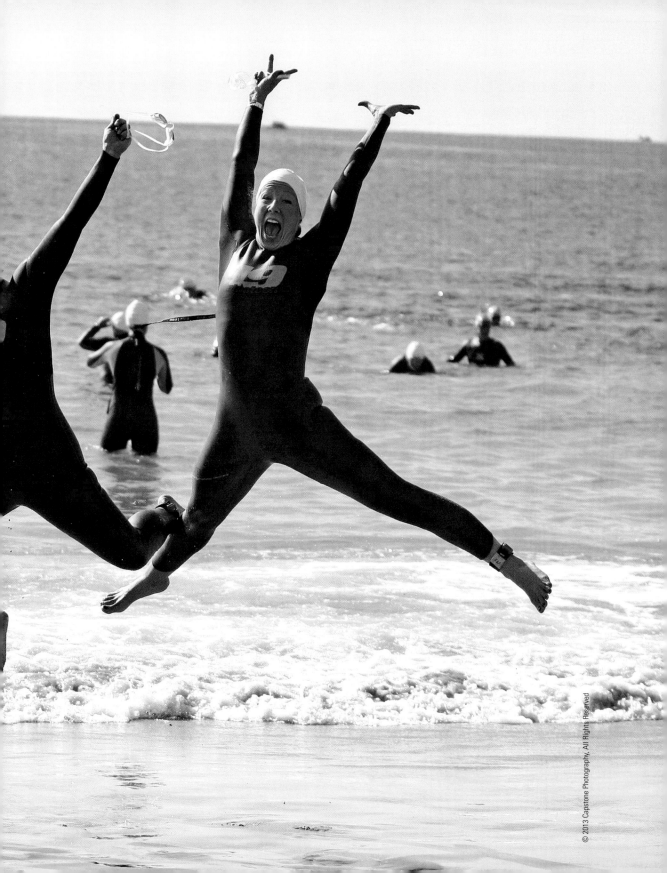

This is the most important chapter in the book. The fundamentals covered in previous chapters have laid a foundation for you, and it's definitely important that you understand those chapters and practice your techniques. Applying the basics of exposure, white balance, focus, and framing will allow you to be a good photographer in favorable conditions.

But a real action photographer is able to shoot not just under the best conditions, but also under the worst. And the worst lighting condition is quite simple: shooting into the sun. When the sun is in front of you, it produces a lighting situation called *backlighting*.

Portrait, wedding, and nature photographers may be able to move to a different position or time or use fill lighting to improve the conditions for photos. But in many cases sports photographers don't have such luxurious options.

The ability to properly shoot backlit subjects represents one of the demarcation points between people with cameras and skilled photographers. Above all other skills that separate photographers from camera owners, this is the big one. And going forward, you'll never again be able to shoot (or even look at) a backlit subject without considering how to handle exposure.

In this chapter I'll describe some ways to produce good results even when the lighting is literally working against you.

uImages on this page and the following one were taking in various backlit conditions, with exposure compensation values of 0, +1/3, +2/3, +1, and +1 1/3. Note how the subject to the left appears relatively dark. The photographer should've chosen a higher value for exposure compensation. Notice how the background highlights in the photo of the runner (next page) are blown out, but the subject remains properly exposed.

"A real action photographer is able to shoot not just under the best conditions, but also under the worst."

An Important Secret

The most important secret of shooting backlit subjects is simply not to do it! That doesn't mean you need to stop shooting for the day or give up completely. It means you should see whether you have a choice of positions and assess them critically for lighting advantage. Shooting front-lit subjects is *always* preferable to shooting backlit subjects. Your best photos are most often going to be when the light is behind you or coming from all around. Those conditions are the easiest to shoot and can produce some of the best pictures you may ever take. So as you're scouting out your potential positions at the event, see which area looks the best as far as putting the sun at your back. Move there if you can. Ask for access from the event organizer. Push for permission if you need to. Your job will be so much easier and more relaxed if your lighting is favorable, so make every effort to get the best possible position you can access.

But sometimes sports photographers are relegated to a particular position on the field. Or there may be a shot, such as a race finish, where the athletes finish with the sun at *their* backs, not yours. So let's consider the case where, despite your best efforts, you're shooting into the sun. The glare hurts a bit, causing you to squint as you move your head from behind the camera to look at your subject. With the sun behind the player, you see his profile almost in silhouette. The area around the athlete is lit from the sun in front of you, but the athlete himself is dark due to his own shadow, which is cast toward you. This is the classic backlit subject. Depending on the height of the sun, the effect of the backlighting may vary. The higher the sun in the sky, the *less unfavorable* the backlit situation will be. The situation will become progressively worse and more difficult as the sun moves lower in the sky.

Why Shoot Backlit?

The answer to this question is simple: Because you have to. Working from a position where our subjects are backlit just comes with the territory of being a sports photographer. None of us particularly likes it. We know this is not often where our best shots come from. We make every effort to avoid these situations, but sometimes we simply can't. If that's your spot, and if the subjects are on the field backlit, you just have to hunker down and do the best job you can.

Of course, you'll have other considerations and constraints, such as:

- What areas you have access to as a photographer

- Where the action on the field is taking place

- Whether the action will be coming back to that place, and how difficult it would be to move back and forth between positions

This is one of the most challenging situations you'll encounter in any type of photography. And as a sports photographer, you unfortunately have to get very proficient at shooting backlit subjects.

"Working from a position where our subjects are backlit just comes with the territory of being a sports photographer."

How to Shoot Backlit Subjects

When it comes time to shoot backlit, commit to it. That is, it's better to shoot an athlete who is fully backlit (in other words, with the sun directly behind him and the shadow pointed directly at you, the photographer), than one who is side-lit. Side-lit subjects are, in essence, partially front-lit and partially backlit, and they are even harder to shoot than an athlete who is all backlit from your vantage point. But in the meantime, if you have to shoot backlit, get to a position where the subject is completely backlit, if possible. Look for a position where the athlete's shadow points within about 30 degrees of your direction.

There are two basic approaches to shooting backlit subjects. The first one, often used in other types of photography, is to use fill flash. Essentially, you expose your shot for proper exposure of the background, and then you progressively increase your flash as a means to light up and fill in details on your subject. It's a technique that requires a fair amount of practice and skill but can produce good results if you're not shooting action.

However, fill flash has very limited application to shooting sports. In Chapter 10, I mentioned the concept of using a flash for primary lighting but I dismissed it out of hand, and I'm going to give fill flash the same treatment when it comes to action photography. The main problem with trying to use a fill flash in sports is that your subjects are always moving, always changing distance from you. Flash exposures vary wildly as distance varies, making the flash difficult (if not impossible) to control for proper exposure of your subject. Using a fill flash requires you to expose for the background, often requiring you to slow down your shutter speed and introducing issues of possible motion blur. It's a somewhat uncommon approach to shooting backlit action subjects. The second approach is to adjust your exposure to capture more light from

the subject. If you simply take your camera (which is set up for front-lit subjects in full sun) and swing around to shoot someone who is backlit without changing any other settings, you'll see that the subject is far too dark. If you feel doubtful, go ahead and try it. This will generally produce a less-than-satisfactory result.

NOFEAR

Simply being aware of backlit subjects is half the battle. So many people take pictures with no regard to the direction of the sun. But not you. You're thinking about the direction of the sun. If you have to shoot with the sun in front of you, just remember the simple technique of using manual exposure compensation.

Side-Lit Subjects

Shooting front-lit subjects is the most straightforward lighting scenario. Backlit subjects are harder. When strong lighting, such as direct sunlight, comes from the side, you really are dealing with the worst of both worlds: One side of the subject is in bright lighting, while the other side of the subject is very dark. Repeating my previous advice, try to shift your position with respect to the subject if you can. You'll have a much easier time and will get better results if you can shoot front-lit. But if you have no option other than to shoot side-lit, try these tips.

- Start with normal settings, including zero exposure compensation.

- Watch your histogram and check your LCD for flashing that indicates blown-out highlights on areas of skin. As I've mentioned before, if areas of the background or white clothing are blown out, it's not really a big deal, but blown-out skin tones are a major no-no.

- If you are getting blown-out skin tones, consider using negative exposure compensation. This is one of the few situations where I actually use a negative exposure compensation.

- Be ready to address the dark, shadowy areas of the photo in post-processing.

There are several ways to change your image's exposure. I'll introduce three options and then recommend one of them as my favorite and the one I consider most practical.

Method 1: Change Your Metering Mode to Spot Metering

Your camera uses any one of a number of different metering modes to assist you in achieving the correct exposure in your images. The first and most common is called *evaluative metering*. This mode uses all of the light within the frame of your viewfinder to determine how much light there is. The amount of light measured is used by the camera's processor to control your lens aperture and/or camera shutter speed. If you're shooting in Av mode, as suggested, then you're choosing the aperture, and the camera is choosing the shutter speed. This is my favorite approach.

Logically, you could consider switching from evaluative "whole frame" metering to a mode called *spot metering*. In spot metering, the camera measures the light by the amount in a small area centered on the selected auto-focus point. You might think that this would result in lowering the shutter speed to brighten the exposure on the relatively dark backlit subject. And you'd be right—sort of. Photographers doing outdoor portraits and other types of photography where things move slowly often find spot metering a useful method for getting the right exposure when the subject has a different amount of light than the rest of the image (in this case, a backlit subject).

But here's the rub: Spot metering doesn't produce consistent results for fast-moving subjects. It depends too much on perfect accuracy of the auto-focus point as you track your subject. Another problem with spot metering is the way it handles subjects with different lightness and color of their uniforms.

Suppose you're shooting a game with home-team players in dark uniforms and visiting players in light uniforms. When you're shooting the dark uniforms, in spot-metering mode, the camera might determine that there is not much light in the subject and slow down the shutter speed to compensate. As a result, the subject may be over-exposed. One second later, you may shoot an athlete in a light uniform, where the camera's algorithm measures plenty of light and increases the shutter speed to compensate. By comparison, the dark-uniformed athlete's photo will appear lighter, and the light-uniformed athlete's photo will appear darker. These wild swings of exposure will create a lot of issues in your post-capture workflow, and you really don't want that to occur.

Method 2: Shoot in Manual Mode

If the green rectangle mode means the camera chooses everything and the photographer nothing, then Manual mode is the opposite. In Manual, you have full control of ISO, aperture, and shutter speed. In Manual, camera metering doesn't come into play at all—you have full control over exposure.

The general approach to shooting in Manual is one of trial and error. You dial in a best-guess value for shutter speed, ISO, and aperture; take a few shots; and then make adjustments until you're happy with the exposure. I know some excellent photographers who produce amazing photos this way. But it requires that you remain extremely and constantly vigilant about checking your exposures via the LCD screen and the histogram. And if your light changes throughout the day (such as if there are intermittent clouds or if one end of the field is brighter than the other), you may find yourself making constant adjustments. Personally, I would rather spend more time taking shots and less time checking them and making adjustments.

"Personally, I would rather spend more time taking shots and less time checking them and making adjustments."

Method 3: Use Manual Exposure Compensation

This is my favorite method of achieving proper exposure in backlit subjects. As you know, I prefer and recommend shooting backlit subjects in Aperture Priority mode with plain old evaluative metering. If you are set up to shoot front-lit athletes and then you swing around to the shoot athletes on the backlit side, you'll see that the images of the backlit athletes are very dark in comparison. This is a common mistake of many amateurs—they take great-looking photos on the front-lit side but very dark ones on the backlit side. Amateurs shoot both backlit and front-lit sides without consideration of the sun, and they wind up with a rather poor-looking batch of backlit pictures. It happens all the time.

Changing exposure for backlit subjects is simple. Use the manual exposure compensation control on your camera to adjust the image's brightness. Exposure compensation is measured in EV, or exposure values, and most cameras will give you two or three stops (both positive and negative) in either 1/2 or 1/3 EV increments. It's actually an extremely simple concept. Leave everything else alone (for now) and just increase the exposure compensation.

Stops

Not unique to sports photography, the term "stop" (as a noun) refers to the relative amount of light collected in a photographic image. Increasing the light by a full stop means to double the amount of light, whereas decreasing the light by a full stop means to cut it in half. The origin of the word refers to a physical plate with a specific hole size that was inserted into the lens of a camera. The smaller the hole, the more light that was stopped by the plate. So swapping out the plate with one with a different-sized hole was called changing a stop.

Today, you can control the amount of light captured by adjusting ISO, aperture, or shutter speed. Don't automatically assume that changing the light by a stop means changing the f-stop. Changing ISO and shutter speed are equally effective ways to adjust the amount of light captured.

Full stops represent doubling or halving of light, but most cameras will give you the option to change the ISO, shutter speed, or aperture values at 1/2-stop or 1/3-stop increments.

The process for getting the right exposure is to find a "typical" backlit athlete and to take a photo of her. Start with your standard settings: Aperture Priority mode, f/4.0, and an appropriate ISO for the amount of available light. Take a few shots of a backlit subject and note the shutter speed. Take a look at the image on your camera screen. You'll notice that the subject is dark—too dark.

Now look at the histogram. Commonly, your histogram will look fine, beautifully spanning the full range from left to right. But in backlit subjects, the histogram is often deceiving. The subject's skin tones are the most important. Using the controls on your camera, increase the EV to +1 as a starting point. Take a couple of photos and look at the images again. You'll see that the athlete is brighter and the histogram is shifted to the right. The histogram may look worse, even hinting at overexposure, but the subject looks better, considerably less dark.

You'll also notice that the shutter speed has dropped, because by dialing in a positive manual exposure compensation, you've essentially told the camera that you want a brighter image of the athlete, and the camera has achieved this by keeping the shutter open longer. So when you increase exposure compensation, keep an eye out for the expected drop in shutter speed. If it drops below 500, you know what to do—that's right, increase your ISO. Take a few more shots and look at them. If the athlete is too dark, you might have to increase the exposure value again. Keep checking skin tones on the camera's LCD while adjusting the exposure compensation until the skin tones look just right. Keep an eye on your shutter speed and adjust your ISO as necessary. With a little practice, you'll be able to complete this routine and be ready to shoot within less than a minute.

NOFEAR

Use exposure compensation liberally. You don't have to delicately add +1/3, then +2/3. Dig right in and dial in positive exposure values of +1, +2, or more. I've gone as high as +2 1/3 in extremely backlit situations. If you've added too much, evident in overexposed skin tones, then you can always back down.

"Use exposure compensation liberally."

Assessing Exposure

Earlier we discussed how you should use both methods to assess your exposure: qualitative (by viewing the preview image on the back of your camera) and quantitative (by interpreting the histogram). I'm a big fan of histogram analysis in general; in many cases it can be the most useful tool you have available to achieve correct exposure. However, when you're shooting backlit subjects, the histogram can be misleading and can potentially lead you to take images that are too dark.

In fact, as you increase your exposure compensation to achieve the proper exposure on the athlete's face and skin, it's likely that you will blow out the highlights of other elements in the picture. For instance, if the athlete has the sky behind him, or if the athlete is running on a street, you may see that background become too bright and washed out. Your histogram will shift to the right, and you may see that your highlights blink in the camera screen. This is one time when it's okay to have blown-out highlights, as long as they're not on the subject. For backlit subjects, this is often a necessary tradeoff that is made to achieve the right exposure for the subject.

You want your subject properly exposed. The background is less of a concern. Don't get too hung up on it if background objects have their exposure overexposed or the highlights are blown out. It is *much* more important to me to have good, accurate skin tones so I can see the effort and intensity on the athlete's face.

You'll want to review your photo on the camera screen frequently when shooting backlit subjects. With even slight variations in lighting or positioning, you may find that your "perfect" exposure can shift considerably during a short period of time, particularly if the reflection of the sun is a factor in the backlit shots you're taking.

Other Thoughts on Backlit Subjects

The classic definition of backlit means that the sun is behind your subject and in front of you. But that's not the only scenario in which you should use backlit shooting techniques. Any time the background is lighter than the athlete, regardless of the position of the sun, you should consider the picture backlit.

On a sunny day, you might take it for granted that you'll shoot with a white balance setting of Sunny. It's actually not always true. If you think about the physical arrangement of sun, subject, and camera for a backlit subject, your athlete's face is actually in his own shadow. Just like you expose for the subject, not the background, you should also select the white balance for the subject, not the background. Because the athlete's face is in his own shadow, a white balance of Shade usually produces the best colors for your subject.

As discussed in Chapter 4, I always shoot with a lens hood. It provides equipment protection, but in the case of backlit subjects, it provides an added benefit. It reduces the glare in your images, which could otherwise quickly degrade the contrast and the quality of your work. Particularly when you're shooting backlit, you run the risk of having sunlight directly shining on your camera lens—a hood can help you avoid this. The hood casts a shadow on your lens, preventing sunlight from directly entering it.

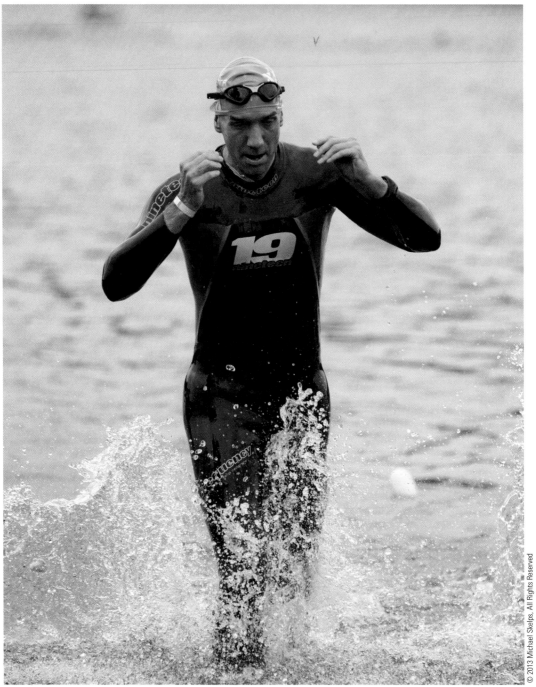

Be aware of backlit scenarios in disguise, as shown in this image and the two on the following page. Even if the sun is not behind the athlete, the situation should still sometimes be treated as backlit. If the background is a lot brighter than the athlete, consider the photo backlit and adjust your shooting as needed.

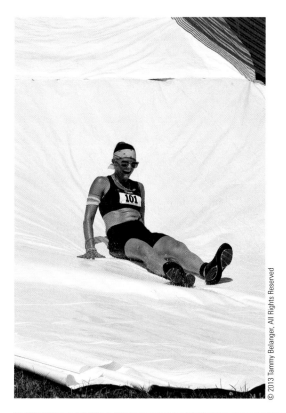

NOFEAR

As long as the outermost lens is in shadow, you won't get lens flare in your shots. If the lens hood isn't providing enough cover from the sun, see whether you can find a spot in the shade from which to shoot. Shooting in the shade is often more comfortable, and you'll spare your shots from harsh glare.

In some types of photography, lens flare is intentionally captured as a photographic technique. Lens flare is visible when your camera is pointed almost directly toward the sun, producing a cascading set of aperture-shaped artifacts in the image, adding to its artistic appeal. In action photography, however, direct sunlight will primarily deteriorate your image by adding glare and reducing contrast. Your best line of defense is to ensure that you have a proper lens hood to prevent sunlight from directly shining onto your lens.

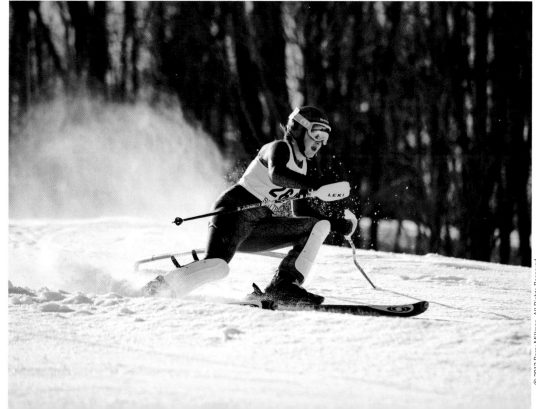

To see whether my hood is providing enough protection, especially when I'm shooting almost directly into the sun, sometimes I'll hold the camera on the monopod in the direction that I'll be shooting and then peek my head around to see whether any sunlight is falling directly on my lens.

To sum up, here are a few things to always keep in mind when you're shooting backlit subjects:

- Aim for proper exposure and white balance of your subject, not the background.

- Your histogram can be misleading. Keep a close eye on the exposure of skin tones.

- Be aware of your falling shutter speed as you increase exposure compensation. Be ready to increase your ISO if your shutter speed falls below 500.

- Be watchful of any direct sunlight on your camera lens and take action to keep your lens in the shadow of your hood or something else.

Conclusion

More than in any other area, shooting backlit subjects is a skill that too few photographers master. Like everything else in photography, with a little knowledge and a little more practice, you can learn to produce good photos under the most challenging backlit situations. Backlit subjects will vary incredibly, and but your commitment to regular practice will ensure that you become confident in your ability to consistently capture quality images even under adverse lighting conditions. From this point forward, as you're shooting always be conscientious of whether your subject is backlit. Be aware of your exposure compensation and use it as an effective means to control exposure. Strive to monitor, adjust, and achieve proper exposure for your subject, giving more weight to previewed skin tones than the potentially misleading histogram.

We've covered both good and bad lighting so far, but we've always assumed environmental factors, such as temperature and precipitation, weren't a factor. Once you've gained some confidence in your ability to shoot in different lighting conditions, it's time to think about how to shoot when the weather isn't quite cooperative.

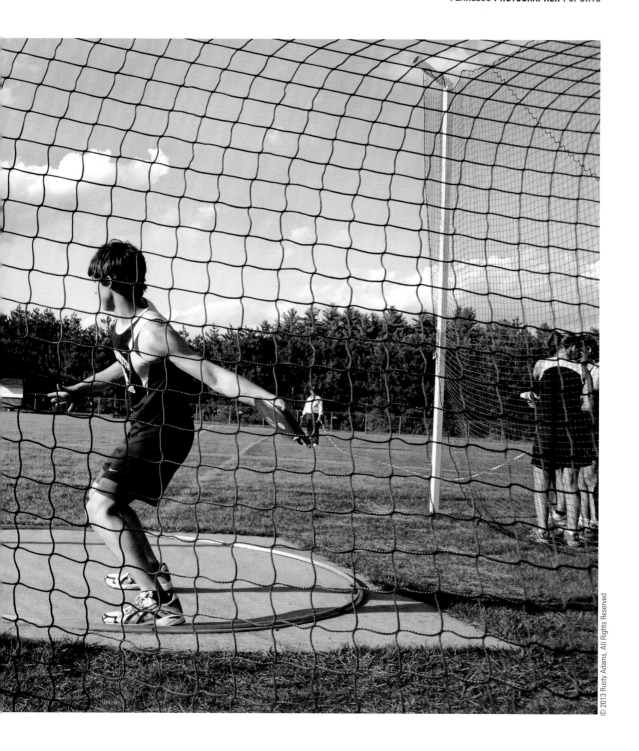

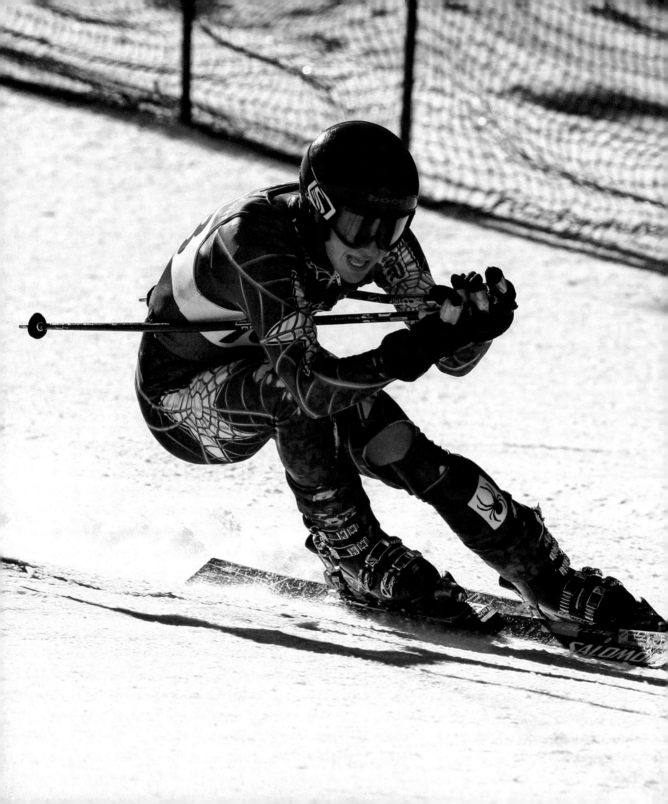

12

Shooting in

Inclement
Weather

Taking photos on a nice, warm summer day is a real pleasure—the sunshine, the fresh air...what could be better? It's one of the things I love about being a photographer. But most sporting events are held outdoors, where weather conditions can vary widely. Even "fair weather" sports such as tennis or baseball can be on cold spring days or under a light sprinkling of precipitation. Indoor shooting of hockey or ice-skating is downright chilly. And some sports events, such as football or road races, can be held in the pouring rain or even snow.

The upside is that some of the sports shots you'll get in bad weather will be among the most interesting and memorable photos you'll take. The bad news is that this is where the romantic notion of the glamorous life of sports photography begins to fade. Photographers' passion for shooting generally remains strong, but shooting in bad weather often makes your photography assignment an experience to endure. Casual photographers may decide not to shoot under such conditions. But if you've made a commitment to take photos—whether to friends or your children or through a paid or contract assignment—you have to be ready to shoot in less-than-ideal conditions. It's just part of what we do as sports photographers.

Bad-weather shooting really falls into two categories: cold or wet. Sometimes when you're really lucky, you'll get a nice combination of cold *and* wet, and you might even get a little wind thrown in. It's a good thing we love shooting sports. Otherwise, we might just decide pack it in. But no, let's press on and get ready to suit up and work in the elements.

Wet-Weather Shooting

Going back to the list of recommended camera gear, wet conditions are another reason why I suggested you buy professional-quality lenses and bodies when possible. Most of the items I've recommended are weather-sealed and will hold up

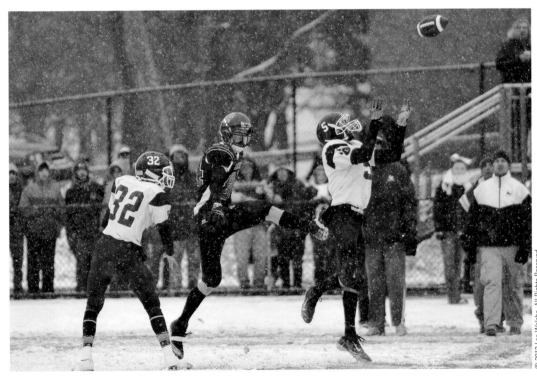

"Some of the sports shots you'll get in bad weather will be among the most interesting and memorable photos you'll take."

well in modest amounts of moisture. Lower-end lenses are notoriously weaker when it comes to performing in damp conditions. However, I recommend minimizing your equipment's exposure to water and moisture, regardless of what the manufacturer suggests. Camera gear is too important and too expensive to take any chances, so I recommend protecting your gear with a cover when shooting in wet conditions. And using this belt-and-suspenders method (professional gear and a cover), you can avoid most problems due to moisture—even after shooting in heavy rain.

There are basically two options for keeping your gear dry in the rain: You can cover your camera with a bag or you can work under an umbrella. I've used both techniques with varying levels of success and comfort.

A number of companies manufacture rain gear for cameras, including AquaTech, LensCoat, and Vortex Media. Camera rain covers are specifically designed for this type of situation, with holes for your hands, a hole for your lens, and even a window so you can see your LCD screens and viewfinders. They are available in a variety of price and quality levels. Disposable camera rain covers sell for less than $10, whereas reusable covers range from $35 to almost $200. Some even come in camouflage, which might come in handy if you're planning to use your gear for nature photography. Bag covers come in different sizes, so be sure to purchase one that is the right size for your camera and lens.

In a pinch, you may have to improvise if you encounter bad weather and don't have a rain cover available. Alternatively, you can go low-tech and use any plastic bag you have available. I've seen large zipper storage bags and even oven bags made for roasting a turkey used with good results. You put the bag on upside down over the camera, tear a hole for the lens to stick through and rubber-band that end to your lens hood, make another hole for the viewfinder, then put your hands in through the open end of the bag from underneath. You won't get any points for style using this approach, but for a dollar or so, you can give your $5,000 rig good protection against the pouring rain.

I find the camera rain cover option a bit cumbersome. And even though my camera may be protected, my head still gets rained on. So instead of bagging my camera, I prefer to to use an umbrella clamped to my monopod. This will keep you *and* your camera and lens dry and comfortable. Using this setup, I've shot in the heaviest rain and stayed relatively dry. It's not easy to walk around with this rig of umbrella, camera, and monopod, though—and the wind can push the umbrella around a bit. But if you can find a good spot and stay there, and if the wind isn't too strong, this rig can be worth its weight in gold. You'll be more comfortable than the athletes, officials, and other spectators.

A camera rain cover will keep your lens and camera body dry in wet conditions.

An umbrella clamped to your monopod provides excellent protection for your gear and comfort for you while shooting in the rain.

The mechanically inclined among you may come up with any number of contraptions to fasten your umbrella to your monopod. The simplest version uses two Bogen-Manfrotto Super Clamps, connecting them with a joining stud. All these parts are made to work together, and they're available online. One side of the clamp arrangement clips to my monopod, and the other end clips to a good-quality golf umbrella. You can have this whole setup for less than $100; and believe me, after one assignment in the pouring rain, you'll be patting yourself on the back for how smart you were to make that investment.

There are a couple of things to watch out for with this setup: First, the lower you have the umbrella, the better the rain coverage will be. Your camera

and lens will be very well protected because they will be beneath the center of the umbrella. You, on the other hand, will be closer to the back of the umbrella, so your back may stick out and will get wet before your equipment does.

A good, warm raincoat is always a great idea. If you start to get wet, see whether you can lower your umbrella and tuck your body in as close to the center as you can. Having your monopod at the right height so you don't have to bend at the waist will help your posture as well as help keep you dry.

Be sure you don't position it so low that it is visible in your shots. You want to be sure that umbrella stays out of your shots throughout the entire range of motion. When you zoom out to

your widest setting, make sure you don't see the umbrella at the top of your frame. If it's visible at your widest zoom, you may want to raise it just enough to keep it out of all your shots.

Next, make sure that the clamp location doesn't interfere with the position of your hand as you work the zoom ring. I always put the umbrella to the right of the lens to keep it clear for my hand.

Although I do 90 percent of my work with the camera in portrait orientation, I like to give myself the option of swiveling my lens inside the collar to the landscape position. So I keep my lens collar loose and make sure that the umbrella and clamp placement don't impinge on my ability to rotate the camera between the two positions. Once your clamp and umbrella are in the right positions, you'll find that you can shoot dry and comfortably in most inclement weather conditions.

If the skies happen to clear up, you can just unclamp the umbrella, invert it to a handle-up position, and re-clamp it to your monopod. This gives you a nice option for storing the umbrella parallel to the monopod in a way that's unobtrusive yet gives you ready access to your umbrella if the weather worsens again.

NOFEAR

Quality camera gear and lenses have varying levels of weather resistance. As a human, however, you can withstand a multitude of foul-weather circumstances. So keep your gear dry, step out of your comfort zone, and get ready to get a little cold and wet!

Cold-Weather Shooting

I love what I do for a living, but when I'm shooting at temperatures below freezing, I'm not singing the praises of my trade. Cold-weather photography is just part of a sports photographer's job. The challenge is to stay as warm as possible while still maintaining your ability to operate all the features of your camera as necessary.

Your first consideration should be staying warm. Commonsense rules apply here, such as dressing in layers and wearing a warm hat, shoes and socks. I'm also a fan of the facemasks that cover your mouth, nose, and cheeks and fasten in the back. Photography is hard work, but it's often stationary work, so you don't have the benefit of working up a sweat to keep you warm.

It would be great if you could put on big, thick winter gloves or mittens to keep your hands warm when it's cold out. Unfortunately, the loss of dexterity is an unacceptable tradeoff. You need very thin gloves that let you keep the sensation of feeling, so that you can feel the buttons on the camera, particularly the shutter-release button. There are three types of gloves to consider:

- Football receiver gloves

- Gloves with removable fingertips

- My favorite—inexpensive Isotoner gloves, available for under $20

When selecting gloves, you definitely want a good combination of warmth and dexterity. Be sure to test them out before your big cold-weather shoot to make sure they're not holding back your ability to work and feel the camera's controls. I once bought a pair of gloves thinking that they would give me a lot of dexterity, only to find that 30 minutes into the shoot, my hands hurt from trying to work while wearing them.

I can't stand having my fingertips exposed in the bitter cold, so I elect to wear inexpensive Isotoners, which give me a good balance of dexterity and warmth. I also shove a hand-warmer in the back of each glove to give a little bit of warmth to the blood as it flows through my hand and into my fingers.

I'm not going to say that you can shoot in 10-degree weather with perfectly comfortable hands. But by properly dressing from head to toe and wearing good gloves, you can make shooting in cold weather bearable. Thankfully, except for some winter road races, skiing, and late-season football, you probably won't be shooting in this level of cold terribly often. So when it's time for your cold-weather assignment, just take a deep breath, bundle up, plan a few breaks if you can, and look forward to the hot cocoa after the shoot.

"When it's time for your cold-weather assignment, just take a deep breath, bundle up, plan a few breaks if you can, and look forward to the hot cocoa after the shoot."

Other Inclement-Weather Considerations

Wind by itself is mostly just a nuisance. Just make sure that you're not in a spot where a gust of wind will put you into an unsafe situation. Some photographers shoot from an elevated position, such as on a stepladder or another perch several feet off the ground, to gain an improved vantage point.

When it's windy, I strongly suggest foregoing any height advantage and keeping your feet on the ground. Safety first! However, when coupled with precipitation, wind can be a real headache when you're trying to photograph an event. My words of wisdom regarding wind and precipitation are limited. Cold, wet, and windy is really the worst shooting condition you can encounter, and there's not a lot you can do. If you can put the wind at

your back to keep your lens dry, that will be a big help to you, but you may not have the option. Keep some dry lens cloths in your pocket, check your lens frequently, and do your best to wipe it dry. You won't see this combination of wind and precipitation too often, but when you do, it's a tough situation. Just try to keep your lens dry—that's really about the best you can do.

In wet weather, you must also be very conscientious about keeping your accessories dry, particularly your memory cards and your batteries. During a lens change earlier this year, I *thought* I had kept my batteries dry, but I must have picked up some moisture between the battery being in my pocket and putting it into the camera body—and my camera froze shortly thereafter. I tried another battery, but to no avail. I wound up switching to my backup camera body for the rest of the day. After I took the battery out of the camera body and let my gear dry for a few hours, everything returned to normal. Moral of the story: You must be vigilant about keeping all your gear dry at all times. It takes only one moment for a drop of water to enter your camera through the lens mount, battery hold, or memory card slot. The extra care you take will reduce the risk of having a temporary equipment failure or worse.

"The extra care you take will reduce the risk of having a temporary equipment failure or worse. "

Cold weather has two other effects you should be aware of, the first of which is surprising. Your camera sensor will produce less noise than it would for the same ISO in warmer temperatures. If you're shooting in the freezing cold, you may be able to shoot with a bit more confidence at higher ISO values.

The other factor you should consider is that battery performance will suffer in cold temperatures. The chemical reaction that produces electrical power from your battery just won't work as well in cold temperatures, and you'll be able to take fewer shots before your batteries are exhausted. So bring extra batteries to cold-weather shoots, and if you can, keep them warm by storing them inside your coat, as close to your body as possible. I've even seen photographers tape hand-warmers to their batteries, though I don't know how well that actually works.

One last commonsense piece of advice: If it's wet outside, don't plan to change your lens. Having water get inside your camera, especially near your sensor and shutter, is just not a risk you'll want to take. If you plan on shooting with both wide-angle and telephoto lenses on a wet day, it's a good idea to have two camera bodies, each with its own lens, rather than trying to change the lens outdoors. If you have only one camera body, go somewhere dry to complete your lens change, such as your car or inside a building.

Conclusion

Shooting in inclement weather is one of the ways in which strong sports shooters are separated from wannabe shutterbugs. It's not necessarily more difficult than other shooting situations, it's just less comfortable, and you'll need to prepare in advance for the conditions you expect to encounter. By showing up well-prepared to shoot at a cold, rainy event, you'll be among a small group of committed action photographers, and in some cases you may be the only one. Whether you're a true professional or a budding amateur, those in attendance will take note of your willingness and preparedness to shoot in such conditions, and the results in your photos will likely be well worth your efforts.

NOFEAR

When it's time to go inside and get warm after your cold-weather shoot, watch out for condensation that may form on your camera body and lens. Anything cold that is brought into a warm, humid environment will attract moisture, which will form as condensation. Though this usually won't damage your equipment, you will have to wait for the camera to warm up before you can use it again. It's a good idea to always have your camera inside a case or at least a plastic bag when you're moving from very cold to warm.

File
Considerations

Just a decade ago, digital photographers were limited to flash memory cards that stored just 128 or maybe 256 MB of data. The largest hard drives held only 40 to 80 GB of data. Storage was not inexpensive, and capacity limitations on cards and drives made it important for photographers to learn to capture and store their images in a space-efficient manner.

Over time, everything has gotten bigger and faster, and that's good news for everyone— action photographers in particular. Higher-

megapixel cameras have allowed photographers to capture images with greater resolutions, but with the result of larger image files. As images have become larger, camera processors have been made faster to handle larger amounts of data in even shorter amounts of time. Camera buffers have been made larger to allow photographers to shoot longer bursts of images than before. Memory cards have been made larger and faster to handle bigger and bigger images in increasing numbers in a shorter period of time.

By comparison, today's cameras may have 10 times the megapixels, hard drives may have 40 times the capacity, and CompactFlash cards are up to a thousand times larger than their counterparts from 10 years ago. Almost unbelievably, while all these technical advances were made, storage media prices dropped steadily, making access to higher-volume and potentially higher-quality photography available to more people than ever, at least in terms of file processing and storage cost.

Despite all of these changes over time, some good habits of file management have remained constant. Though some of the practices I will recommend may originate from these older constraints, they are still good commonsense practices that you should implement as part of your shooting regimen.

JPG versus RAW

You can save your images in two formats: JPG and RAW. Each offers its own benefits and drawbacks. While you are free to use either type, action photographers usually choose to shoot their images in JPG rather than RAW. This section will provide a quick rundown of these two main file formats and the reason why JPGs are often preferred for shooting sports.

RAW Images

As the name implies, RAW images are unprocessed and saved by your camera. RAW images contain data for each individual pixel of your sensor. Most high-quality cameras are capable of capturing 12-bit RAW images—that is, 4096 (2^{12}) shades of each channel, red, green, and blue. These three colors in all their possible combinations result in 68 billion different colors.

Most camera manufacturers, including Nikon and Canon, have their own proprietary RAW format. Canon uses CR2, while Nikon uses NEF. In post-processing, your editing software must support the particular RAW format of the camera you use. You generally need special software to open these files, which is why you don't see CR2 or NEF files as viewable images on the Web.

Because RAW files contain more data and it is not compressed in any way, they are almost always larger than their JPG counterparts. Because every pixel's data is stored individually in a RAW file, these files are considered *lossless*—there is no loss or degradation when the image is captured and later reopened.

JPG Images

JPG images are all around us, particularly on the Web. JPG (and its variant, JPEG) stands for *Joint Photographic Experts Group*, which created the original standard for this file format in the early '90s. JPG images have two primary differences from RAW images that make them beneficial for use in sports photography. The first difference is that JPG images use 8-bit channels, yielding 16 million color combinations. But perhaps the biggest difference is that JPGs use a mathematical compression algorithm to reduce the amount of data stored. Rather than saving every pixel individually, the algorithm selects nonadjacent pixels that have a similar range of colors and provides a mathematical approximation of the colors of the pixels between.

In your camera, you can specify the amount of compression to produce smaller files with lower quality or larger files with higher quality. At lower quality levels, a phenomenon called *JPG posterization* will appear in the saved files. At higher quality levels, the resulting image normally will not have any perceptible difference from the original file. Because of the approximation factor in JPGs, this file type is referred to as *lossy*, meaning that there is a certain amount of degradation or loss when capturing and then reopening the file. At the maximum JPG quality level, the algorithm can be set to capture exact pixel color, rather than by approximation. (JPG images may also be saved with lossless format.)

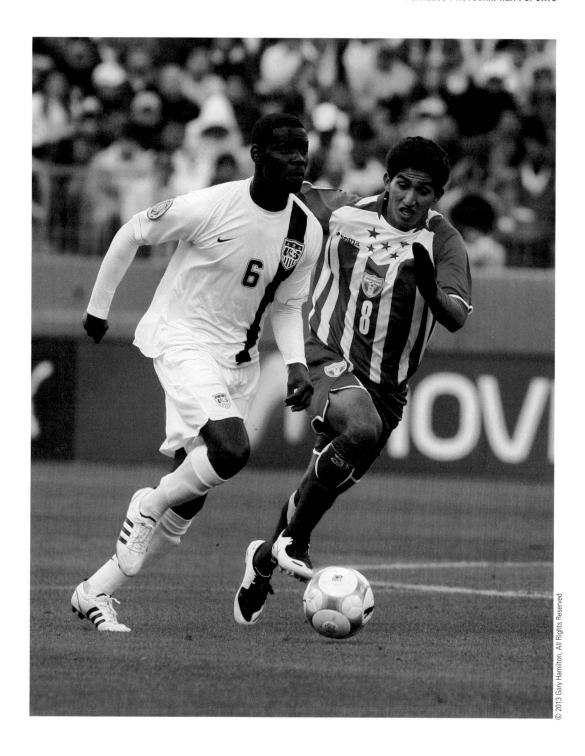

JPG Compression

I was curious about how JPG compression works, so I did some research on it. I found that engineers who figured this out use some very advanced mathematical techniques to compress the images, with names like "downsampling the chrominance channels," "quantization of the discrete cosine transformation," and "entropy coding." If you're interested, there is a lot of technical information available on these topics. For me, it's enough to know that JPG compression is available in the camera and in editing software, and that I can reduce file size without reducing the total pixel count.

The Case for RAW

A lot of pro photographers shoot in RAW. Because there are 4096 levels of each color channel, you can capture extremely subtle variations in color in the RAW format. Compared to the 16 million possible color combinations of JPG, RAW can capture far more colors.

The benefit is not in the ability of the human eye to perceive such color differences; in fact, most computer monitors and printers are able to output only colors in the 8-bit variety. The benefit comes in the ability to rescue severely underexposed and overexposed images. Because there are so many more variations of color, post-processing of RAW files allows photographers to have a much wider margin of error while shooting. It's a great luxury to have. But it comes at the expense of much larger image files than JPGs. Larger files are slower to write to the card, filling up your buffer faster and limiting the number of bursts you can fire. RAW images will also fill up your memory cards faster, take longer to download, and require more storage space. And most people won't be able to view RAW images; you'll need to convert them to JPG for viewing, printing, and sharing.

The Case for JPG

In the world of sports photography, JPG has distinct advantages that in my mind make it the only feasible option. The reasons all revolve around the fact that the file size of JPG files can be so much smaller than RAW—in many cases five to ten times smaller. Smaller files fill up less of the camera's buffer and take less time to write to the memory card. And because JPG files are smaller, I can fit more of them onto a memory card before I have to switch to a new card. Fewer card swaps mean less downtime when shooting. Smaller files mean that you can fit more of them onto your storage drive before it fills up and you have to buy another one.

"In the world of sports photography, JPG has distinct advantages that in my mind make it the only feasible option."

So it's really about file size, time, and speed. Just the other day, I was photographing a football game, and I had an opportunity to capture a runner making a long swerving run, ending right in front of me for a touchdown. In the 10 seconds that the play took, I fired off about 40 shots, and I simply wouldn't have been able to do that in RAW. The buffer would have filled up, I would have been waiting for the data to be written to the card, and my camera would have been very sluggish by the time the player crossed the goal line.

Large, Medium, or Small

When shooting JPG, your camera will give you the ability to shoot in various resolutions. For Canon cameras, you'll have Large, Medium, and Small settings. (On some cameras there are two Medium settings: M1 and M2.) Nikons have similar settings called Fine, Normal, and Basic. Large or Fine will capture the image with every single pixel on the sensor corresponding to a pixel in the JPG image. Medium and Small settings will mathematically combine the pixels to result in a smaller image captured electronically on your memory card.

I used to always shoot in the largest file size that my camera body would allow. But as megapixels increased to 10, 12, 16, and beyond, I started to realize that the sensor resolution was no longer a limiting factor in the quality of my photography.

It's worth considering a few questions:

- What is the final output you intend with these photos? 4×6 prints? 8×10s? Posting them on the web? A magazine cover?

- How many photos are you going to take at an event? How much memory do you have and how many photos can you take at various resolution settings in the camera?

- How many pictures will you be taking this year? How much storage space will you need for those images and what will it cost?

I encourage you to consider these questions and to do your own analysis of the best file size for your photography. If budget isn't an issue, you may decide that shooting at the highest resolution is an option for you. But even so, let me offer some practical considerations.

The largest that I print is a 20×30 image, and 98 percent of my work goes to 8×10 prints and smaller. For this size, I find that resolutions of 2000 pixels wide by 3000 pixels high are satisfactory. Larger file sizes will take more memory, but they won't necessarily produce a more detailed image. They will also slow down how many images per minute you can write to the card and limit the number of images you can get on a card.

NOFEAR

A little advance practice goes a long way. Take a close look at your camera's quality settings. In addition to selecting the ideal quality and size settings, take a look at the extremes. Get familiar with settings at both ends of the spectrum: lowest quality, smallest size and highest quality, largest size. Take some test shots at each extreme and look at the resulting shots. Each camera is different. How large is a typical JPG size at each setting? And how many shots will you be able to get on your memory card? Are digital artifacts such as JPG posterization present?

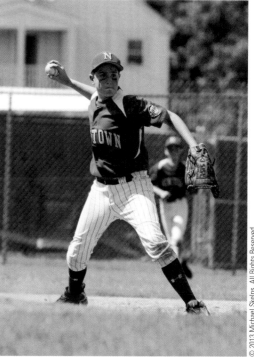

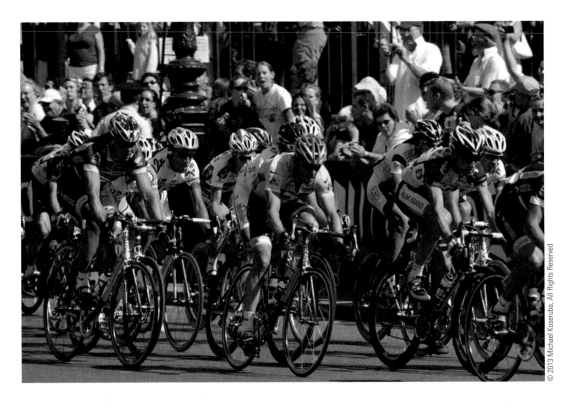

File Compression

JPG images also have an important characteristic in that they can be compressed. There are detailed technical explanations of how this is accomplished, but the details are outside the scope of this book. A simplified explanation is that JPG images can "skip over" pixels by specifying a pixel's color and another one further in the series and then have the software fill in the pixels in between. Your camera will give you the option to decide how much "skipping and refilling" goes into each image. I've found that slight to moderate JPG compression is undetectable as you look at an image. Severe compression, however, may result in visible "blockiness" of the image, called *JPG posterization*.

Canon cameras have a "step" compression feature that reduces the file size by about a factor of two without affecting image size or visible quality. Smaller size with the same quality is a no-brainer for me. Nikons have a similar option; your choices are Optimal Quality and Size Priority. I like to see JPG files between 1 and 3 MB with 2000×3000 pixels or higher, though with bigger memory cards, faster processors, and cheaper hard drives available, I'm open to slightly larger files with more pixels and more bytes. I encourage you to experiment with your camera's size and quality settings to achieve the best combination of resolution and file size.

NOFEAR

Suppose you're shooting at a higher quality setting, and you realize you only have a hundred shots left on your card and you didn't bring a spare. Don't worry! Shift to a lower JPG quality and/or size. You may see your remaining 100 images jump to 400 or more with the lower settings. Your images won't have quite the fine detail as at the higher settings, but at least you can keep shooting. But keep an eye on your remaining shots to make sure you don't run out of memory before the end of the event!

Conclusion

As you develop your own photography regimen, make sure you consider the correct format in which to save your photos. Selecting the right file type, size, and quality will ensure that you can capture all the shots you want without running out of memory, while ensuring that you have images large enough for your intended print size or other purpose.

Now let's assume you've completed a shoot, filling up your card with lots of great JPG image files of the right size and quality. In the next chapter, let's look ahead to what you'll do with your images once the event is over.

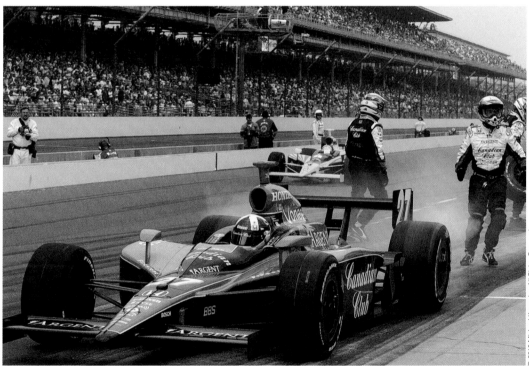

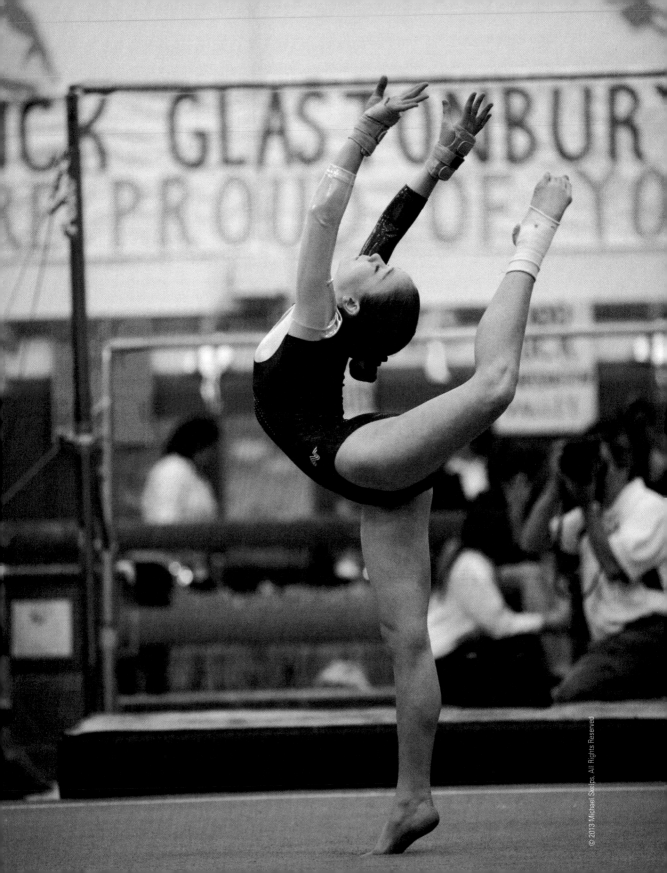

Workflow and Image Enhancement 14

It all starts with a camera, but it ends somewhere else. You might simply catalog your images to view later on a computer screen. Or, on the other end of the spectrum, you could be preparing your images for commercial publication or printing. Or you might use them to post on social media sites. The point is that your pictures ultimately will be seen in a different medium than on the back of your camera.

One key difference between a professional photographer and an amateur is that an amateur shows you *all* of his or her photos! Even if you're not turning your photos into cash, and therefore you aren't professional in the strictest sense, let's define a "professional" as someone who wants to present his or her best work throughout the photography process. Surely we can agree that in this sense, we all aspire to be professional in what we do.

With that in mind, one of your goals as a photographer is to capture images with the best possible exposure, composition, framing, and white balance. The previous chapters addressed techniques to help you achieve this goal. However, striving to capture perfect images is an *ideal* goal. In reality, you will be able to improve your photos using some basic post-capture adjustments, sometimes called *post-processing* of images. Photoshop is the most common tool used for making these adjustments, so in this chapter I will lay out some simple yet effective Photoshop adjustments you can make to your images.

The closer your photos are to perfect—perfectly exposed, perfectly timed, perfectly framed, and perfectly focused—the less work is ahead of you in post-processing. In some cases where your picture just looks "that good," you might be tempted to forego this step in the process. But I encourage you to always incorporate some type of post-capture review and editing workflow to make meaningful improvements to your images.

However, don't interpret the fact that you can improve your images in post-processing as license to shoot with wild variations in exposure or other aspects of your photography. Your finished image will always look better if you have captured it as close to ideal as possible in your camera. All good photographers approach shooting with a disciplined mindset and a desire to capture photos as best they can in-camera. With that being said, post-capture adjustments can optimize your image and help make up for any aspects of your original photo that were less than perfect.

A Recommended Digital Workflow

Recognizing that the final output of your image is different from what you see on the back of your camera, you'll need to follow a sequence of steps to get your photos ready for printing, online viewing, posting to social media sites, or other purposes. This sequence of steps is called a *workflow*. A simple workflow might be to download the images in a folder and then preview those images using Windows Explorer. A more sophisticated workflow could involve renaming files, saving to primary and backup locations, selecting images for print, and then conducting a detailed editing and enhancement process, including cropping for the desired print size.

So what workflow should you use? It really depends on your intention. It starts with the question, What do intend to do with your photos? If you were to ask a hundred different photographers about their workflow and how they select, edit, and store their images, you would receive a hundred different answers. In fact, you might get more than a hundred answers, because most photographers alter their workflow as their needs progress and as their processes become more repeatable. No single enhancement sequence is the "right" one. In this chapter, I simply offer a process that I find effective to organize and edit your images for the best results with the least effort. The process consists of selecting your best images, adjusting the exposure of your overall image, tweaking the highlights and shadows in your images, adjusting the color, cropping,

"Your finished image will always look better if you have captured it as close to ideal as possible in your camera."

reducing the noise, and then sharpening the image. It may not be necessary to perform every step on every image. After a little practice, you will be able to make a determination as to whether each specific step is necessary for the particular image you're working on.

Note that in the steps outlined in this chapter, the sequence is important. Sequence matters! Performing the tasks in the order outlined will produce the best results with the least effort.

Download Your Images and Name Your Folders

Image files belong in organized, backed-up storage. They do *not* belong on memory cards for any longer than absolutely necessary. There are just too many things that can happen. A memory card may be lost, misplaced, stepped on, or erased! It's no fun discovering that your images have been lost due to chance or error.

As soon as possible after the shoot and certainly *on the same day*, be sure to download your images to a computer and hard drive specifically dedicated to storing your images—or at least a dedicated folder. At the end of a long day of shooting, you might be tired and tempted to wait until later to download the images. If you must, then wait until morning, but the very next morning only! Don't let your memory cards hang out for too long in your camera bag or in your camera body. While the event is still fresh in your mind, download those images—certainly within 24 hours! Otherwise, in a few days, you may find yourself trying to remember what was on what card. Did you download those files yet? Is it safe to reformat the card? Save yourself the hassle, risk, and guesswork by developing a good habit of promptly downloading your image files.

Memory Cards

I can remember my first (and at the time only) memory card: a little 2-GB Microdrive containing a tiny physical hard drive about the size of a quarter. It was cutting edge in the early 2000s. That card could hold about 600 images, which at the time seemed like a good batch of shots. But by working more events with other photographers, a lot more cards flow through my office—I currently have an active inventory of about 1 Terabyte in CF and SD cards.

Once you get past having two or three memory cards, the need to identify and organize them becomes apparent. Labeling your cards is a quick and easy way to reduce confusion about which card was used for what purpose. There's little more frustrating than knowing you shot some images on a 4-GB card of a certain brand—or did you? Were those images on another card? Is it okay to format that card in your hand?

The first step in your digital workflow is to label your cards. Even if you have only one card, at least write or apply a label to the card with your name, email address, and phone number. I also state "Reward If Found," which has turned out to be helpful for those rare occasions when a card finds its way to the turf unnoticed in the middle of a shoot. I'm happy to send a few dollars of reward—or, better yet, some free images from the event where they found the card—to the Good Samaritan who helped get it back in my hands. Believe me, if there are pictures on that dropped card, you're going to want someone to have the information and incentive to get it back to you. There are plenty of good people in this world, so set yourself up for them to help you. Trust me. If you do this long enough, you *will* drop a memory card on the ground and walk away at some point. It happens to everyone eventually.

When you're working with other photographers, it's helpful to know which photographer used which card, as well as which cards were shot, which need to be downloaded, and which can be reformatted. I simply fill out a pre-shoot inventory of the card numbers being used and which photographer they're assigned to. That way, if a card is going to come back late or out of sequence, I know about it right away from this inventory. From the card number and the inventory sheets, I know the event and photographer to which that card number was assigned. It doesn't happen often, but on those rare occasions that it does, I'm glad for the ability to quickly solve the mystery.

When shooting, I suggest a simple "pocket flow" for memory cards. I put empty cards in my left pocket, and, once shot, full cards go into my right pocket. I like to use my pockets rather than digging in a backpack or camera bag, because pockets are so accessible. I'll stuff the cards into the camera bag later, but while the action is happening, my pocket is just a whole lot more convenient.

You can come up with a similar system that works best for you (top vest pocket to bottom vest pocket, and so on). What you ultimately want is a repeatable process that eliminates any doubt as to which cards you have already shot on and which cards are already full. There's nothing worse than that sinking feeling you get when you're not sure which cards are empty and usable and which ones you've already used and you dare not format. An easy solution to this is to format all cards before the shoot. Read that again: Format every card you might be using that day *before the beginning* of the event.

"When shooting, I suggest a simple 'pocket flow' for memory cards."

To help identify folder contents easily, I name my folders with a combination of date and folder description. For example, if I took photos on August 9, 2011, of the Falcons football team, I would name the folder 20130109HartfordBasketball. (Note the zeros used to keep the month and date at a consistent two digits.) This approach keeps my oldest photos at the top of my folder list and my newest photos at the bottom, making them easy to find chronologically while also allowing me to scan and search using the descriptions.

Whether you're using a manual workflow, such as dragging and dropping files in Windows Explorer, or software such as Lightroom or Photo Mechanic, it's important to know exactly where your files are stored. By using a dedicated folder or drive and reviewing it frequently, you'll stay in control of your folders and their content. Most importantly, you'll be able to find files when you need them. Avoid the temptation to store a few on your desktop, a few in a folder, and some on another computer in the office. The risk of misplacing your files becomes too much, and the task of backing up your files changes from routine to nightmarish.

Back Up Your Files

Many home-computer users will back up their files onto their hard drive and then consider their images safe and accessible forever. That's fine (sort of) as long as nothing goes wrong with your drive. But as you know, Murphy's Law can be hard at work, and it's never a good idea to count on everything going right.

It hurts to permanently lose any type of digital files, and in particular, good quality action photos are really something you want to protect. And if there's any commercial angle to your sports photography (for instance, selling the photos to a wire service), then the need to protect your images becomes even more apparent.

After I have created the folder for my images with a date and description and then renamed them, I back up that folder to an external hard drive. The external drive acts as an archive drive. I never really intend to use that drive, but I physically separate it from my computer, leaving it unplugged and (better yet) in a different building, so that if something happens in my office, I still have the files intact. I suppose if a meteor crashes in my vicinity and wipes out both buildings, both sets of my images are at risk of being destroyed, but at that point we'll all have bigger things to worry about.

There are also plenty of online storage options for your photos, available at a variety of costs and capacities. The problem for an active sports photographer is that you're going to produce a *lot* of data. It's easy to fill up a 4-GB card during a youth baseball game. But 4 GB is a lot of data to upload to the Internet. It's really a practical limitation of file transfer time and speed. If you shoot only occasionally or if you're shooting lower volumes (two things I would generally not recommend), you may find that files will transfer overnight, and most backup services will run the backup during idle hours on your PC. But if you're shooting more often and at higher volumes (good job!), you may find it impractical to upload via the Internet.

Also, online storage is priced per GB, so the more files you have, the more it will cost to store them in the cloud. And I prefer to have control over how my files are backed up so I'm not depending on a third party to hold up their end of the bargain. For these reasons, I have chosen and recommend a low-tech non-cloud-based backup process. Just an extra hard drive that I plug into my office and copy to each week.

Just as you shouldn't wait to download images from memory cards to your hard drive, backups should be handled promptly. You can manually back up files, or you can use software to manage these backups. I use a simple DOS script to copy the files in a way that skips all files previously backed up. Either way, I suggest backing up all images within a few days of downloading them. Just make this an automatic part of your workflow so you can always be confident that your files are properly backed up.

Continued

"Murphy's Law can be hard at work, and it's never a good idea to count on everything going right."

Whenever a primary storage drive exceeds 90 percent of its capacity (not the backup), I purge the oldest 25 percent of the files to make space for new images. Up to this point, these images existed in two different locations, a primary storage drive and a backup. But upon deleting those images, the backup drive becomes the sole location for the files in question. My rationale is that most of my images are more useful when they're newer, and that's why I primarily need to have both "belt and suspenders" for newer images.

Some images may gain sentimental value over time, but sports photos are subject to spoilage. They're usually most valuable while they're fresh, and that's why I keep two copies of the newest image, shifting down to a single copy when the likelihood of ever needing the photo is lower. Conversely, if you're preserving photos of your son or daughter, you may find that having a second copy of the images is even *more* important for older images. However you decide to archive, keep a backed up copy of the images that are most important to you. Your original digital images *will* fail; it's just a question of when. Having a second copy of them makes that question irrelevant.

Rename Your Files

Your camera records images with indiscernible, cryptic filenames such as IMG_0001.jpg. Let's say an image with that file name is viewed by someone, and he says he wants the original image for some certain use, such as for magazine publication. When he provides the generic filename, its nondescriptive nature makes it all but impossible to know where the file came from. What event was it from? What was the date? In what folder could it be located on the hard drive?

You could try to make an educated guess as to what event the photo came from using clues in the image as well as available metadata. You could ask the person what folder the image was found in or where he or she saw the image. Either way, you would have to spend some time scratching your head and working to locate the image in question—if you could find it at all. You can save this

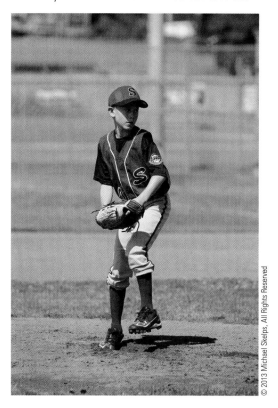

step in the process by assigning unique file names for every image on your hard drive. You can do so through use of a standard naming convention.

I apply a naming convention with an event identifier as well as the year in the filename. So IMG_0001.jpg becomes WXYZ110001.jpg. I can easily identify this as a photo of the Yankees in 2011, as long as I'm sure the prefix WXYZ is unique for any event I shoot in a year. This convention happens to be four letters identifying the event plus two digits for the year and then the sequence number of each image. But you could just as easily use eight letters or twenty. You could include the month in addition to the date, such as WXYZ13010001.jpg (for the first image in the series taken of event WXYZ in January of 2013). Make sure you keep a list of the events you've shot along with the event identifier to ensure that you don't have any duplicates and to make it easy to look up an event based on the identifier when necessary. Feel free to deviate from these specific naming conventions, but be sure to design a file-naming convention that works best for your specific needs.

Using a standard naming convention makes it possible to know precisely the event from the filename. When someone is looking for an original image and he or she provides the filename, it's a cinch to locate the image. Without a naming convention, the task of finding a specific image named IMG_0001.jpg becomes much more difficult.

You can use a number of tools to rename files, but one of my favorites is a free piece of software named IrfanView (www.irfanview.com). This free software is quite powerful and performs a variety of functions, such as creating slideshows, batch-converting RAW file to JPGs, and many more, but the function I use most is renaming files using a naming convention I specify. Whether you have 20 images or 20,000, IrfanView can quickly and easily convert the names to filenames that you can easily identify in the future. Some other software packages have the ability to specify a batch rename of the files during the import process.

Select Your Best Shots

One of the most popular tools for viewing and selecting images from a large shoot is called Photo Mechanic, produced by a company called Camera Bits. Photo Mechanic will actually download images from your memory card and allow you to specify a destination folder (existing or new) on your hard drive while automatically renaming the files to your specific naming convention.

Whether you use Photo Mechanic or another tool, the task is to review your images and select only those that are worth any further consideration, including for viewing, printing, or sharing. You should scan through your images one by one and decide whether to tag the image for further usage. The right software makes this a quick process. You'll quickly become adept at tagging the keepers and skipping the others. I recommend copying the keepers to a destination folder where they can be used in the future. Personally, I'm a bit of a digital packrat, so I keep everything, but saving the keepers in their own folder is definitely a time-saver down the road when you want to review the event pictures that represent the best 10 percent of your work. Images that make the cut should then continue through the following workflow steps to bring them to their full potential.

Adjust Brightness

For each image in your Keepers folder, the first step is to adjust the image's brightness. I recommend using one of three techniques that you can employ in Photoshop: Levels, Curves, and Shadows/Highlights. You will often employ a combination of these tools to achieve the best results. Make sure you view the histogram to help evaluate the image and decide which tool or combination of tools to employ.

First, determine whether the shape of the histogram spans the full range from left to right. Although every image will have a somewhat different histogram, a properly exposed image will have data spanning from the far left, indicating dark or shadow regions, to the far right, indicating highlights within the image. If your histogram doesn't span the spectrum fully from left to right, it is indicative of an image with too little contrast.

Photoshop's Levels tool is an excellent way to restore contrast to images with a short or lopsided histogram. To use the Levels tool, you can select Image > Adjustments > Levels or use the keyboard shortcut Ctrl+L (Command+L on a Mac). Move the right and left sliders to the point where data begins and ends on your histogram. If you have the Preview checkbox selected, you will see the image contrast increase, and you'll see an immediate and noticeable improvement in how your photo looks. Toggle the Preview option off and on a few times, and you will see that it looks like someone "cleaned the lens" when the effect is applied.

While you're using the Levels tool, you can also move the center slider slightly to the left to brighten the midtones in your image. But be advised that moving it too much can reduce the contrast, essentially undoing the improvement you're striving for. Like most tools in Photoshop, moving the center slider can be overdone, and small adjustments here often best produce the best results.

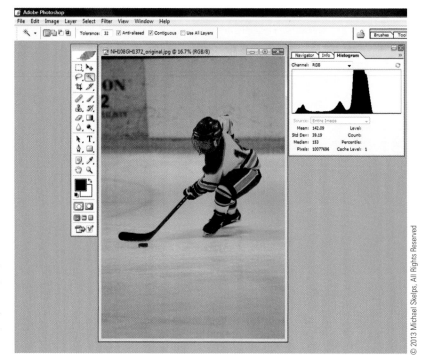

You can enhance a slightly dark image with a histogram shifted toward the left by using Photoshop's Levels tool.

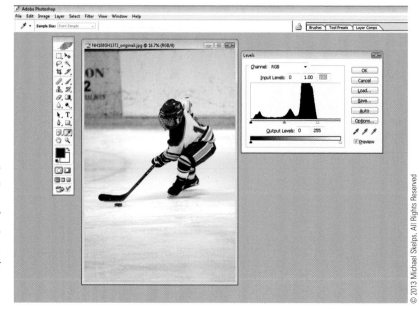

By moving the outside sliders to where the data begins and ends, your image will receive an immediate contrast benefit, usually resulting in a brighter, clearer image.

Sometimes the histogram will span fully from left to right, yet the overall image still appears too dark. If you were to use the Levels tool to try to brighten the image, you would have to move the left and right sliders inside the ends of the histogram. This would result in you forcing highlights to pure white, resulting in a loss of detail in the light areas of your image. Instead, try using the Curves tool (Images > Adjustments or Ctrl/Command+M) to brighten up your shot. Place your cursor at the center of the diagonal line and gently pull it to the upper left or "northwest" (the line will curve as you move it) until your image brightens sufficiently. You will see the histogram adjust as you do this.

Be careful not to blow out your image's highlights. The Curves tool will actually allow you to set multiple points on this line, turning it to a complex curve (hence the name *Curves*); however, I find that the best results are achieved by simply turning the straight line into a gentle upward bow.

A third scenario involving brightening images is when the overall exposure of the image is good (that is, you see a full histogram distribution) but certain areas are very dark—for instance, an athlete's face in the shadow of a hat or helmet. Using the Curves or Levels tool would adjust the overall image, but here you're only concerned about the part of the image that is particularly dark. Photoshop's Shadow/Highlight tool can be particularly useful because it can be used to brighten only the darker (or, less frequently, the brighter) areas of the image. Use Images > Adjustments > Shadows and Highlights to access this tool. (I use it so often that I have assigned a custom keyboard shortcut on my computers.) This tool will default to Shadows=50%, Highlights=0%.

In the vast majority of the cases where I use Shadows and Highlights, I adjust only the Shadows slider and leave the Highlights value at zero. Toggle the preview to compare the effect of 50% Shadows (default) and 0%. Move the slider

The Curves tool.

left a bit and try to find the ideal value for Shadows. Applying too high of a value to shadows will reduce the contrast of your image and cause the darker portions of your picture to look artificially dull and grayish. You want just enough to brighten the darker areas to bring out some detail while maintaining acceptable contrast.

Consider each of these three techniques as tools at your disposal to brighten and occasionally darken images as necessary. Just as a carpenter will use different tools for different instances, you'll need to determine the best tool for the particular image you're working on. Lopsided histograms typically call for the Levels tool, whereas good histograms where the picture still appears dark call for Curves. Images with particular dark areas call for Shadows/Highlights. Play around with these three tools and compare the results. Try using them in combination—for instance, using the Levels tool followed by the Curves tool. With practice, you will soon develop a feel for which tool is best for your image, and when one tool is sufficient or when a combination will produce the best results.

The Shadow/Highlight tool is best applied to images with darkened midtones you want to brighten and bright highlights you don't want to blow out.

Adjust Color Balance

If you used the right white-balance setting when taking your photographs, you may be able skip this step. However, if you didn't set the white balance correctly, or sometimes when you're shooting in twilight or other unusual lighting conditions that don't exactly match the camera's presets for Sunny, Cloudy, or Shade, you may notice that the image may have a yellow, red, or blue hue. Using the Color Balance tool (Image > Adjustment > Color Balance or Ctrl/Command+B) will help you adjust this to a more natural hue. You'll see three sliders: Cyan-Red on top, then Magenta-Green, and Yellow-Blue. Although you can adjust the

three sliders individually to any possible combination, you'll tend to achieve the best results by moving the top and bottom sliders in opposite directions, one to the right and one to the left. Moving the middle slider from its center position never seems to improve the image, so my best advice is to leave it at its zero value.

You'll notice a section in this window called Tone Balance. By default, the Midtones radio button is selected on this screen. I always leave Midtones selected when I'm adjusting Color Balance. Like all the other tools and settings in Photoshop, you can play around to see the effect on your images. You can always undo the changes, and you'll come to better understand the tools in the process.

By moving the Cyan-Red and Yellow-Blue sliders in opposite directions, you can correct some out-of-white-balance images to a truer hue.

Adjust Color Saturation

Vibrant color is so important to the overall appearance of your images. After you've achieved the proper color balance, it's often beneficial to adjust the color saturation. Select Image > Adjustments > Hue/Saturation or use keyboard shortcut Ctrl+U (Command+U) and then press A. Typically, you will either leave the saturation unchanged or increase it slightly. The goal is to bring the colors to a vibrant level while they still look natural.

I like my images to be just slightly more colorful than reality. I typically find increase in saturation of between 8 and 15 points to be beneficial to many pictures, though there will be cases when you will need to go a bit higher. If you increase the saturation too much, your images will start to look unrealistic and cartoonish, so I limit my saturation increase to a maximum of +25. Also, watch for signs that indicate excessive saturation, particularly overly red faces while you're increasing saturation. If the athlete's face is becoming too red, bring the saturation back down.

Although the Hue control is available within the Hue Saturation window, I tend to use this tool only to manage the color saturation. You can better manage colors using the Color Balance tool instead of the Hue tool.

The Hue/Saturation tool.

Crop

In the step of cropping, you'll take an image from its original full height and width from the camera and cut it down to a smaller rectangle. Images may be cropped for a number of reasons, including to achieve a desired print size or to emphasize the subject or eliminate extraneous objects in the top, bottom, or sides of your image. Select the Crop tool in Photoshop's Tools palette or use the keyboard shortcut C for the Crop tool. (Not Ctrl+C, just plain old C.)

Cropping comes naturally to most people, so it doesn't warrant a lot of detail in this chapter, but here are some helpful tips to consider when cropping your image.

- Click your mouse at the upper-left corner of where you would like to crop, drag down to the lower-right corner, and then release your mouse. (Actually, you can start at any corner and drag to the opposite corner.)

- If you're producing a particular size print (5×7, 8×10, and so on), use the preset values available in the Crop toolbar at the top of the screen. Selecting 8×10 will constrain the crop to that particular aspect ratio.

- It's okay if you don't get the crop perfect on the first click. You can drag each corner to the ideal position to tweak your crop.

- You can even rotate the crop box to straighten the image where the camera wasn't level. To do this, establish your preliminary crop and then click outside the crop box and drag from side to side. You'll see the crop box rotate.

- When you're happy with the crop position, simply press Enter or double-click with your mouse.

Before the crop.

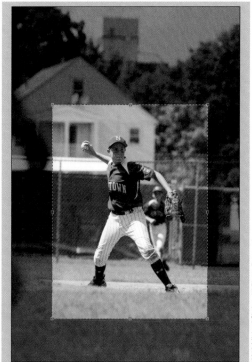

Performing the crop.

Crop presets.

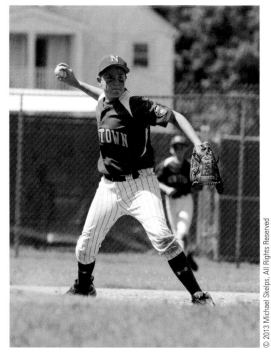

Cropped image.

Note that cropping images for 8×10 prints can be more challenging than cropping for 5×7 or 4×6 prints. This is because 8×10 prints are closer to a square in shape than some other print sizes, whereas dSLR cameras capture images that are more rectangular. As a result, you'll have to crop a substantial amount from the top or bottom of the image (for portrait-orientation shots). It probably goes without saying, but never crop part of a person's head, and try to keep as much of her body in the image as possible. If you plan ahead when you're shooting and include some margin in your shots, your images can be printed as 8×10s without you having to crop out important parts.

Reduce Noise

Today's quality dSLR cameras generally have low-noise sensors. No, that doesn't mean they are quiet on the sound they produce. It means they produce a relatively low amount of digital noise. You are already familiar with my recommendation of taking photos with your camera set to a low ISO value (400 or lower) whenever possible. Whenever you're able to do this, the issue of digital noise becomes largely moot.

Unfortunately, low-light situations will require you to shoot using higher ISO values from time to time, so expect to see a certain amount of noise in those photos. Noise degrades the image because the individual pixels lose their color fidelity when the sensor gain is cranked way up.

Fortunately, software is available that can be a big help in reducing the appearance of digital noise in your images. One of the most widely used is an application called Noise Ninja (available at www.picturecode.com) to help reduce the appearance of the noise. Noise Ninja is also available as a Photoshop plug-in, which is how I use it.

To reduce noise in an image using this plug-in, open the image in Photoshop and choose Filter > PictureCode > NoiseNinja. (I created a custom keyboard shortcut for easy access to this tool.)

Although Noise Ninja has many advanced options and settings, I feel it is sufficient to use the Auto Profile function to remove the noise. I'll leave it to you to explore the many settings in detail, but I generally leave the defaults, with one exception. On the Filter tab, I've found that increasing the USM (Unsharp Mask) values slightly works well.

Try tweaking the USM amount to 130% and the USM radius to around 1.3. Then click OK and sit back for a few seconds to see the output. The results are surprisingly beneficial to noisy images and well worth the reasonable price of the plug-in.

After you apply the effect, toggle Undo (Ctrl+Z in Windows or Command+Z on a Mac) to see the image before and after the noise reduction. You will see a slight softening and smoothing of the image. The Unsharp Mask feature helps offset this to some extent. This softening is the reason why I recommend using Noise Ninja only where the noise is substantial and where the benefit of the noise reduction outweighs the downside of the softened image. If your image does not contain substantial noise, you can just skip this step. Also, if you use Noise Ninja, you can skip the following Unsharp Mask step. (If you were to complete the Unsharp Mask step after removing the noise, it would restore much of the noise you just removed.)

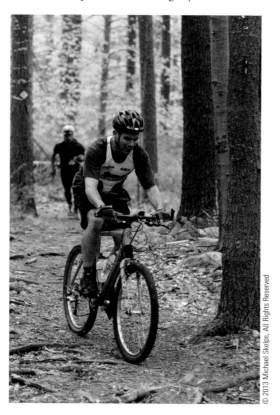

When you zoom in on this image, you can see significant noise.

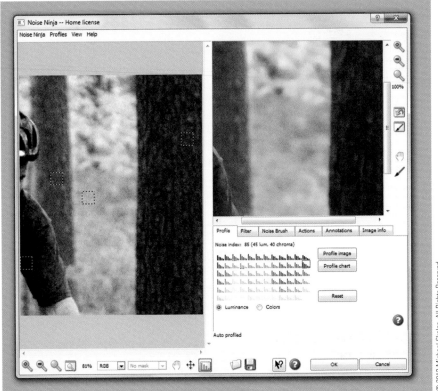

Noise reduction software, such as Noise Ninja, can easily reduce noise in your images. Be aware that some image softening can occur as a result, so you should make this type of adjustment only when absolutely necessary.

Unsharp Mask

Skip this step if you reduced noise using Noise Ninja in Step 5.

Photographers should strive for the sharpest focus they can achieve. But looking at your pictures close and zoomed in, you will always be able to find a certain level of softness. Photoshop's Unsharp Mask tool is a way to help provide a slightly sharper look to your images.

Unsharp Mask's weird name harks back to the days of chemical darkrooms. A negative of the original image was combined with an intentionally blurred or unsharpened positive. The result is that the blurry portion of the positive cancelled out (masked) the blurry portion of the negative.

In more practical terms, Unsharp Mask works like this: It looks for high-contrast areas (areas of light and dark) that are very close to each other. In those areas, the effect darkens the dark areas and

lightens the light areas, giving the appearance of better focus. You'll find the Unsharp Mask option under Filters > Sharpen > Unsharp Mask. The keyboard shortcut is Ctrl+Alt+Shift+U. I prefer to create a more accessible custom keyboard shortcut, as I use Unsharp Mask all the time.

Use Unsharp Mask to give a sharper look to your images. By darkening the dark areas of an image and lightening the light areas, this tool makes the photo appear to be in better focus.

On well-focused images, I recommend using Unsharp Mask with settings as follows:

- Amount (available values of 0–500): 100%

- Radius: 1.0

- Threshold: 0

Be careful not to over-sharpen your images. If you apply too much of the effect, your images will take on an unnatural appearance. Like any effect in Photoshop, there's a good amount, and there's a "too much" amount. Play around with the different values on Unsharp Mask and other effects until you gain a feel for the optimal settings that give you the best results.

Save the Image

The cardinal rule in digital image workflow is to never save over the original image. Sure, your intent is always to make an image better, but occasionally you may reconsider the work you've done, and you always want to be able to access your original image and start over in your editing. So when you open an image to do some work on it, don't just save the image; use Save As and specify a new filename or a different folder from the original.

For most printing or web-display purposes, you will want to save the image in the JPG format. When you save a JPG file, you will get the option to choose the quality setting for the image, ranging from 1 to 12. Higher numbers result in larger

file sizes and preserve the image fidelity. Lower numbers are used for greater JPG compression. At the lower end of the range, the quality of the image will start to be diminished, and it may show posterization (visible as square patterns in the image). In most cases, there is no reason to reduce the quality of the image, so I recommend keeping the quality at the higher end of the range. Personally, I cannot detect any visible difference between a JPG quality of 11 and 12. Because a quality of 11 produces a slightly smaller file size, I tend to use that setting when saving files.

To summarize, here are the process steps I recommend:

1. Adjust brightness (Levels, Curves, Shadows/Highlights)

2. Adjust color balance

3. Adjust color saturation

4. Crop

5. Reduce noise (if necessary)

6. Unsharp mask (unless you've applied noise reduction)

7. Save as JPG

Conclusion

Your images will show your best work only if you've taken the time to bring your best images to their full potential through a consistent workflow process. This process allows you to identify your best work and organize the enhanced images both on your primary drive and your backup.

Let's look ahead to a very important aspect that is critically important when shooting sports—the issue of safety.

JPEG Options dialog box.

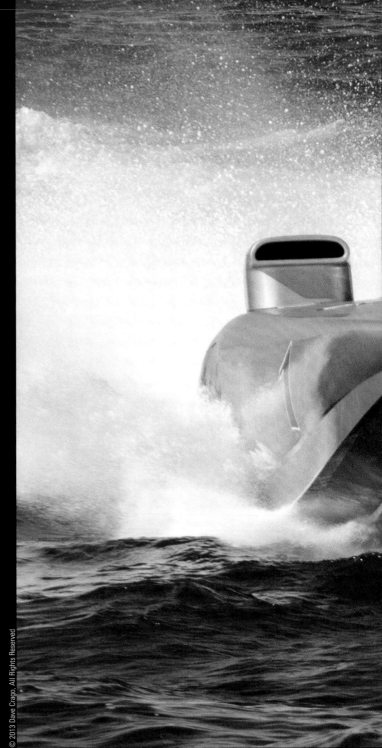

15
Safety

You might be tempted to just skim this section or gloss over it entirely. Don't! I'll make it a short one, but it's terribly important that you put yourself in a safety mindset whenever you are at a shoot.

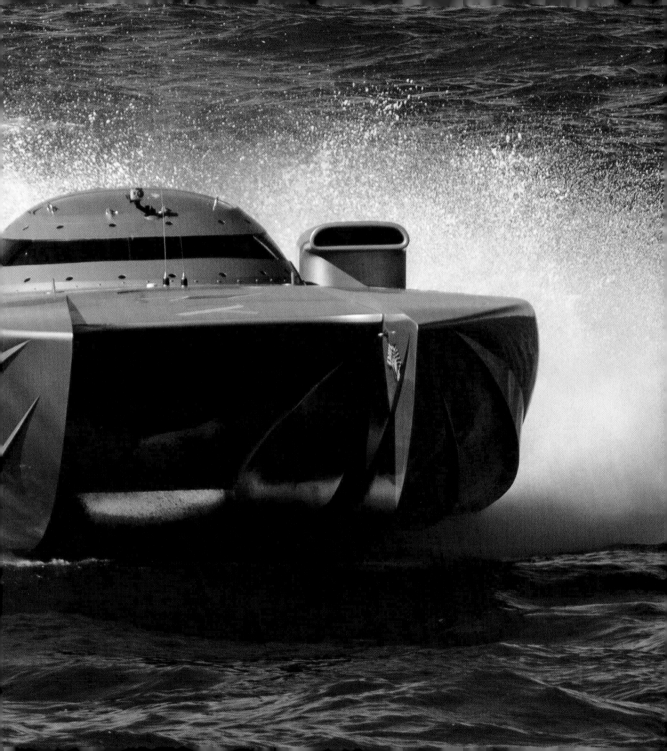

Whatever your profession, you should have safety on your mind in your work and personal life. As a sports photographer in particular, safety is absolutely critical. You are photographing athletes who are moving at a high rate of speed and who are solely focused on their sport. In some sports, such as football, your subjects may be very big guys running at a full clip and changing directions unpredictably. In other sports, such as baseball or hockey, you will have hard projectiles hurtling unpredictably at more than 100 miles per hour. You'll also be around spectators who are totally engrossed in the game, unaware of little around them except the action. The combination of fast-moving projectiles and many oblivious people nearby can be a dangerous one.

"The combination of fast-moving projectiles and many oblivious people nearby can be a dangerous one."

It is essential that you remain alert and vigilant at all times. That certainly applies to your photography, because you will need to follow the action through your camera and anticipate where the action is going and where to photograph next. But it also applies to being constantly aware of your environment and scanning it for potential hazards. Think about what could go wrong at all times while shooting action. You need to know where people are around you (including behind you) and where you can move for refuge if you need to.

In addition to your own personal safety, you should think about the safety of the athletes, spectators, and officials. If someone at the event trips over you and is injured, you'll be having a very bad day.

Choosing the right location is already a big challenge for photography. Where is the best lighting? What position will give me the best access to the action? What positions will the officials or event management allow me access to? But now you need to consider your position from a safety standpoint as well.

I remember photographing a large 5K road race. Through shooting similar events previously, I've learned that the safest place to be is behind a car, mailbox or telephone pole at the side of the road when shooting the group start. Runners tend to spill out from the main running area (the road) and onto the sidewalk. Having come close to being clobbered when shooting from a supposedly safe spot on the sidewalk, I've come to seek a more substantial point of refuge. And when the runners start coming out fast and thick on both sides of me and there's no real opportunity to get a decent shot, I simply stand there safely in my refuge spot, pause shooting for a few moments, and wait until the crowd thins out so I can resume shooting safely.

"You need to know where people are around you (including behind you) and where you can move for refuge if you need to."

(Opposite page) Even shooting from a supposedly safe location can quickly become a hairy situation if an athlete loses control. It only takes a moment for a situation to go from safe to scary. Stay alert!

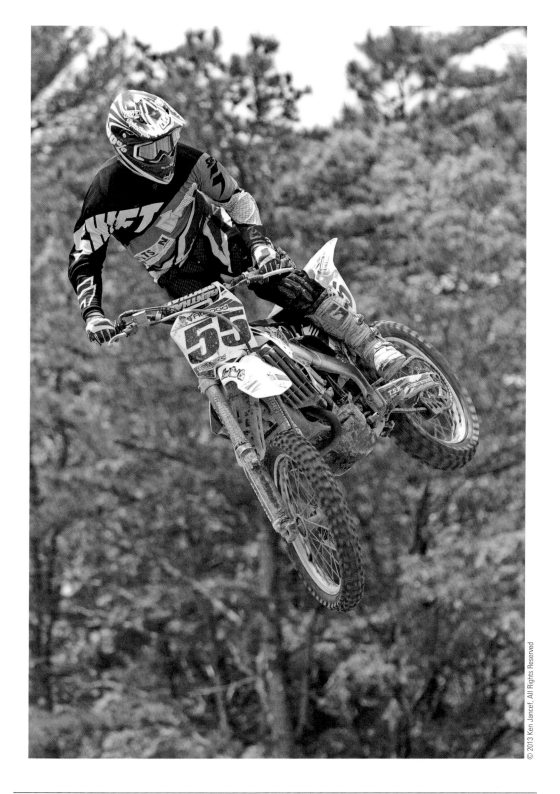

But on this particular day, there was an amateur photographer who wanted to get a shot of the group start. She was about 100 yards out on the course, which meant that the fastest runners would be there in slightly more than 10 seconds. There were about 2,000 athletes in this event. The lady, who was very small in stature—around 5 feet tall and maybe 100 pounds—apparently wanted a little more height to get her desired shot. I don't know where it came from, but she found a cinderblock at the side of the road and, with considerable effort, slowly dragged it into the middle of the street and stepped up on it. I watched her do all this, and then I looked back at the assembled group of runners about 90 seconds away from the start.

The horrific worst-case scenario quickly played out in my mind. The race would start, with the mass of runners sprinting toward her. She would get her shot and then step off the cinderblock and try to drag it back to the side of the road. As the runners moved quickly toward her, she would panic and run to the side of the street, leaving the cinderblock in the road. The lead runners would probably see it and dodge or run around it. But the runners a few rows back wouldn't see it, and someone would trip. And then I could imagine people not seeing the fallen runner and accidentally trampling him. Overly dramatic? Possibly. But the potential outcome of this action could be very, very bad. In addition, if a person taking pictures was connected to this, I could just see the news headline: "Photographer's Mistake Leads to Race Death." Even though this had nothing to do with me, I didn't want anything this woman did to come back on me as a pro photographer.

I mustered a tone of authority and told her she needed to move that cinderblock off the road before someone got hurt. She did, and that was the end of the story, thank goodness. But I've never forgotten that event and what could've happened.

I have covered events where deaths occurred. I've seen the structure holding up a race finish-line banner be blown over by high winds and crush a woman's leg (which could've been worse, by just a matter of a few feet). I've seen a football player run out of bounds, giving the photographer a concussion and breaking his gear. I've seen a hockey puck hit a photographer's lens, damaging it and giving the photographer a black eye. I've even seen a photographer walking while taking candid photos and then tripping over a rock, breaking the lens filter and bloodying his nose.

This isn't meant to scare you—well, maybe just a little! It's meant to make you think about what can go wrong during a sports-photography assignment. Here are a few dos and don'ts to help keep you safe.

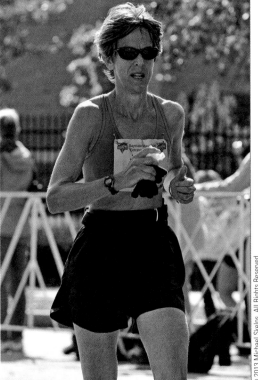

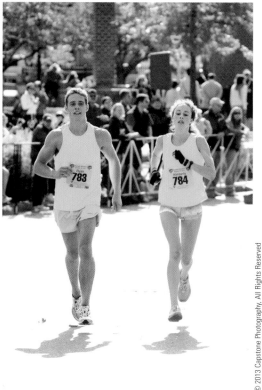

Do:

- Remain alert regarding the activity you're photographing. Be aware of the location of the ball or puck and where the action is going at all times.

- Consider yourself an active participant in the event. Active means being ready to move at a second's notice as the situation develops.

- Obtain permission from the person managing the event you're shooting (or at least notify the person that you're going to be shooting). In doing so, let him know that you will be shooting from a position that doesn't interfere with the event, but that allows good photography while maximizing safety.

- Think about safety from all angles: safety to the athletes, to other spectators, to officials and volunteers, to yourself, and to your equipment.

Don't:

- Assume the worst won't happen. Don't just assume, "With all this field, do you really think a line drive will come through the little spot in which I'm sitting?" Trust me, if you do this long enough, the ball will come right at you at 80 mph. You can't eliminate all risks in shooting sports, but be sure to choose the safest spot where you can still get a great shot, and be ready to move at a moment's notice!

- Become complacent and get distracted while the action is happening. This is how people get hurt.

- Ever infringe on the playing field. Stay clearly out of bounds at all times.

16
Conclusion

Sports photographers do it for love. We love the action. We love the game. We love the challenge. And it's a good thing we do. Shooting sports requires expensive gear. It requires an extensive skill set that takes some time to master. It has us working in physically uncomfortable conditions—sometimes cold and wet and other times sweating beneath a hot sun. But the rewards of capturing and sharing great action shots are well worth it. I'm sure you'll have a lot of fun and gain a tremendous amount of personal satisfaction as you begin shooting sports.

But your development and growth as a sports photographer is really a lifelong journey. Maybe you're choosing to build skills in sports photography to take pictures of your children in youth sports, or maybe you're planning to become a professional sports photographer, or perhaps you simply want to round out your skills so you can be the person who can shoot anything. Whatever your reason, you won't learn everything you need to know from a single book or video, and you won't get everything right your first time out. Becoming a successful sports photographer takes a long-term commitment, but reading this book will give you a solid foundation from which to build upon.

You may have heard the story about the guy in Manhattan who encountered but did not recognize world-renowned violinist Jascha Heifetz. "Excuse me," he inquired of the virtuoso, "but could you tell me how to get to Carnegie Hall?" Heifetz's tongue-in-cheek reply was, "Practice, practice, practice!"

Practice, indeed. This advice is spot-on for sports photography as well. Developing excellent skills in action photography requires repeated application of your best efforts, analysis of your work, and tweaking your approach at each relevant opportunity. Keeping your skills honed requires frequent and regular intervals for your action photography. If you go for too long between shooting action-photography gigs, your skills won't continue their development. Worse yet, you may find your skills take a step backward if you get a little too rusty. Action photography is fun and interesting, so embrace it as a hobby and do it as often as your lifestyle and interest permit.

It doesn't matter so much whether you shoot ten hours a week or just one hour a month. But it *does* matter that you make the commitment to start from a basic foundation, continue practicing, and continue learning from your work. Be critical of your work, but don't be hard on yourself, especially given that you're just starting out. Allow yourself to make mistakes, but don't be complacent. Look for areas where you can improve your photos, such as in framing, exposure, or other aspects of your work. In photography or any other area of life, it's okay to make mistakes. That's how we learn. But it's not okay to repeat them.

Shooting sports has brought me immense personal satisfaction. I've captured images that have meant so much to the athletes and their friends and family. I've also taken great pleasure in working with other sports photographers, helping them grow, and seeing them succeed in personal and professional photography. Now and then, I even see a national sports magazine with photos from photographers I've worked with. Indeed, having skill as a sports photographer can open many different doors.

"In photography or any other area of life, it's okay to make mistakes. That's how we learn. But it's not okay to repeat them."

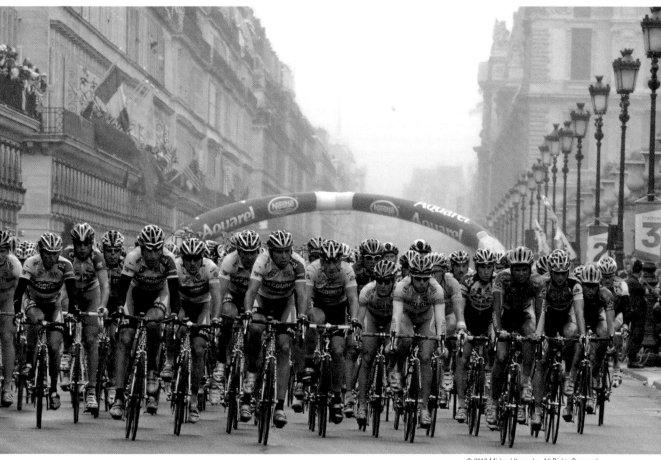

In addition to the satisfaction you'll receive from the photos you take as a sports photographer, I hope you'll experience a sense of pride in knowing that you've learned to shoot one of the most challenging and exclusive segments of photography. True, every different photography discipline requires its own specific demands and skills, but if you become proficient in sports photography, there's no other type of photography you can't learn.

I wish you great success and satisfaction as you embark upon your own personal journey of sports photography, wherever it may take you. As you develop skill and experience, I wonder whether you may eventually have a sense of calm and confidence as the critical moments draw near for the sporting events you're about to photograph. As for me, it's always butterflies and excitement, no matter how many events I shoot. However you approach your events—with calmness or excitement—I extend my best wishes for all your sports-photography endeavors.

Index

Numerics

1D Canon camera, 49
2/3 rule, 96
4 shutter speed, 31
5D Canon camera, 49.50
7D Canon camera, 50
20 shutter speed, 32
20D Canon camera, 48
60 shutter speed, 31
60D Canon camera, 48
70-200mm lens, 51–53
80-200mm lens, 53
100 ISO value, 33–34
200 ISO value, 33–34
300mm lens, 53
500 shutter speed, 31–32
800 ISO value, 34
1000 ISO value, 34
1600 ISO value, 35
4000 shutter speed, 31
8000 shutter speed, 31

A

adjusting
 camera exposure, 69
 the f-stop, 30, 35
 the ISO, 30
 shutter speed, 30
AFC (Continuous-Serve AF) auto-focus setting, 86
AF-Continuous focus mode, 85
AF-Single focus mode, 85
AI Focus mode, 85
AI Servo focus mode, 85
alertness, 18
aperture
 70-200mm zoom lens, 52
 blur and, 36
 cloudy/overcast conditions, 110
 concepts, 35–38
 depth of field and, 35–36
 f-stop and, 35
 opening or closing, 35
 size effects, 36
 small *versus* large, 35
 stopping down, 35–37
 sunlight conditions, 108
 wide-open, 38
Aperture Priority mode
 adjusting camera exposure, 69
 cloudy/overcast conditions, 110
 susunlight conditions, 108
AquaTech rain gear, 141
ASA values, 33
aspect ratio, 98
Auto White Balance (AWB) setting, 75
auto-focus
 camera, 83–84
 cloudy/overcast conditions, 110
 lens, 84–86
 sunlight conditions, 108
automatic mode, for exposure, 30
AWB (Auto White Balance) setting, 75

B

background, framing and composition, 92
backlight
 background and location consideration, 126
 concepts, 136
 considerations and constraints, 126–127
 evaluative metering, 129
 exposure, 128
 exposure compensation, 124, 128
 fill flash, 128
 histogram analysis and, 69, 133
 lens flare, 135
 lens hood use, 133, 136
 manual exposure compensation, 130–132
 Manual mode shooting, 130
 side-lit subjects, 128–129

spot metering, 129–130
stops, 131
white balance, 133, 179
backups, 162–163
bag covers, 141
batteries
in cold weather, 146
extra supply of, 58–59
high frame rate and battery life, 45
moisture around, 145
OEM, 59
blur
aperture and, 36
bokeh, 37, 45
shutter speed and, 21–22, 31–32, 37
Bogen-Menfrotto Super Clamps, 142
bokeh, 37, 45
bracketing, exposure, 65
brightness adjustment, 165–168

C

camera
Canon and Nikon rivalry, 47–48
Canon models, 47–50
consumer-grade SLRs, 60–61
grip, 57
new *versus* used, 54–55
Nikon models, 50–51
non-recommended, 46–47
phone as, 46–47
point-and-shoot, 46–47
rain cover, 141
recommended, 47–51
recommended gear characteristics, 42
sensor, 43–45
used, 47, 54–55
warranty, 54
camera auto-focus, 84–86
camera phone, 46–47
camera shake, 21
Canon
1D model, 49
5D model, 49.50
7D model, 50
20D model, 48

60D model, 48
auto-focus modes, 85
lens, 51–53
model types, 47
and Nikon rivalry, 47–48
center point, 92, 102
center slider (Photoshop), 165
challenges
being alert and interactive, 18
equipment, 22, 24
lighting conditions, 12, 15
readiness, 18
shooting lots of frames, 18, 20
shutter speed, 21–22
"chicken winging," 57
chimping, 67
clamps, 142–143
clipping, 66
clothing, cold-weather, 143–145
cloudy conditions, 108, 110, 112
Cloudy white balance preset, 74–75, 77
cold-weather shooting, 143–145
color
best guess color adjustment, 75
light and, 74
color balance adjustment, 169
Color Balance tool (Photoshop), 169
color cast, 74
color saturation adjustment, 170
commitment, 6–7, 186–187
composition. *See* framing and composition
compression
file, 154
JPG, 152
concepts
aperture, 35–38
backlight, 136
exposure, 28–30, 71
file management, 155
focus, 82–83, 89
framing and composition, 103
ISO, 32–35
lighting conditions, 112, 121
shutter speed, 31–32
weather condition, 146
white balance, 79
consumer-grade SLRs, 60–61

Continuous-Serve AF (AFC) auto-focus setting, 86
cost
 70-200mm zoom lens, 51
 Canon 1D, 49
 Canon 5D, 50
 Canon 7D, 50
 Canon 20D, 48
 Canon 60D, 48
 equipment, 24
 lens filter, 56
 lens hood, 56
 monopod, 58
 new camera, 47
 Nikon D3, 51
 Nikon D300, 51
 Nikon D700, 51
 used camera, 47
crop factor, 49
cropping, 170–171
Curves tool (Photoshop), 167–168
custom white balance, 76–77
Cyan-Red slider (Photoshop), 169

D

D1X and D1H Nikon camera, 50–51
D2H Nikon camera, 50–51
D3 Nikon camera, 51
D300 Nikon camera, 51
D700 Nikon camera, 51
darkness/night-time shooting, 120
depth of field, 35–37, 39
digital noise
 ISO and, 33
 as result of high shutter speed, 37
downloading images, 159

E

editing. *See* image enhancement
equipment
 camera grip, 57
 challenges, 22, 24
 cost threshold, 24
 importance of high-quality, 3–4, 22, 24
 lens filter, 56

 lens hood, 56–57
 memory card, 60
 monopod, 58
 new *versus* used, 54–55
 non-recommended, 46–47
 tripod collar/tripod ring, 58
EV (exposure value), 69
evaluative metering, 129
exposure
 adjusting the, 69
 automatic mode setting, 30
 backlight, 128
 bracketing, 65
 in camera, 64
 chimping, 67
 concepts, 28–30, 71
 highlights, 64
 histogram analysis, 66–68
 ideal standard, 28
 JPG image format, 64–65
 lighting conditions and, 28–30
 manual exposure compensation, 69
 midtones, 64
 negative/positive exposure compensation, 69
 overexposed image, 29, 64, 66, 70
 properly exposed image, 28, 30
 RAW image format, 64–65
 shadows, 64
 shutter speed and, 31
 underexposed image, 29, 64, 66, 70
exposure compensation
 backlight, 124, 128, 130–132
 cloudy/overcast conditions, 110
 sunlight conditions, 108
exposure value (EV), 69

F

face, focusing on, 83
facemask, 143
fast and clear focus, 45
file management
 backups, 162–163
 compression, 154
 concepts, 155
 file size consideration, 153

JPG image format, 150, 152
RAW image format, 150, 152
renaming files, 164
resolution, 153
saving images, 176–177
selecting best shots, 165
viewing images, 165
fill flash, 128
film ISO values, 33–34
filter, lens, 56
flash, back-lit subjects, 128
focus
AF-Continuous mode, 85
AF-Single mode, 85
AI Focus mode, 85
AI Servo mode, 85
camera auto-focus, 83–84
concepts, 82–83, 89
Continuous-Servo AF (AFC) setting, 86
on face, 83
fast and clear, 45
lens auto-focus, 84, 86, 89
One Shot mode, 85
panning technique, 86–89
practicing with, 86
folder name, 159–160
frame rate, 45
frames, shooting lots of, 18, 20
framing and composition
2/3 rule, 96
anticipating potential output, 97
center point, 92, 102
concepts, 103
full-body framing, 94–98
head shot, 99
location and background importance, 92
portrait orientation, 102–103
Rule of Thirds, 92
upper-torso framing, 99
vertical orientation, 92
zoom, 96
free market, 54
freezing action, 31–32
front-lit conditions, 107–110
f-stop
adjusting, 30, 35

aperture and, 35
high, 36
low, 45
stopping down, 35–37
full stops, 131
full-body framing, 94–98

G

gain, 33
gear. *See* equipment
gloves, 143, 145
gray card, 76–77
gray market, 54
grip, camera, 57
gymnastics, 21

H

head shot, 99
high ISO values, 33
high shutter speed, 21–22
highlights, 64, 66
histogram analysis, 66–68, 133
hockey, 76
hood, lens, 56–57
Hue/Saturation tool (Photoshop), 170
human eye, 35

I

IfranView software, 164
image enhancement
brightness adjustment, 165–168
color balance adjustment, 169
color saturation adjustment, 170
cropping, 170–171
downloading images, 159
naming folders, 159
noise reduction, 172–174
softened image, 173, 175–176
workflow, 158–159
image stabilization (IS), 52
ISO
adjusting the, 30
cloudy/overcast conditions, 110

concepts, 32–35
digital noise, 33
digital values, 33–34
film values, 33–34
high values, 33
low-light conditions, 116–117
low values, 33
standards, 32–33
sunlight conditions, 108
Isotoners, 144

J

JPG compression, 152
JPG image format, 64–65, 150, 152
JPG posterization, 150, 154

L

landscape framing, 102–103
Large resolution setting, 153
LCD screen
blinking area in, 68
reviewing, 67–68
lens
70-200mm, 51–53
80-200mm, 53
300mm, 53
auto-focus, 84–86
Canon, 51–53
cloth, 145
filter, 56
hood, 56–57, 133, 136
image stabilization (IS) feature, 52
Nikon, 53
old *versus* new, 52
Sigma, 61
Tamron, 61
third-party, 61
used, 51
lens flare, 135
LensCoat rain gear, 141
Levels tool (Photoshop), 165–168
lighting and color, 74

lighting conditions
backlight
background and location, 126
concepts, 136
considerations and constraints, 126–127
evaluative metering, 129
exposure, 128
exposure compensation, 124, 128
fill flash, 128
histogram analysis and, 69, 133
lens flare, 135
lens hood use, 133, 136
manual exposure compensation, 130–132
Manual mode shooting, 130
side-lit subjects, 128–129
spot metering, 129–130
stops, 131
white balance, 79, 133
challenges, 12, 15
cloudy/overcast conditions, 110, 112
concepts, 112, 121
developing awareness of, 29
exposure and, 28–30
front-lit conditions, 107–110
indoor *versus* outdoor shooting, 12
low-light conditions
from bright to moderate, 118–119
darkness/night time, 120
ISO, 116–117
moderate to dark, 119–120
shutter speed, 116
from very bright to just bright, 118–119
proficiency in shooting under, 4
shooting from different locations, 15
weather and, 15
white balance and, 77
low f-stop, 45
low ISO values, 33
low-light conditions
from bright to moderate, 118–119
darkness/night time, 120
ISO, 116–117
moderate to dark, 119–120
shutter speed, 116
from very bright to just bright, 118–119
low noise sensor, 43–45

M

"machine-gunning," 20
Magenta-Green slider (Photoshop), 169
manual exposure compensation, 69
Manual mode, 130
Medium resolution setting, 153
megapixel, 43
memory card, 60, 160
midtones, 64, 66
monopod, 58
motion blur, 21–22, 31–32, 37

N

naming folders, 159–160
negative exposure compensation, 69
new *versus* used equipment, 54–55
night-time shooting, 120
Nikon
 auto-focus modes, 85
 and Canon rivalry, 47–48
 D1X and D1H model, 50–51
 D2H model, 50–51
 D3 model, 51
 D300 model, 51
 D700 model, 51
 lens, 53
 model types, 47
noise, 44–45
Noise Ninja application, 173–174
noise reduction, 172–174

O

OEM batteries, 59
One Shot focus mode, 85
overcast conditions, 110, 112
overexposed image, 29, 64, 66, 70

P

panning technique, 86–89
permission to shoot, 106
personal satisfaction, 186–187

Photo Mechanic tool, 165
Photoshop
 brightness adjustment, 165–168
 center slider, 165
 color balance adjustment, 169
 Color Balance tool, 169
 color saturation adjustment, 170
 Crop tool, 170–171
 Curves tool, 167–168
 Hue/Saturation tool, 170
 Levels tool, 165–168
 as most common image adjustment tool, 158
 noise reduction, 172–174
 Shadow/Highlight tool, 167–168
 softened image, 173, 175–176
 Tone Balance feature, 169
 Unsharp Mask tool, 173, 175–176
pinhole camera, 36
point-and-shoot camera, 46–47
portrait orientation, 102–103
positive exposure compensation, 69
post-processing. *See* image enhancement
practice, 6–7, 186
proficient photographer techniques
 basic approach and theory of sports
 photography, 4
 commitment and practice, 6–7
 components, 2–3
 high-end equipment needs, 3–4
 lighting conditions, 4
 readiness, 8
pupil, 35

R

raincoat, 142
rain cover, camera, 141
rainy weather, 140–143
RAW image format, 64–65, 150, 152
readiness
 being alert and interactive, 18
 proficient photographer techniques, 8
recommended cameras, 47–51
red-green-blue color value, 44
renaming files, 164

resolution, 153
Rule of Thirds, 92

S

safety, 180, 182–183
SanDisk memory card, 60
saving images, 176–177
sensor, low noise, 43–45
Shade white balance preset, 74, 77, 79
Shadow/Highlight tool (Photoshop), 167–168
shadows, 64, 66
shallow depth of field, 37, 39
shutter lag, 20, 42–43
Shutter Priority mode, 69
shutter speed
 adjusting, 30
 camera shake, 21
 challenges, 21–22
 cloudy/overcast conditions, 110
 concepts, 31–32
 for everyday photography, 21
 exposure and, 31
 fast, 31
 fractional value representation, 31
 freezing action, 31–32
 high, 21–22
 low-light conditions, 116
 motion blur and, 21–22, 31–32
 recommended, 21
 slow, 31
 for sports photography, 21
 sunlight conditions, 108
side-lit subjects, 128–129
Sigma lens, 61
skating, 76
SLRs, consumer-grade, 60–61
Small resolution setting, 153
softbox, 110
softened image, 173, 175–176
spot metering, 129–130
"step" compression feature, 154
stopping down, 35–37
stops, 131
subject matter, 106–107

sun, front-lit conditions, 107–108
Sunny white balance preset, 74–75, 77

T

Tamron lens, 61
Tone Balance feature (Photoshop), 169
tripod, 21
tripod collar/tripod ring, 58

U

umbrella, 141–142
underexposed image, 29, 64, 66, 70, 112
Unsharp Mask tool (Photoshop), 173, 175–176
upper-torso framing, 99
used camera, 47
used lens, 51
used versus new equipment, 54–55
UV filter, 56

V

vertical orientation, 92
Vortex Media rain gear, 141

W

warranty, camera, 54
weather
 bad-weather shooting, 140
 cold-weather shooting, 143–145
 concepts, 146
 lighting conditions and, 15
 wet-weather shooting, 140–143
 windy conditions, 145
wet-weather shooting, 140–143
white balance
 Auto White Balance (AWB) setting, 75
 for backlight, 133
 Cloudy preset, 74–75, 77
 cloudy/overcast conditions, 110
 color cast, 74
 concepts, 79

custom, 76–77
gray cards for, 76–77
light and color, 74
lighting conditions and, 77
Shade preset, 74, 77, 79
sunlight conditions, 108
Sunny preset, 74–75, 77
wide-open aperture, 38
windy conditions, 145
workflow, 158–159

Y

Yellow-Blue slider (Photoshop), 169

Z

zoom
framing and composition, 96
in full-body framing, 94–95

WE'VE GOT YOUR SHOT COVERED

New Releases

New Image Frontiers: Defining the Future of Photography
1-4354-5857-5 • $29.99

A Shot in the Dark: A Creative DIY Guide to Digital Video Lighting on (Almost) No Budget
1-4354-5863-X • $44.99

Fashion Flair for Portrait and Wedding Photography
1-4354-5884-2 • $34.99

Fearless Photographer: Portraits
1-4354-5824-9 • $34.99

Picture Yourself Making Creative Movies with Corel VideoStudio Pro X4
1-4354-5726-9 • $29.99

Complete Digital Photography, Sixth Edition
1-4354-5920-2 • $44.9

The Linked Photographers' Guide to Online Marketing and Social Media
1-4354-5508-8 • $29.99

Picture Yourself Learning Corel PaintShop Photo Pro X3
1-4354-5674-2 • $29.99

Fearless Photographer: Weddings
1-4354-5724-2 • $34.99

Photographs from the Edge of Reality
1-4354-5782-X • $39.99

Killer Photos with Your iPhone
1-4354-5689-0 • $24.99

David Busch's Mastering Digital SLR Photography Third Edition
1-4354-5832-X • $39.9

New from #1 Bestselling Author David Busch!

To learn more about the author and our complete collection of David Busch products please visit www.courseptr.com/davidbusch.
David Busch, Your Complete Solution

David Busch's Compact Field Guide for the Canon EOS Rebel T3/1100D
1-4354-6030-8 • $13.99

David Busch's Compact Field Guide for the Nikon D5100
1-4354-6087-1 • $13.99

David Busch's Compact Field Guide for the Nikon D3100
1-4354-5994-6 • $13.99

David Busch's Compact Field Guide for the Canon EOS 60D
1-4354-5996-2 • $13.99

David Busch's Compact Field Guide for the Nikon D7000
1-4354-5998-9 • $13.99

David Busch's Compact Field Guide for the Canon EOS Rebel T3i/600D
1-4354-6032-4 • $13.9

David Busch's Canon EOS Rebel T3/1100D Guide to Digital SLR Photography
1-4354-6026-X • $29.99

David Busch's Nikon D5100 Guide to Digital SLR Photography
1-4354-6085-5 • $29.99

David Busch's Nikon D3100 Guide to Digital SLR Photography
1-4354-5940-7 • $29.99

David Busch's Canon EOS 60D Guide to Digital SLR Photography
1-4354-5938-5 • $29.99

David Busch's Nikon D7000 Guide to Digital SLR Photography
1-4354-5942-3 • $29.99

David Busch's Canon EOS Rebel T3i/600D Guide to Digital SLR Photogra
1-4354-6028-6 • $29.9
